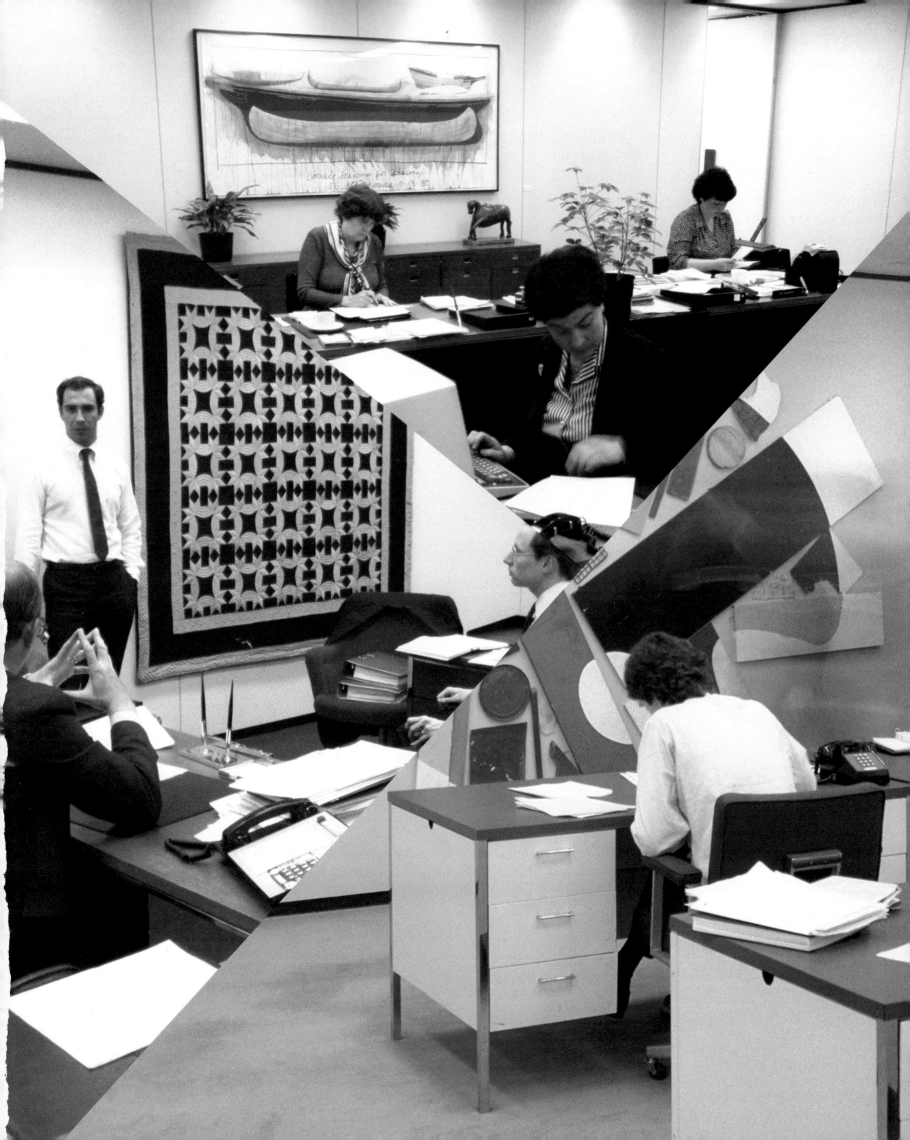

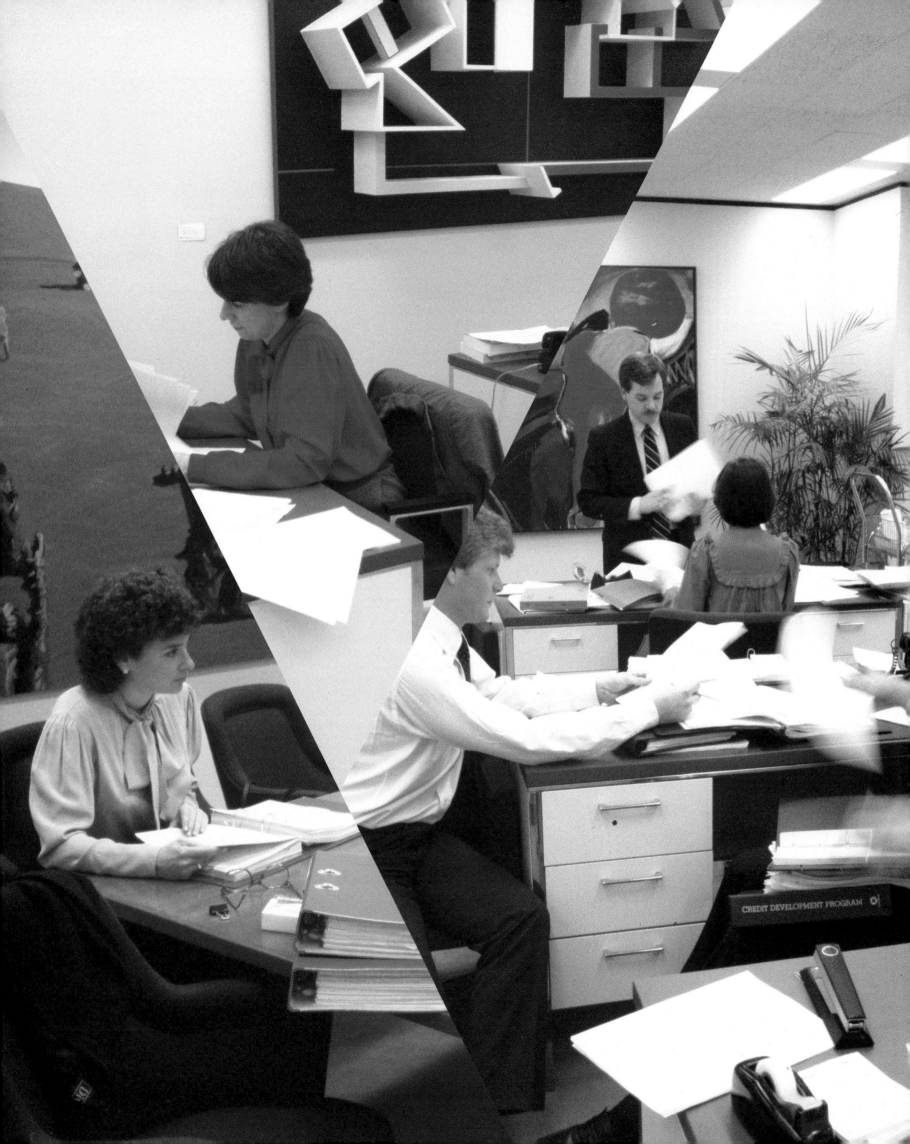

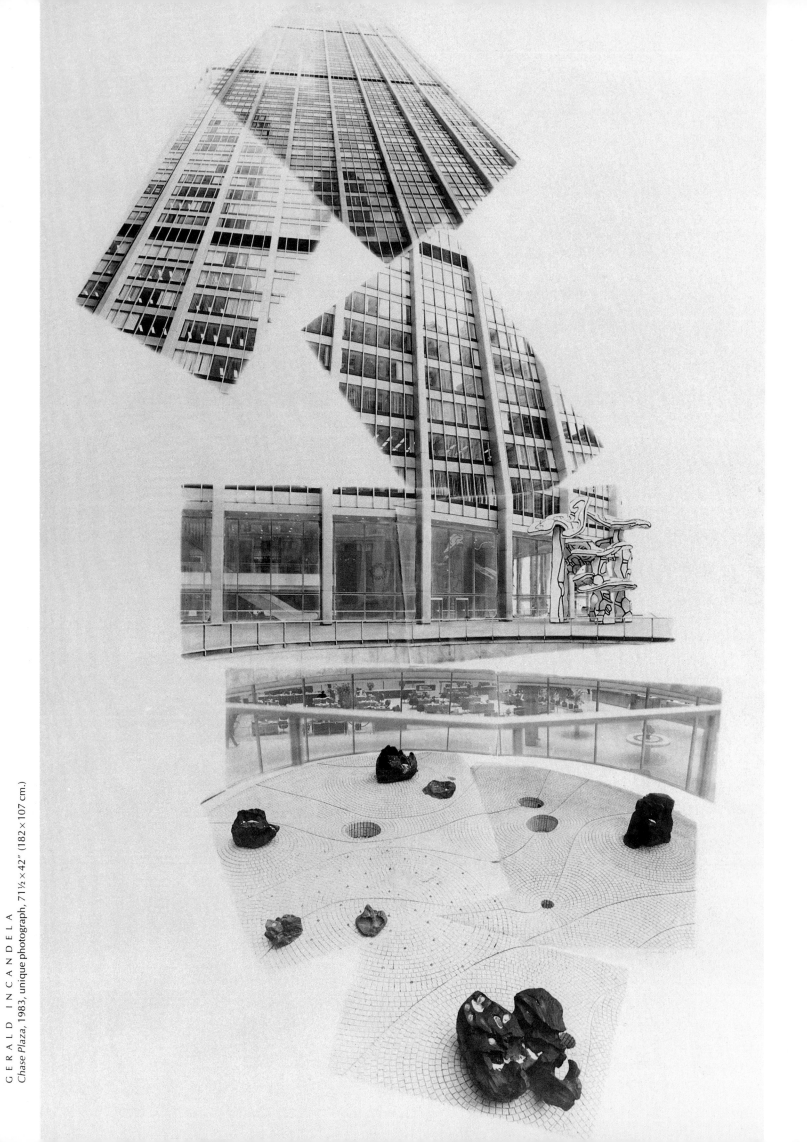

ART AT WORK

THE CHASE MANHATTAN COLLECTION

ESSAYS BY J. Walter Severinghaus

Dorothy C. Miller

Robert Rosenblum

FOREWORDS BY David Rockefeller, Willard C. Butcher

EDITED, DESIGNED, AND PRODUCED BY MARSHALL LEE

E. P. DUTTON, INC., NEW YORK

in association with THE INTERNATIONAL ARCHIVE OF ART

Published simultaneously in Canada by Fitzhenry & Whiteside Limited,
Toronto.
Printed by Nissha Printing Company, Kyoto, Japan.
Library of Congress Catalog Card Number: 84–71580
ISBN 0–525–24272–4
10 9 8 7 6 5 4 3 2 1
First Edition

Editor's Note

The Chase Manhattan art collection was begun in 1959 with the practical object of decorating the new headquarters of the Chase Manhattan Bank near Wall Street. Because the management of the company—particularly David Rockefeller, who was then its president—was determined to have nothing but high quality in this, as in its other endeavors, the selection of works for their art program was made with the advice of a committee of highly qualified professionals, including five leading museum directors and curators. Twenty-five years and over nine thousand works later, this collection is widely regarded as the granddaddy of corporate collections, respected and emulated by hundreds of companies throughout the world.

If the Chase collection is to be compared with others, it will be seen as resembling more the accumulations of an old and great family—personal, eclectic, diffuse—than the systematic collection of a museum striving to fill in weak spots, building up areas of strength, making educational points. It is like the private collection also in being less visible and less accessible than the holdings of a museum. Scattered in offices throughout the world, the Chase collection is known only by its parts even to those responsible for it. Since it has been accumulated over a quarter of a century under several hands, then dispersed, no one person has seen it all.

A collection of such size and diversity is an elusive object of study—the more so since it was not built to a plan. It seemed to us that the best way to make sense of it would be to see it developing, to watch it subtly change its shape and emphasis over time and through several curators. Accordingly, the 256 examples in the plates section of this book are shown in the order of their acquisition. The section is divided into three parts—the first ten years (1959–68), the second ten years (1969–78), and the last five years (1979–84)—which correspond roughly to the major stages in the collection's evolution; the first period being informed by the original advisory committee, the second by a shift toward acquisition by a professional staff under the curatorial direction of Mary

Lanier, and the last by the exceptional vision of the present art adviser, Jack Boulton. Through all these changes, the Chase Art Committee has maintained its control and policy direction—now with more bank members and fewer outside experts.

The general purpose and thrust of the collection has remained constant throughout its twenty-five year history, but the changes reflected in the three periods have certainly affected the collection's content in discernible ways. With three of the five original art advisers associated with museums of modern art, and a fourth committee member, Gordon Bunshaft, a designer of modern architecture, it is not surprising that the first ten years saw a strong emphasis on the acquisition of contemporary works—particularly by American artists. This tendency was countered somewhat by traditional leanings in the committee and the bank's management, so there was a substantial proportion of earlier works—including American folk art—purchased. At the end of this period the collection numbered about 1500 items, of which almost 60 percent were contemporary paintings, drawings, prints, and sculpture.

During the next ten years there was a certain amount of consolidation and the pace of acquisition slackened. These were also years of great expansion in the print market, and a large percentage of the collection's purchases were prints and other multiples. Nevertheless, the direction of the previous period continued, and the bank's holdings in modern paintings and sculpture were enlarged. By 1979 the number of works totaled some 4800, with about 4000 of these modern art—of which perhaps 50 percent were multiples.

The following years, with acquisition mainly by Jack Boulton, saw a continuation of emphasis on contemporary work but with a move toward somewhat more adventurous styles and imaginative pieces. At the same time, the collection became stronger in the works of foreign artists, both modern and traditional, with a substantial increase in folk art and utilitarian objects of aesthetic interest. Another notable tendency during

this period has been the acquisition of many photographic works. In general, the collection has become more diversified in the past five years.

Of the nine thousand plus items in the collection at this writing, about 70 percent are works of modern art, all but a few of them contemporary (after 1945). Of these, about half are prints, a quarter are paintings, approximately a fifth are drawings, and the rest are sculpture. Photographs now make up about 17 percent of the collection. The remaining 13 percent is a mix of textiles, ceramics, utilitarian objects, maps, furniture, ceremonial objects—which include works of African, Oceanic, pre-Columbian, and other "primitive" art—and a sprinkling of traditional Oriental and Western art. Most of these categories include some folk and "naïve" art.

Obviously, the tremendous variety in the collection results from the varied interests of the bank staff whose work places are the setting for the art acquired, as well as the different tendencies of the purchasers over the years. It is also not unreasonable to assume that with the passage of twenty five years some of the collection's character is due to changes in the world and how they are perceived.

In selecting works for inclusion in this book, the object was to represent the collection in all its parts rather than to choose the best. Understandably, many of the stars are present, but some gave place to pieces that underscore the collection's depth and range. The selection does its best to encapsulate nine thousand works in 256 examples; if it can be faulted, so, to be sure, might any other.

An observation on works in the Chase Manhattan collection has been written by Robert Rosenblum, professor of fine art at New York University, author of many books and articles, and a member of the Chase Art Committee since 1973. Contributing their recollections and observations about the collection are: David Rockefeller, who, as President and then Chairman (now retired) of Chase Manhattan was the prime mover and guiding spirit behind the collection from the start to the present (he remains a member of the Art Committee); Willard C. Butcher, present Chairman of the Board and of the Art Committee; J. Walter Severinghaus, a partner in Skidmore, Owings & Merrill, the architects responsible for planning the Chase headquarters building— which included the concept of combining art and architecture; and Dorothy C. Miller, retired Senior Curator of Painting and Sculpture of the Museum of Modern Art, New York, who is, besides David Rockefeller, the only member of the Art Committee who was there at the beginning and is still active.

Many people at Chase and outside helped in the preparation of this book, but by far the greatest contribution was made by the very able Director of the Art Program, Merrie Good, and the department staff. To her and all those who helped go our gratitude and admiration.

M L
June, 1984

Contents

Looking back
David Rockefeller

Like so many things in life, the Chase Manhattan art collection began in part by chance. In planning the bank's big new head office building in lower Manhattan, architectural beauty was achieved by good proportions, attention to detail, and quality of materials used, rather than through architectural ornaments characteristic of earlier periods in architecture. Gordon Bunshaft, the partner of Skidmore, Owings & Merrill who was most responsible for the design of the building, pointed out that it would seem somewhat cold and uninviting unless we provided works of art to enrich and enliven bare walls and large spaces. I agreed with his concept, and we decided to embark on a program of art acquisition for this purpose. It was only later that we began to think of our accumulated works as a collection.

Having been exposed to beautiful works of art in my parents' home since childhood, and having been involved at an early age in planning for the Museum of Modern Art, of which my mother was a founding member, I had more than a casual interest in the visual arts. In 1948, after my mother's death, I replaced her as a board member of the Museum. I felt that I knew enough about contemporary art to be aware of the fact that, for the bank to select wisely, it needed the advice and guidance of professionals. As a result, we put together an Art Advisory Committee of distinguished museum directors and curators. Jack McCloy, then Chairman of the bank, became chairman of the committee. I was the other bank officer to serve on it.

The paintings and sculpture that were first commissioned and purchased for our new midtown headquarters, at 410 Park Avenue, and One Chase Manhattan Plaza evoked a great deal of discussion. Many of the more conservatively minded members of our board and senior management were shocked and displeased by what was acquired. Many of the painters whose works we bought were members of the New York school of abstract expressionism, which was very much in vogue at the time. Since this new school was unfamiliar to many in the banking world, who were accustomed to representational

painting of a more classical variety, they could see little to recommend what had been bought. Nevertheless, it was recognized that we had world-renowned experts on our Art Committee who had made the selection, and the bank went forward with the project.

The Chase art program attracted much attention and gathered momentum. While there were many who were critical of it, an increasing number of both staff members and customers became fascinated by it, even though they did not like everything we bought. Little by little, other banks and corporations in this country and abroad were encouraged to start art programs of their own. Today, relatively few major banks and corporations are without an art program of one kind or another. I believe that Chase can take pride in having established a trend that has beautified the work places of businesses everywhere and, at the same time, has given important encouragement to contemporary artists.

The collection has expanded enormously and today consists of more than nine thousand items located in fifty-five countries, with nearly three thousand artists from all over the world represented. I hope that Chase will continue in its role of leadership and that it will never lessen its insistence on excellence. The utility of its having set high standards right from the beginning is demonstrated by the fact that the value of the collection today has increased very substantially. This fact is nice to know, but, in my judgment, the prime reason for buying quality works of art is not for an appreciation of their monetary value but for the enjoyment such a program brings to the beholder and the benefits it brings to the artists.

Foreword
Willard C. Butcher

The Chase Manhattan Bank art collection has benefited the corporation in many ways. Our acquisitions throughout the world demonstrate our ongoing commitment to gaining knowledge of the many cultures in which we do business; the thinking processes of our employees are stimulated by the influence of art in their work environment, sometimes directly, sometimes subtly; the emphasis on contemporary art underscores our responsiveness to the present and our commitment to the future.

We believe the collection is clear evidence that the Chase Bank is very much a part of the world in which it exists. The sense that art is something to be used, loved, understood, integrated into our everyday work lives—not revered as something beyond our grasp—is one of the real advantages in living with it as we do. By relating to art as an integral element of our work place Chase people have come to gain respect for the creativity, the thinking, the imagination, and, indeed, the hard work that artistry requires.

When I succeeded David Rockefeller as Chairman of the Chase Manhattan Art Committee, I asked the members of senior management to express their views as to the future direction of the art program. It is perhaps no real surprise that two themes dominated their responses: first, that we should reaffirm our commitment to the continued vitality of the program itself; and second, that quality should be the watchword underlying and driving that commitment.

This book, then, is simply an expression of our firm determination to seek quality in everything we do, and to create a work environment within which our people can flourish and grow.

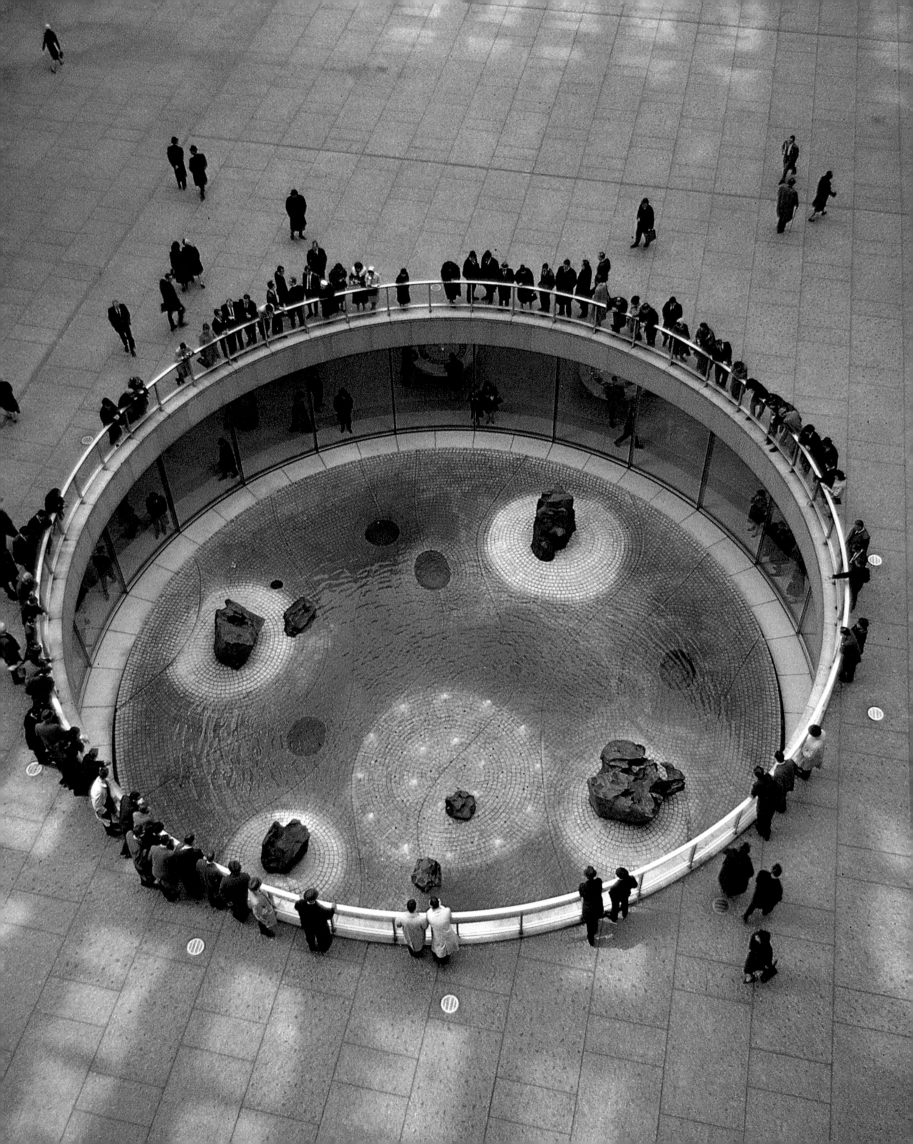

Work places for art
J. Walter Severinghaus

J. Walter Severinghaus (left) with art program director Christopher Gerould, November 1966

In the spring of 1955, not long after it was formed by the merger of the Bank of Manhattan and Chase National, the Chase Manhattan Bank began interviewing architects for its headquarters building, which they had decided would be in the Wall Street area. This was an important decision, because, at a time when everyone else seemed to be moving to midtown, this would be the first major building to be constructed in the downtown area for a quarter of a century. Skidmore, Owings & Merrill was selected to design the building.

Modern architecture, based on Bauhaus-inspired functionalism, had essentially eliminated the use of traditional ornament and sculpture as an integral part of a structure. However, Skidmore, Owings & Merrill believed that the simplicity of modern structures called for a sympathetic approach to the use of sculpture, paintings, and furnishings to complement the prevailing architectural simplicity and create a harmonious environment for both public and private areas. The bank agreed with this concept, and our contract was expanded to include all the interior layouts and furnishings—from works of art down to desk accessories. The need for a comprehensive program to plan the acquisition and placement of the art works was established with this decision.

SOM's experience in using art as an element in architecture had not included anything nearly so extensive as what was contemplated here, but we had completed several projects that gave us background for undertaking the Chase headquarters challenge. Immediately following World War II we had secured a commission from industrialist John Emery to design a new hotel in Cincinnati. Mr. Emery was then President of the Cincinnati Museum of Art, and he was not only sympathetic but enthusiastic about combining the best contemporary art with architecture. With his support, and through his connections, we commissioned Alexander Calder to do a large mobile for the hotel lobby, Saul Steinberg to paint a mural for the dining room, and Joan Miró to paint a mural for installation in a penthouse restaurant.

ISAMU NOGUCHI
Pool, 1963, stone and water, 60′ (18.3 meters) diameter

15

This was the beginning of SOM's continuing interest in using the arts as a component of architectural design. In 1952, a large commissioned Stuart Davis painting was installed as the focal point of the lobby of the Heinz Research Laboratory in Pittsburgh. In 1954, for the Manufacturers Hanover Bank at Fifth Avenue and Forty-third Street in New York, we provided a metal screen by Bertoia and contemporary paintings in the executive area; we also "created" a work of art by using the classic round vault door as a piece of sculpture. Three years later, our design for the Connecticut General Life Insurance Company headquarters, in Bloomfield, was the beginning of a long association with Isamu Noguchi, who created both outdoor sculpture and garden courts for this project. One year after that, in 1958, the main entrance lobby of the International Arrivals building at Kennedy Airport provided us with another opportunity to work with Calder on a mobile.

As the Chase Manhattan building design and construction progressed, we discussed the treatment of the interiors. Until this time, paintings and sculpture in commercial buildings had been restricted primarily to public spaces and executive offices. With the enthusiasm of David Rockefeller, then President of Chase Manhattan, and Gordon Bunshaft, my partner in charge of design for the Chase project, the idea of extending the use of art throughout all areas of the bank was developed. We felt that a better atmosphere was possible if employees could live with art in their work areas instead of being exposed to just a few examples as they came through the lobby in the morning and evening. At the same time, this enhanced environment would have a beneficial effect on those who came to the bank's offices on business.

Quoted below is the transcript of a 1961 exchange between James F. Fox, then Vice President for Public Relations of Chase Manhattan, Davis Allen of SOM's Interior Design department, and me that highlights the thinking underlying the art program:

JFF: What is the importance of all this to the client either in economic or human terms? What difference does it make, aside from the aesthetic point of architecture?

WS: What we are aiming at is to provide a pleasant place for employees where they can do their jobs happily. Everyone is sensitive to his surroundings. Hopefully, if we have done a good job, you will have less labor turnover and better productivity than in a cluttered place.

DA: There are delayed reactions. Many people are unhappy with change at first. In six months, the reaction is entirely different. We found at Lever House that there is a big reduction in turnover of personnel. Same experience at Connecticut General in Bloomfield. At first there was great resistance to a move into the country. This in spite of all the benefits offered by Connecticut General. Later, everyone was very happy about moving.

In previous projects, the limited amount of art required could be specially commissioned or selected at galleries just before completion

David Rockefeller (left) with Alfred Barr

Gordon Bunshaft

of the building. This new concept, requiring hundreds (eventually thousands) of items, called for an entirely new approach. It was obvious from the number of pieces required that we could not afford to buy many works by artists already well established. To enable us to stay within an acceptable budget, it was decided that the collection should be made up of works by emerging American and international artists, Americana, indigenous art from cultures around the world, and a limited number of photographs from museum collections. (The requirement that photographs come from museums was meant to avoid the awkwardness of turning down amateur submissions by bank personnel.)

Wise selection of the art called for engaging the assistance of recognized art experts. David Rockefeller was very persuasive in presenting the idea to the bank's management, and an Art Committee was established. It consisted of Alfred Barr of the Museum of Modern Art, James Johnson Sweeney of the Guggenheim, Robert B. Hale of the Metropolitan Museum of Art, Perry Rathbone of the Boston Museum of Fine Arts, David Rockefeller, and Gordon Bunshaft. After the first meeting, Alfred Barr suggested that it would be very helpful if his assistant, Dorothy Miller, could join the committee. She did join, and became one of its most active members.

It was anticipated that if the selection of current artists was judicious, the art should appreciate in value, and could later be given to museums, with the proceeds from tax deductions used to acquire the works of new young artists. This idea was put into practice a few times, but then the committee decided that it was better for the bank to keep its important works in the collection. This proved to be a good decision, both economically and in terms of the bank's objectives.

The first meeting of the Chase Art Committee, February 17, 1960. Seated, beginning second from left: committee members Alfred Barr, John J. McCloy, James Johnson Sweeney, Gordon Bunshaft, David Rockefeller, Robert B. Hale, Dorothy C. Miller. At far left, Ward Bennett. To the right of Mrs. Miller, John J. Scully and J. Walter Severinghaus.

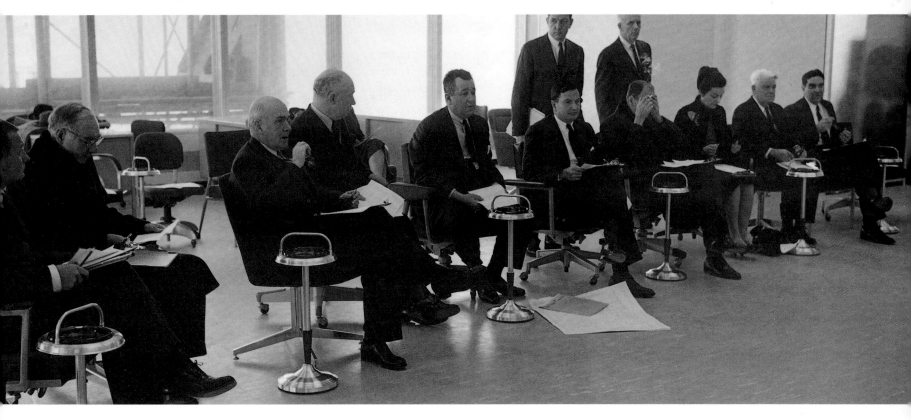

Another idea discussed briefly was renting rather than buying works of art. Below are some excerpts from a 1960 discussion of this possibility. (John McCloy was then Chairman and George Champion was President of Chase Manhattan. David Rockefeller had become Vice Chairman.)

MR. McCLOY: By renting paintings, we would have a chance to evaluate works before purchasing them. [Mr. McCloy definitely favored the idea and asked for a further study.] We could have a rental contract from museums.

MR. ROCKEFELLER: Because we are so far behind in our acquisitions, rental may be the answer. Instead of buying in a rush, this idea gives us more leeway.

MR. BARR: Collecting takes time and the committee simply doesn't have enough time to suggest or scout paintings.

MR. CHAMPION: I like the rental field very much.

MR. ROCKEFELLER: I believe this is an idea worth exploring.

Despite the very favorable attitude of the committee and the bank officials at this time, later studies were negative, and the idea of renting was never tried.

The general plan of the offices, banking spaces, and departmental areas had been agreed on at this stage. Using these preliminary plans for thirty-seven floors of the tower and five floors below grade, we marked all the places where small, medium, and large paintings and sculpture might be needed. We then assigned an arbitrary price for each class of item, ranging from $100 to $10,000. When the numbers were totaled and the figures extended, we arrived at a budget of $500,000, which included $50,000 for exterior sculpture.

With a definite program established, a distinguished committee selected, and a realistic estimate of cost, we were prepared to present the proposal to the Board of Directors for approval. To strengthen our case, we could point to a pilot project just completed.

While the downtown headquarters was under construction, we had designed a new Chase branch in New York, at 410 Park Avenue at Fifty-fifth Street, which included not only regular banking facilities, but additional space where bank executives could meet clients in the midtown area. This floor provided several private offices, dining facilities, and a large lounge that could also serve as an informal board room for occasional midtown meetings.

In order to get approval of the proposed interior treatment, Gordon Bunshaft and Davis Allen of SOM's Interior Department had selected several contemporary paintings and sent them to our office as examples. John McCloy and David Rockefeller came to the office. They were pleased by what they saw and authorized us to proceed on this course. At this meeting we got approval for Bunshaft's plan to commission a mobile by Alexander Calder for the main banking

Top: Reception area, One Chase Manhattan Plaza. Painting by Adolph Gottlieb.

Middle: Reception area and offices, One Chase Manhattan Plaza. Painting by Kay Sage.

Bottom: Street floor, Chase branch at 410 Park Avenue, New York

ALEXANDER CALDER
Untitled mobile, 1959, iron, 240″ (609.6 cm.) diameter

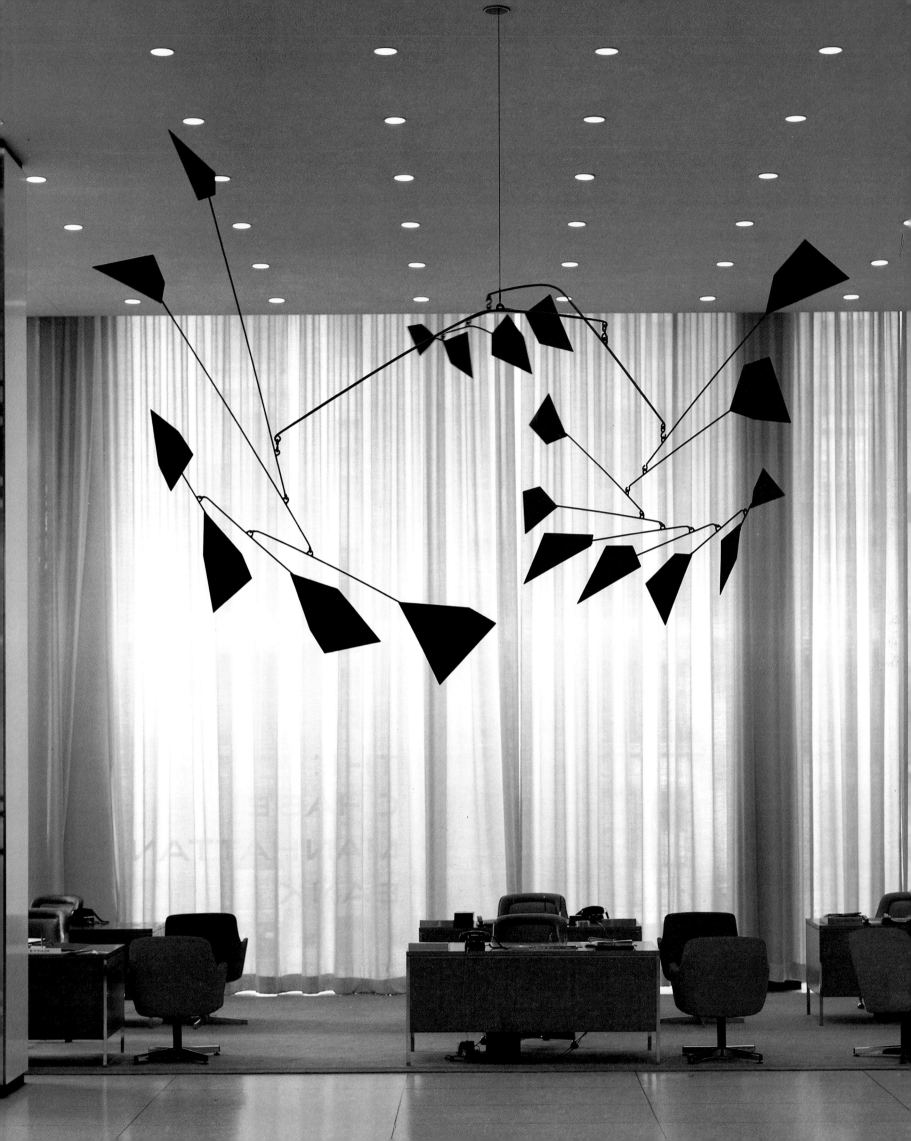

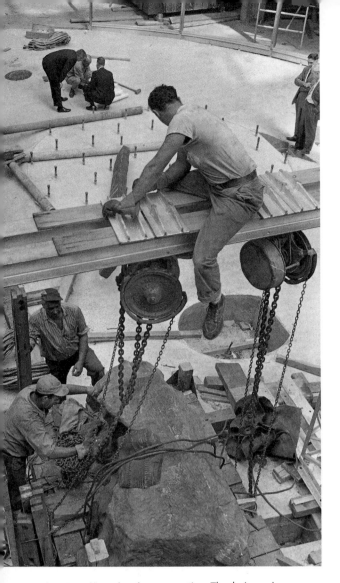

The Noguchi pool under construction. The designer, Isamu Noguchi, is at the top of the photograph in light-colored clothing.

Below: Models of proposed sculptures for the plaza

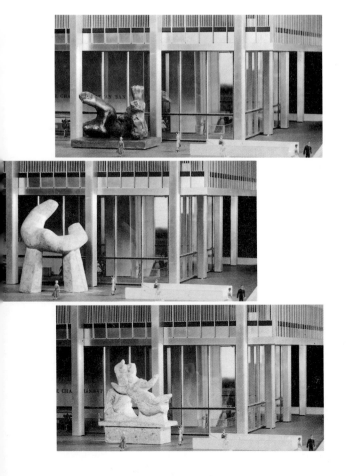

room. At David Rockefeller's suggestion, Dorothy Miller was asked to participate in carrying out this program, and it was she who recommended the large Sam Francis mural for the informal board room.

The result at 410 Park Avenue met with considerable approval from the critics, and even some doubting bank officers were sufficiently impressed to help us encourage extension of the art program throughout the entire downtown headquarters.

It was appropriate that our presentation of the art program to the Board of Directors was made in the new informal midtown board room. I would not say that their enthusiasm was overwhelming, but the proper groundwork had been done, and we received approval to spend $500,000 on unspecified works of art.

The project was under way. The members of the committee began to bring things in for consideration, and by the time the headquarters was ready to be furnished, an impressive collection of art had been acquired.

The most difficult problem was the choice of a major sculpture for the plaza. There were two locations that called for sculpture at their focus. The first was a large circular well, off-center on the plaza area. This feature had developed as a solution to the problem of where to put the public banking area, which was too large to be housed in the tower. The obvious location was under the plaza, but due to adjacent street levels this was essentially a basement floor, which connoted secondary space. The introduction of the circular well brought light into the banking room and made it into prime first-floor space.

Isamu Noguchi had been retained as a consultant for this feature, and he suggested the idea of a tranquil pool with weathered dark granite rocks from Japanese streams—such as are used in Japanese gardens—set in a sculptured floor of four-inch-square light gray granite cobblestones. The design was completed with a pattern of simple water jets, water flowing from some of the weathered rocks, and several wells to hold tubs of waterlilies.

That solution fell into place easily, but the search for an appropriate sculpture for the plaza was to go on for the next ten years. The obvious location was the intersection of the center line of the principal steps to the plaza from Pine Street and the center line of Cedar Street, which was now interrupted by the plaza. We even designed the plaza to accept a heavy load at this point, in the event that the solution turned out to be a large granite piece.

I doubt that any search was more conscientiously pursued than this one. Over a period of ten years, six major sculptors—Calder,

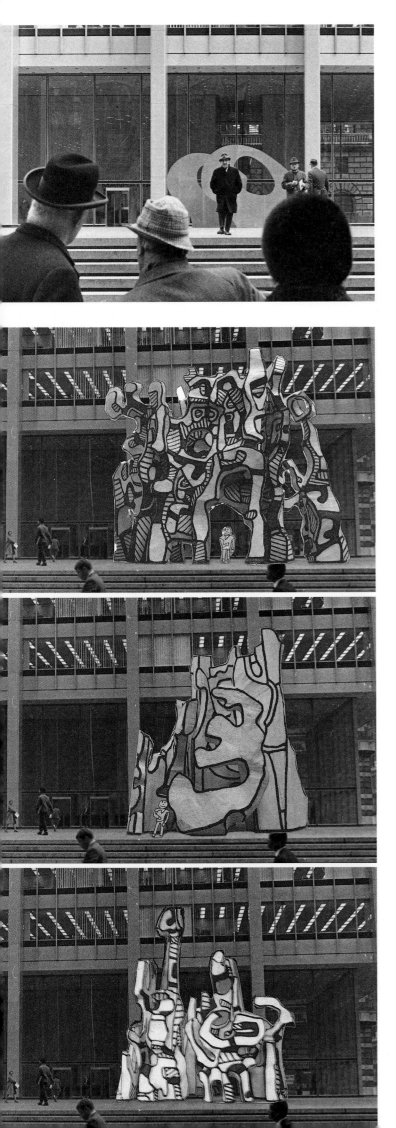

Giacometti, Dimitri Hadzi, Henry Moore, Noguchi, and William Zorach—were asked to make submissions for the committee to consider. As individual works of art these were interesting, but none seemed to have the scale to compete with the sixty-story tower behind them. For one submission by Henry Moore we made full-size wooden profiles of the proposed sculpture and placed them in the plaza. On seeing the installation, even the artist agreed that it was not the right answer.

The final breakthrough began when Gordon Bunshaft, in Paris on another assignment, visited the first exhibition of Dubuffet's large sculptures in the new epoxy-and-fiberglass medium. When he returned, Bunshaft told the committee about the Dubuffet show and suggested that his work might be worth considering. Alfred Barr was also aware of this phase of Dubuffet's work, since the Museum of Modern Art had on loan a ten-foot-high model of one of his early concepts. Barr took the committee to the Museum to see it. It was agreed to authorize Bunshaft to ask Dubuffet if he would be interested in the Chase project. He was, and for the next six or eight months developed various concepts in model form. When Bunshaft next visited Paris, he selected five of them and arranged to have them shipped.

As it happened, David Rockefeller was in Paris before the shipment was made and visited Dubuffet's studio. He saw a model of another concept that appealed to him, and asked that it be included in the shipment. This was the *Group of Four Trees*—the design that was accepted unanimously. (Bunshaft always enjoyed the fact that after all the professionals had made their recommendations, the so-called lay member of the committee picked the work that everyone agreed was most appropriate.)

Once the choice was made, we made preparations to bring the finished sculpture to New York and install it on the plaza. Given the unique medium and extraordinary size of the work, we sent our consulting engineer, Paul Weidlinger, to Paris to work with Dubuffet in the design of the structural framework and to participate in its disassembly for shipment.

With the building constructed and the art collection well advanced, SOM had completed its assignment for Chase Manhattan. However, our interest in the project continues and there is still an SOM member—Michael McCarthy—on the Art Committee. Indeed, SOM has not only continued but expanded its interest in combining art and architecture through projects in many cities and with many artists.

Top: Committee members and Henry Moore (foreground center) studying a mock-up of the artist's proposed sculpture for the plaza.

Three of Dubuffet's models shown against a photograph of the Chase headquarters building. All were rejected in favor of *Group of Four Trees*.

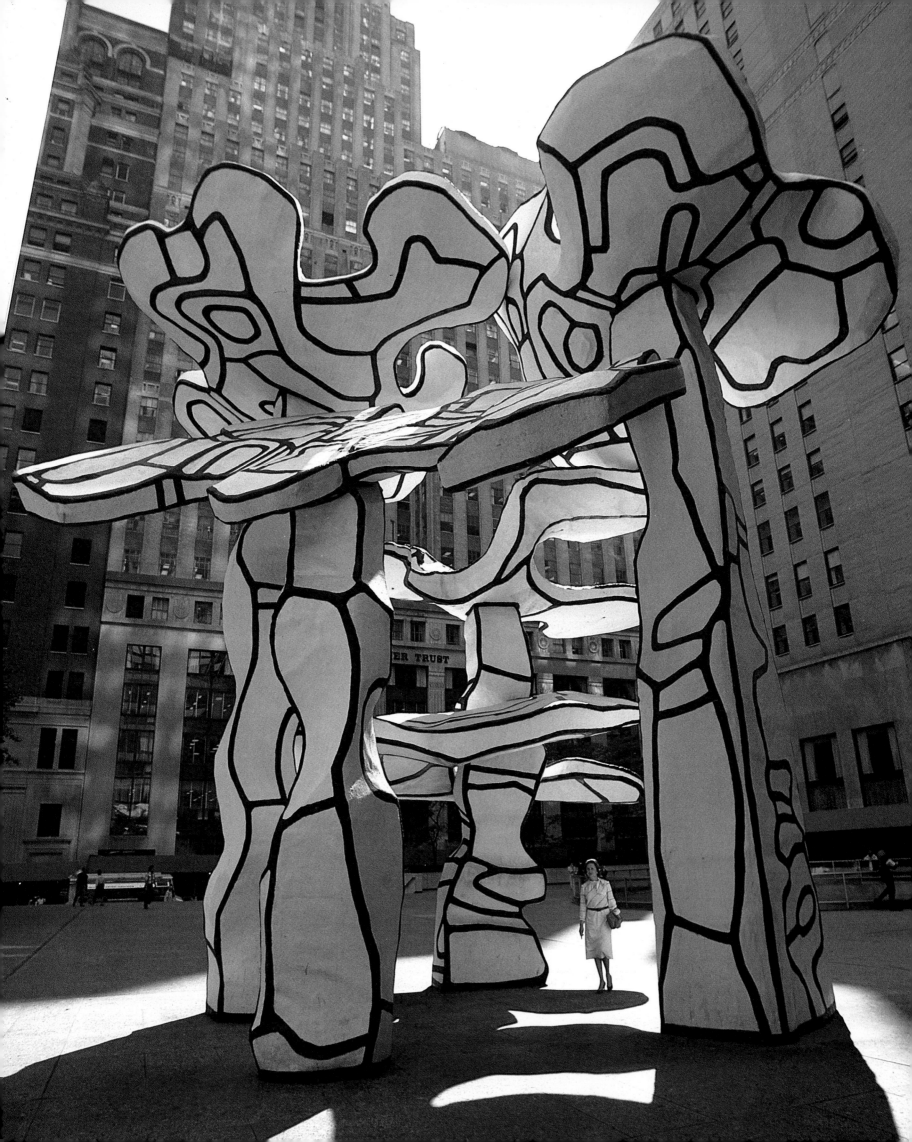

Art for work places
Dorothy C. Miller

Dorothy C. Miller

Until the Chase Manhattan Art Committee began to select works of art for the bank, when one thought of banks one thought of pillared temples of commerce, staid environments in which decorum and reliability were expressed by lots of woodwork, dark green leather chairs, and bronze-and-glass chandeliers.

The solemn kind of art considered proper for a bank setting until about twenty-five years ago has more or less gone out the window. Banks can now do almost anything in architectural design and art, which surely must make for a more stimulating environment for the bankers and public alike. The educational process that this openness has generated has been marvelous. Bankers learned to see and admire modern art, and their use of it has created immense public interest.

Chase's art program could not have occurred on such a scale much earlier than it did. First, the clean, functional lines designed by Chase's architects—Skidmore, Owings & Merrill—provided splendid spaces for art. Second, contemporary American art had achieved an international reputation at the end of the 1950s. And third, the Chase had the leadership of David Rockefeller.

David Rockefeller's parents were both deeply involved in the arts, and their big house on West Fifty-fourth Street was full of art of widely different kinds: Italian Renaissance paintings, the great "Unicorn" tapestries (later given to the Metropolitan Museum), Mrs. Rockefeller's large collection of twentieth-century American art, which she later gave to the Museum of Modern Art, where it formed the nucleus of its collections of American paintings, sculpture, and prints. David listened to his Art Committee explaining and defending their choices, and he was ready to take the committee's word for quality even in cases where he did not yet feel the quality himself. However, his eyes rapidly became attuned to modern art. It was impressive to watch. Soon he was easily picking out the best of the works of art that the committee had spread out to be discussed for purchase.

JEAN DUBUFFET
Group of Four Trees, 1972, fiberglass, aluminum, and steel, 42' (13 meters) high

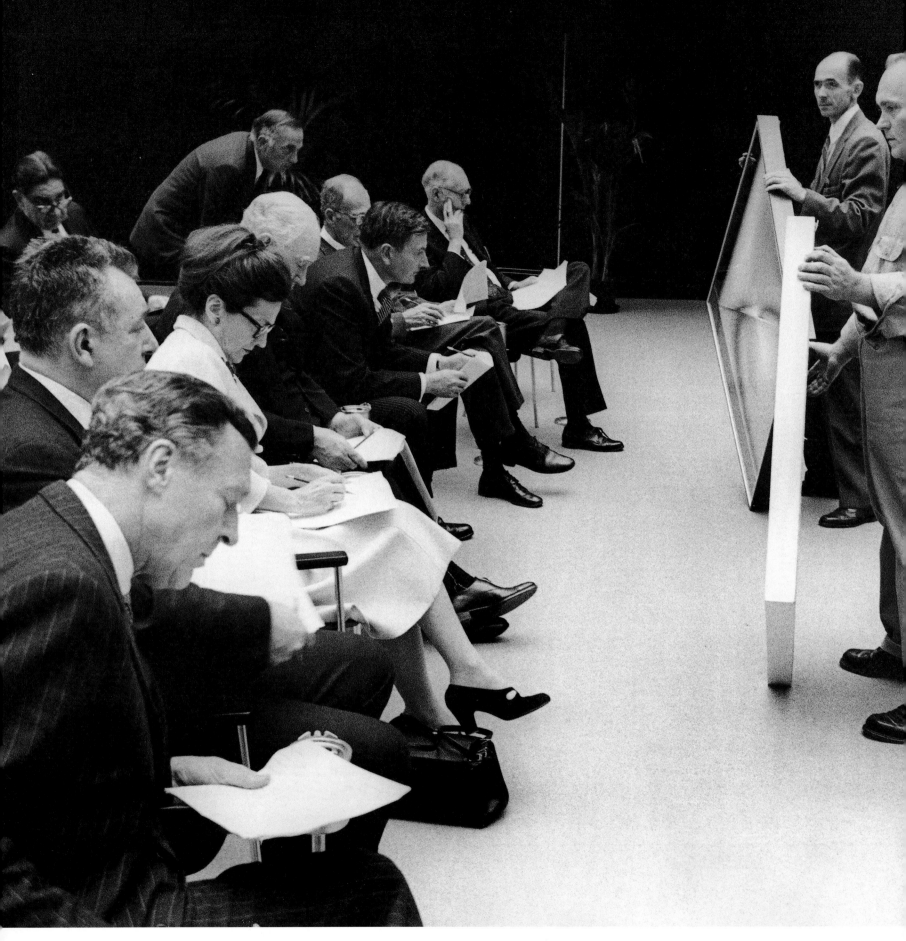

The Art Committee voting

One of the most rewarding things about the program was the way the bankers on the committee, and the staff, welcomed the work of new and unknown artists. I don't remember ever running up against anyone at the bank who said, "Well, who is he? He's not known at all." Most of the top bank people were extremely liberal with the committee. They would often say about a work we wanted to buy, "You're the experts. We don't have to like it right away. We'll learn to like it or we'll learn to hate it."

This does not mean that there was uniformity of opinion. Witness the following excerpts from the minutes of the first Art Committee meetings:

February 17, 1960: At the morning meeting, Mr. McCloy and Mr. Rockefeller viewed the selection of 60 paintings and sculptures. Mr. McCloy expressed the wish to see more historical paintings and felt that they would not clash with the abstracts.

March 21, 1960: Mr. McCloy was still concerned that there was a continuing tendency toward abstract and a brief discussion centered around the long history of the bank. ("We were founded in 1799 and therefore the past should be represented.") It was generally conceded that the art program should reflect our own times and we should have courage to look ahead. Nevertheless, it was noted that the program would include old prints, etc., of New York and a selection of art from old as well as contemporary artists.

The Chase was wise in the beginning not to let somebody who worked in the bank do the selecting, but to get a group of museum directors and curators as expert advisers.

At some companies, if a secretary doesn't like a picture, it is immediately removed. At Chase, they let the person grow up with the picture. That process of education was usually successful. Often, members of the staff would first say, "Ugh", and then, a little later, "Don't take it away!" That certainly happened with the Sam Francis mural. At first some people who saw it said it was terrible. Recently the mural was taken down for cleaning, and there were all kinds of protests from the staff: "Where is it? You haven't sold it, have you? When is it coming back?"

Even considering the open-minded attitude they began with, the Chase Art Committee is much more willing to take risks now than it was at the beginning. In the twenty-five years since 1959, the public has become much more sophisticated in its appreciation of modern art, and this general climate of acceptance has extended to the bank's management at all levels.

When the Chase Art Committee was chosen and began to consider art for the new office tower in lower Manhattan, it functioned much like a museum acquisition committee. The process was very similar—not surprisingly, since five of the seven members worked in museums. On

From left: James Johnson Sweeney, Merrie Good, David Rockefeller—October 1973

the other hand, we didn't have the museums' obligation to represent all important aspects of their field of art.

My impression is that the committee bought a large percentage of the works brought in. Although we were working within a budget, the thought of spending what seemed like a lot of money on art did cause some twinges of doubt among the bankers, as was noted in this excerpt from the minutes of an early meeting:

The thought was expressed that perhaps the committee was reviewing art objects too expensive for the offices. For this reason, it was suggested that one meeting be devoted to consideration of items up to $500.

Every four to six weeks the committee would meet on the lower floor of the new branch at 410 Park Avenue. The works sent in by the members—there might be as many as 150 items—were assembled a few days before these meetings. Each item was individually considered by the committee. The member making the proposal would provide information and prices, and this was often followed by a general discussion. The committee would then vote by secret ballot, using a scale of 0 to 3. Three meant "definitely yes"; 1 meant little interest. Zeros were rare. After every offering had been examined, discussed, and voted on, the ballots were collected and tabulated. Any item that got a total of 11 points or more was purchased; most of the others were not. There would sometimes be a close vote, perhaps a 9 or a 10. The member who had selected the work rejected by such a narrow margin would often make an impassioned speech that would change the committee's decision.

An admirable tradition at Chase has been buying the works of younger, less-recognized artists. It was Alfred Barr's initiative that led us to buy avant-garde works before they inflated in value, just as he had done at the Museum of Modern Art. When the Museum had shows of such works, there were always some shockers. I would go down to the galleries and listen to the visitors' remarks. "Disgusting! Shocking! Horrible! I'll write a letter of protest!" Such a reaction doesn't seem possible today. A list of those works looks so solid now, and their prices are very high. Nineteen fifty-nine was a wonderful moment to start the Chase collection, just when American art was making its worldwide mark. A number of American artists were becoming famous, but the prices asked for works by emerging artists were still low.

I don't remember ever deliberately avoiding any type or school of art in building the Chase collection. Our only object was quality. No one ever said, "We must have the realists!" Without prejudices to affect our selections, we gravitated naturally toward a well-rounded collection. Anything we thought valid was represented, *including* realists such as Charles Burchfield and Walter Murch.

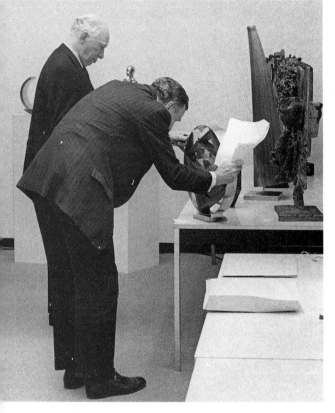

Close examination

CHARLES BURCHFIELD
Pink Locusts and Windy Moon, 1959, watercolor, 33 x 40" (83.8 x 101 cm.)

As a result, the Chase collection is notable as much for its eclecticism as for its quality and size. While the first direction it took was toward contemporary American art, it has since embraced both traditional and contemporary art of many different cultures, as well as folk art, primitive art, and aesthetically interesting "found" objects from all over the world. The collection was made without any particular plan or structure. The purpose was to find art of quality for use in spaces of various kinds and styles. Occasionally something was sought with a particular place in mind; sometimes a need for something specific was expressed, and the available art in the collection would be searched for the right thing. A notable exception to this practice was the purchase of works of native art for the bank's branches abroad. British artists are represented in the London office; Japanese works are in the Tokyo branch—including a beautiful painting by Kenzo Okada that was commissioned; Argentine art fills the Buenos Aires building, and so on.

When we began buying art for the Chase headquarters we concentrated on the New York art market, though not exclusively. For the first two or three years, buying was intensive. We bought from large and small dealers, and occasionally from collectors. Sometimes we bought directly from the artist, once in a while on the recommendation of another artist. Considering the growing fame and prestige of the Chase collection, as well as the natural desire of artists to sell their work, it would not have been surprising if we had been bombarded by artists—as we were at the Museum of Modern Art (hundreds every year). For some reason, this did not happen to any great extent in the early years of the Chase collection, although we were always under a certain amount of pressure from both dealers and artists.

Buying the thirty-eight-foot Sam Francis for the big wall at 410 Park Avenue was my suggestion. Sam Francis was a Californian who had lived for a dozen years in Paris and Switzerland, and painted murals there. I had met him at that time. When he came back to the United States, I went to see him in the New York studio he had borrowed from Larry Rivers. He was just finishing "our" mural, and I asked him what he was going to do with it. He said, "Oh, just roll it up, I guess." Then I thought of the huge wall at 410, and later arranged for David Rockefeller and Gordon Bunshaft to go to the studio to see the painting. They reacted enthusiastically and decided to buy it. I am happy to say that this turned out to be one of the bank's soundest purchases.

The original art collection storage room

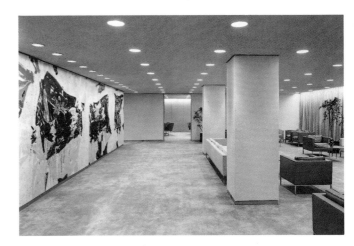

Sam Francis mural at 410 Park Avenue

Overleaf:
S A M F R A N C I S
Untitled, 1959, oil on canvas, 98 x 456″ (249 × 1158 cm.) ▶

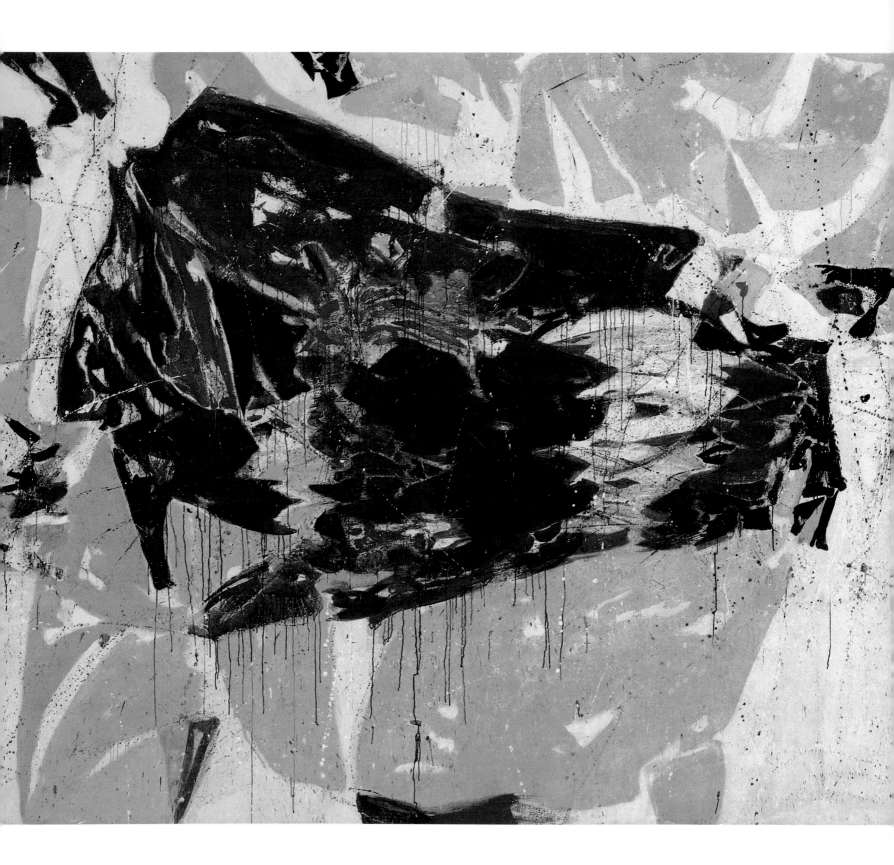

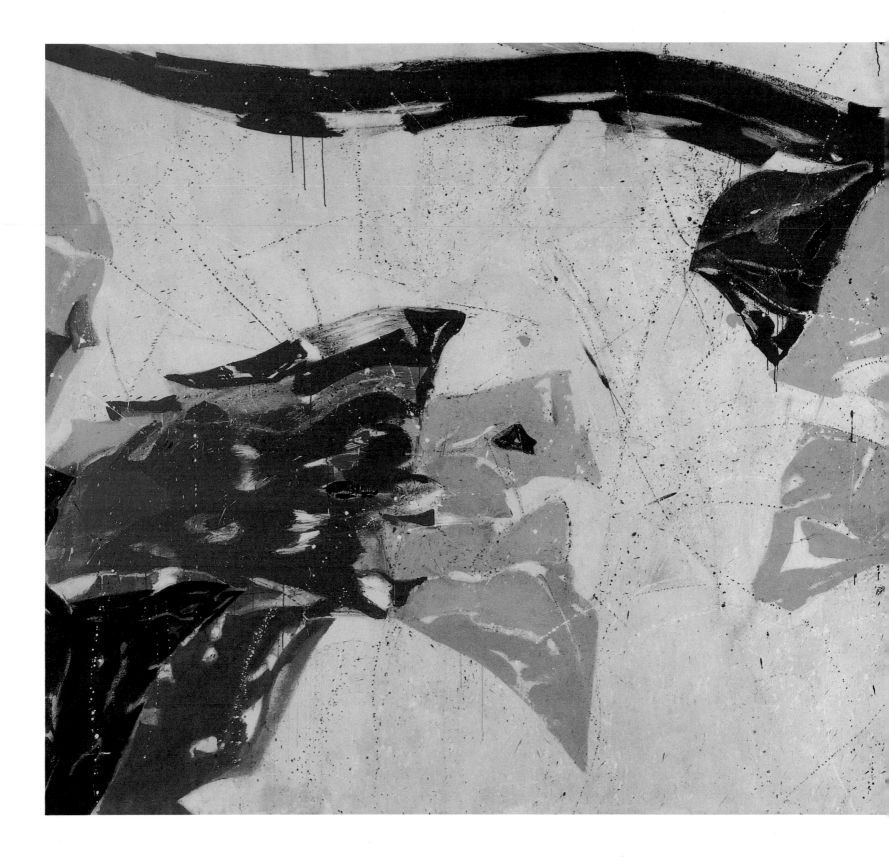

OPEN ▶

◀ O P E N

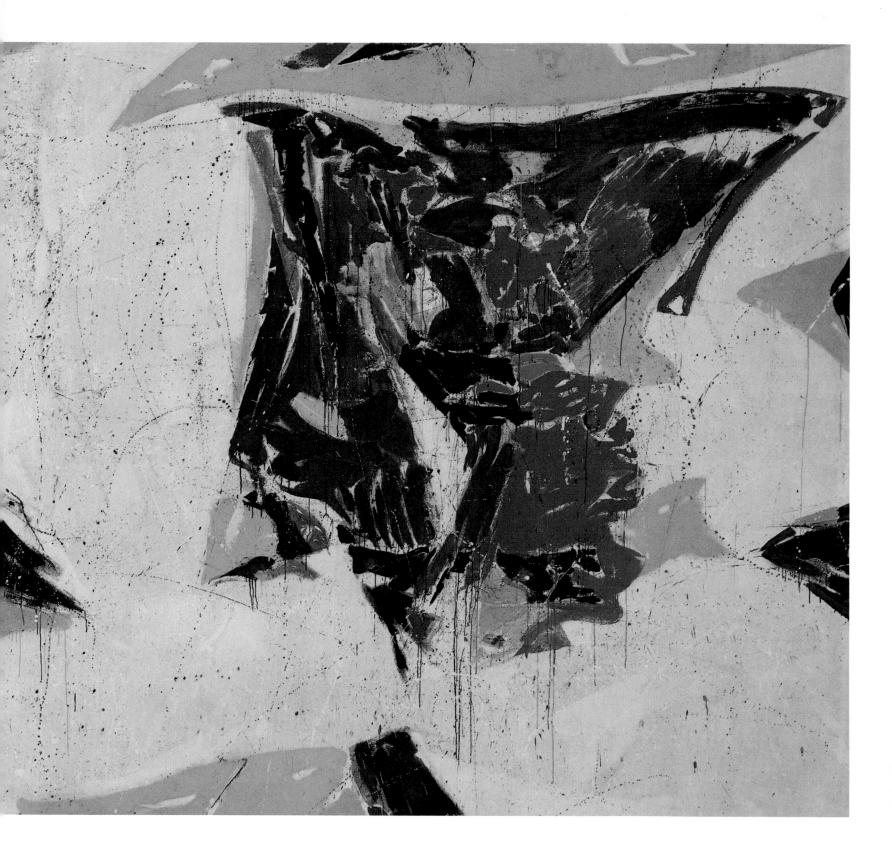

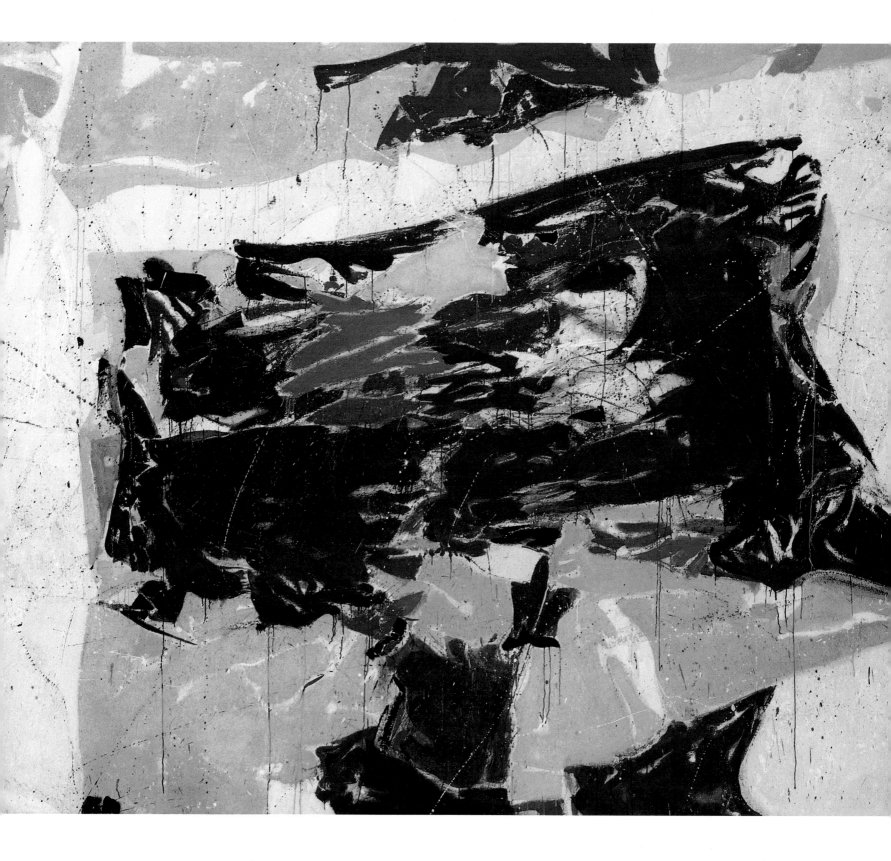

Persuading the committee to buy the more difficult works was sometimes a challenge. The Jason Seley *Triptych* is a particularly good example. I was very much convinced about Seley's work in general, and I was crazy about that piece in particular—and fascinated by the fact that he had used automobile bumpers to create a subtle work that was no longer bumpers but a fine sculpture. I knew the bank staff and the public might be put off at first, but I was sure they would like the piece eventually. To persuade the committee, I placed the work temporarily against the red mosaic wall where it is now, in the main lobby of Chase Manhattan Plaza, and brought the members in at a distance, so they could see the sculpture but not be able to see what it was made of. By the time they got close enough to see that the work was made of bumpers, they had already admired it as sculpture and decided to keep it.

Unfortunately, the Seley was hung on the wall during the lunch hour, and it brought forth expressions of horror and derision from the passing crowds as they saw the welded bumpers. Protests poured into the office of George Champion, then Chairman of the Board of Chase Manhattan. Mr. Champion was less than enthusiastic about the art program in general, and was very responsive to the cries of outrage about this particular work. As a result, the Seley was loaned for exhibitions at several museums around the country and was installed again in the Chase Plaza lobby only after a year of travel. This time it was hung over the weekend, when the staff and public were absent. Its reappearance caused no excitement. By now—after more than seventeen years in the same place—the public has come to accept this sculpture as the excellent work that it is.

Just as there were problems of choice, there were potential problems of placement. Alfred Barr was really distressed about the hanging of two Fritz Glarner paintings in the executive men's room. I talked to Glarner about it, because I knew he'd hear about it, and he said, "Dorothy, wherever your committee puts a picture, I'm sure it belongs there. And what's wrong with the men's room?" He was right. It was a beautifully designed setting. Glarner was a wonderful artist and a generous spirit, but in fact, I don't remember any case in the twenty-five years of the collection when an artist objected to the location of his or her work.

There were sometimes problems when bank employees didn't like certain kinds of art or particular works of art. Usually these problems sorted themselves out very well. One particularly happy ending grew out of a fortunate error. When the bank's management decided that each of the some 130 vice presidents could choose a work of art for his or her office, each was asked to express a preference. Some said they liked ship models, some said fishing, but very few said modern art. There was one vice president who said, with considerable force: "Don't put any modern art in my office!" When we were ready to start

Three viewers of the Seley *Triptych* shortly after the work's installation.

Jason Seley's *Triptych* being installed in the main lobby of One Chase Manhattan Plaza, March 1965.

November 17, 1962 *New Yorker* cover drawing by Saxon; © 1962, The New Yorker Magazine, Inc.

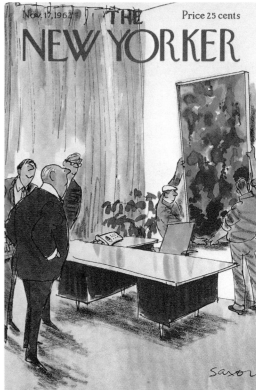

arranging art in the building, we had to work at night, because the staff had already moved in and was conducting business. We spent three or four hectic nights there placing works of art. In the confusion, we accidentally left a large painting by Jack Youngerman in the office of the vice president who didn't want any modern art. (We had taken it into his office because it had a beautiful midnight blue fabric on the walls, and Gordon Bunshaft thought the Youngerman painting would look wonderful against that color.) The next morning, this vice president came into his office and found the Youngerman there. Instead of exploding, he called me and said, "I'm crazy about that painting, I'd like to have it for my office." We had intended the Youngerman, which was large, for a big public space in the bank, but we were so pleased by his unexpected reaction that, of course, we agreed to let him have it. I said, "By the way, you can see where Jack Youngerman lives from your office window, right down there on Front Street." "Really!" he said. "I'm going to ask him to lunch." He did, and they became friends.

There have been significant changes in policy and direction in the twenty-five years that I've been on Chase's Art Committee. The first art we bought was for 410 Park Avenue, and then we began buying for the sixty-story Chase Plaza building. That brought forth requests for art from the local branches. Then we were told that the New York program was so successful that Chase wanted to extend it to its branches all over the world. Happily, when that was decided, the committee established a policy of buying art first from the country in which the branch is located, and then adding art objects from America and other countries.

In the course of these developments, the nature and function of the Art Committee changed also. The original expert members began to reduce their participation after a few years, as their museum responsibilities expanded and allowed less time for the Chase activity. At the same time, extension of the art program to the hundreds of branches vastly increased the amount of time needed for acquisitions, curatorial services, placement and hanging of the works, and administration of the program.

It soon became apparent that a full-time departmental staff was required, and that it would have to be gradually entrusted with much

The November 1973 meeting of the Art Committee was the last one attended by Alfred Barr and was the first for Margit Rowell and Robert Rosenblum. From left: Rowell, James Johnson Sweeney, Rosenblum, Mary Lanier, David Rockefeller, Barr, Dorothy Miller.

In the garden of the Museum of Modern Art, New York, from left:
Jack Boulton, Merrie Good, Michael McCarthy, David Rockefeller.

of the responsibility for selection, which had, until then, been the function of the Art Committee. In 1968, Christopher Gerould and Clare Fisher were chosen from within the bank to do this work. Clare left in 1972 and Mary Lanier was hired to succeed her as curator; she became director of the program when Gerould retired, two years later.

By this time, I was the only one of the original art advisers remaining on the committee, and in 1973 the bank asked Robert Rosenblum, professor of art history at New York University, and Margit Rowell of the Guggenheim Museum (who served only briefly before going to Europe on a fellowship) to join. Gordon Bunshaft retired from the committee and was replaced in 1978 by Michael McCarthy of Skidmore, Owings & Merrill. I continue to propose works of art for addition to the collection, and the art committee continues to meet regularly to decide on the more important purchases and to set policy, but the collection's management is carried on by the Art Program staff.

Starting with Mary Lanier, all the staff had training and background in the arts. Not long after she left, at the end of 1977, buying for the collection was put in the capable hands of Jack Boulton, and the administration in those of Merrie Good, who had been with the art

39

program since 1972. (It is interesting to note that at about the time when large museums such as the Metropolitan began splitting the position of director in two—a business manager and an artistic director—the Chase collection had grown so much that it was necessary to do the same thing.) An indication of the extent to which the collection has become an accepted part of the bank's activity is the composition of the present Art Committee, on which there are five bank people (including the retired Chairman, David Rockefeller) plus Robert Rosenblum, Michael McCarthy, and myself.

It has been suggested that when corporations started buying heavily in the 1960s they had an influence on art itself, on what artists made. Suddenly there were commissions for paintings and sculpture to be placed in big spaces, and certainly in the 1960s much of art took on a mode of public address. One can read a Frank Stella or a Gene Davis at a distance and appreciate it, but one can't read a de Kooning, for example, at a distance and appreciate it to the same extent. This distinction undoubtedly affected what some corporations bought.

It is interesting in this connection to note that our longstanding difficulty in finding a suitable sculpture for the Chase plaza—a space as large as the Piazza San Marco in Venice—was resolved with a work by Jean Dubuffet, who was not generally thought of as a monumental sculptor. It was only because Alfred Barr and Gordon Bunshaft knew of Dubuffet's experiments in large-scale sculpture that this seemingly unlikely artist was proposed for the plaza project and then enthusiastically chosen. Even so, only one of the several models by this artist worked—but it worked beautifully.

In the final analysis, I don't really believe that corporate buying has had a significant impact on the artists themselves. I think that the best artists go on doing what they feel like doing, no matter what the market is or where art is being seen. In general, the artist leaps ahead of us and we follow.

Alfred Barr and Dorothy Miller

David Rockefeller and Jean Dubuffet standing in front of *Group of Four Trees* on Chase Manhattan Plaza.

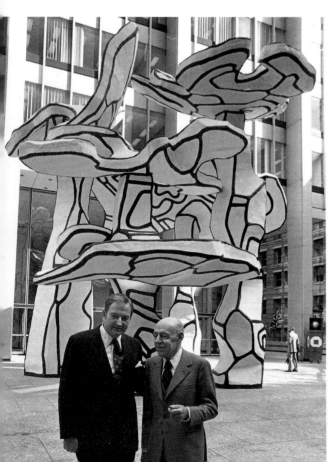

THE COLLECTION

Observations
Robert Rosenblum

Works referred to in the following text are illustrated with small black-and-white reproductions in the margins. Numbers in parentheses in the text after names of works, and numbers underneath pictures in the margins, refer to the pages on which color reproductions of the works appear. If there is no color reproduction, the reference in the text will say "see margin" in place of a page number.

Works of art are so often seen in museums, locked up like precious objects in a vault totally sealed off from the outside world at 5:00 P.M., that we tend to forget many things about them. Above all, we too often forget that works of art are made by human beings like the rest of us, who live in particular times and places and have their own distinct psychological contours. As for time and place, we would hardly expect that an American artist working in 1959, when the Chase Manhattan Bank art collection was launched, would have the same attitudes toward, among other things, the equality of the sexes, the new world of electronic images or space exploration, the awareness of a vanishing nature on our planet, as an American artist working in 1984, when the collection celebrates its twenty-fifth anniversary with this volume. Nor would we expect that the anonymous Eskimo or Japanese artists in the collection who may both have worked c. 1700 A.D., when measured by Western calendars, would share many attitudes with or understand much about the Westerners working at the same time.

Were it possible to see in one place the ever-proliferating Chase collection, it would offer, for one, the most far-reaching voyages in time and space, from an unidentified Pennsylvania town c. 1885 to Peru before Columbus, from the Ivory Coast in the nineteenth century to Manhattan or West Berlin in 1982. It would reveal as well that visual artists can play a multitude of roles, from geometer to sorcerer, from journalist to philosopher, from aesthete to Yankee craftsman, from stage director to architect. And it would also tell us, again and again, how artists, just like the rest of us, may interpret an experience—whether of the human face, the bounty of nature, the language of mathematics, the structure of the modern city—in a multitude of ways.

To be confronted with a collection of such diversity and immensity is like looking through a huge, constantly shifting kaleidoscope. Take, for one, the possibilities artists can explore with a motif in the real world so commonplace that we seldom think about it—the magic, visual or mental, of words, of letters, of numbers. What in America we take so

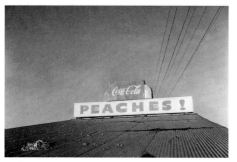

274

much for granted that it approaches invisibility—the signs, the advertisements that shout their wares—can suddenly, in the hands of a photographer like William Eggleston (p. 274), be isolated and startle us. Singling out, like a sharp-focus mirage on the horizon, the prosaic but striking combination of billboards juxtaposing two words (one, *peaches*, as organic as the Garden of Eden, the other, *Coca-Cola*, as artificial as twentieth-century American life), Eggleston makes his photograph speak volumes that reverberate in other contrasts as well—the pure blue sky against the tilled soil; the old-fashioned, turn-of-the-century calligraphy of the Coca-Cola logo versus the vernacular bluntness of the lettering that ends *peaches* with an abrupt and arresting exclamation point. Through so simple a dialogue of the words of commerce so ubiquitous in our environment, Eggleston sets into motion dense associations about modern America.

For other artists, no moving automobiles or state highways intrude upon speculations about the meaning of words. For Joseph Kosuth, one of the leaders of the "conceptual art" movement of the late 1960s and 1970s, it is the purified idea of a word that presides in its entirety. Using the unexpected format of a framed painting, his four-foot-square photostat *Purple* (p. 236) has nothing at all to do with the color except in the abstract verbal terms of a dictionary definition, blown up for us to read in lieu of the color itself. The immediate gorgeousness of that hue is willfully canceled by the artist's slow cerebration, which explains, in the most impersonal black-and-white, and through an exact replication of a dictionary typeface, the wide range of definitions applicable to the word, which, as noun, verb, or adjective, may mean anything from the chromatic components of the hue to the metaphorical associations of imperial grandeur. Here, in the same domain of words, the artist-philosopher has usurped the artist-reporter, bleeding purple dry of sensuous experience and relocating it in the realm of a concept.

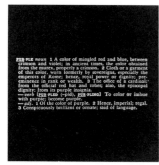

236

But for artists, as for everybody else, words can do countless things, among them telling stories. In Vernon Fisher's *Monahan's Sandhills* (p. 223), words and an image thrust us into the midst of an incomplete narrative that begins to recount, as if we walked into a movie with explanatory titles still on the screen, a long, evocative story about the gas stations, the people, the landscapes encountered on an automobile trip somewhere in the American Southwest. Through the unlikely medium of painting, Fisher tries to rejuvenate the narrative potential of words.

223

On quite another level, letters and words as linear pattern, translated into the verbally meaningless arabesques of high-style ornament, can be found in the work of Saul Steinberg, whose drawing of 1966, *Grand Ratification* (p. 101), is a witty parody of the calligraphic flourishes most familiar in the Declaration of Independence. The medium becomes the message, a virtuoso cornucopia of quill-pen fireworks that spiral, scratch, and swirl over the paper, threatening in

101

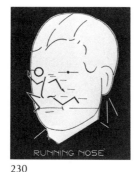

230

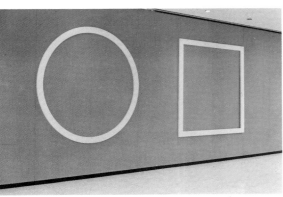

292

every nook and cranny the legibility of both the legal statements, if such they be, the ratifying signatures, and the monarchic emblems above them. An aristocratic variant of the populist art of graffiti, which prefers the handmade to the printed, Steinberg's drawing again demonstrates how the stuff of written symbols can be re-created totally through the alchemy of art.

Artists can also re-create language by startling dialogues of image and word in visual puns that range from the outrageously comic to the uncannily macabre. In Steve Gianakos's goofy, cartoonlike *Running Nose* (p. 230), it is only the title, like a one-line joke, that provides a clue for making sense of this stick-figure nose, which tries to race away from its owner's nondescript head. In Barbara Kruger's untitled photograph (p. 292), the blunt image also illustrates literally the words of a commonplace idiom of speech, but now, instead of laughing like schoolchildren, we wince.

Just as letters, numbers, words can be seen through the differing lenses of countless personalities, so too can some of the basics of geometry, which from the beginnings of civilization have formed the foundation of visual order, from the venerable circles of Stonehenge to the pyramids of Gizeh.

But it is probably our own century whose art has demonstrated the most abundant and passionate search for a visual language of such elemental purity—circles, squares, triangles, parallels and perpendiculars—that a whole new world of clarity and order could be built upon it. In the words of Edna St. Vincent Millay, ''Euclid alone has looked on beauty bare''—a tribute that might be paid to many artists in the Chase collection.

At the head of this class might be Sol LeWitt's Platonic ideal of a square and a circle (p. 252), a pair of absolute statements that float on the wall like the disembodied ideas in Euclid's brain. As distressingly simple and simple-minded as LeWitt's primer in plane geometry may look, it, like most twentieth-century works that offer variations on these eternal shapes, ends up being surprisingly complex. For one thing, we might have trouble categorizing it as painting, sculpture, or architecture. As lacquered white shapes, each ninety-three inches high and wide and occupying the better part of a red wall in one of the bank's offices, this primary pair almost becomes part of the architectural rhythms, like moldings or basic articulations of a long flat plane that divides the spaces where people pause or move. But as evocations of two pure white frames, one a perfect square, the other a perfect circle, they also function as the boundaries of invisible paintings, pulling the carpet out from under our familiar expectations that such geometric frames are secondary to what they enclose. But of course, they are no more paintings than they are architecture, and trespass further on the domain of sculpture, suggesting the conventions of low modeling on a flat ground associated with relief sculpture. What starts as just a square and circle ends up as a synthesis of all three major arts, architecture,

252

painting, and sculpture, as if LeWitt had wished to wipe the slate clean and reassert the abstract building blocks upon which all these media have been based over the millennia of human thought and art.

To the innocent eye, LeWitt's two-part dictionary of geometric essentials—a work of 1977—might look like the very first and surely the most austere statement of the theme in abstract art; but in fact, the tradition of restating these essentials is a long one, and countless artists of many different twentieth-century generations and from many countries have offered their own personal homages to this magnetic theme. In 1960, the Chase collection, only a year old, acquired another artist's offering to the gods of geometry: Josef Albers's *Homage to the Square: In Late Day* of 1959 (p. 64). Then as now, Albers's painting must have radiated an image of elemental purity that, like LeWitt's, would present a kind of clean visual drawing board, a first statement of principles. Nevertheless, Albers's painting in turn harked back to multiple earlier twentieth-century efforts to do exactly this again and again; and it reflects in particular this German-born master's own training in the Bauhaus, from 1920 to 1933, when, with other artists of a post–World War I generation who had witnessed the insane destruction of so much of European civilization, he hoped to reconstruct the world on the utopian fundamentals of a purified geometry. The Chase's painting, in fact, is one of hundreds of Albers's variations on the immutable truth of the square, a series he began in 1949. His vision, we realize in an instant, has little, if anything, to do with, say, LeWitt's. Here, three squares of differing autumnal colors that evoke the sunset glow of the title seem to float and pulsate in a field that is at once as luminous as the sky and as razor-edged as an architect's ground plan.

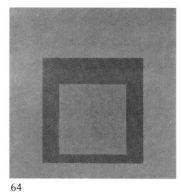

64

For artists of our century, the circle was worshipped no less ardently than the square, providing the rock-bottom purity of another vocabulary, this time of arcs. Within its first decade, the Chase collection laid these two geometric foundations not only with the Albers of 1959, but with another painting of the same year, *Color Wheel* (p. 108) by Alfred Jensen, which, in fact, subtly fuses the circle and the square. Its centralized image, with its hypnotic rings of concentric circles, is, we slowly realize, both bisected and quartered by the equal geometric claims of the twenty-four-inch-square format, creating, as in the Albers, a complex series of forward-and-backward vibrations that belie our first impulse to describe the canvas as looking as flat as a target. Indeed, the polarities between white and black, circle and square, can even move into more evocative spheres of meaning, since the artist, who has always been concerned with mythic symbols of a kind familiar to him in the Mayan civilization of his birthplace, Guatemala, intended this geometric pattern to be charged with some of the eternal dualities of nature: light versus darkness, male versus female. For other, younger artists, the inspiring muse of the circle seems closer to Euclid than to a pre-Columbian deity, as in the case of Robert Mangold's *Four Arcs Within a*

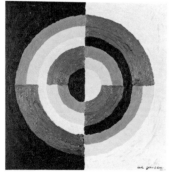

108

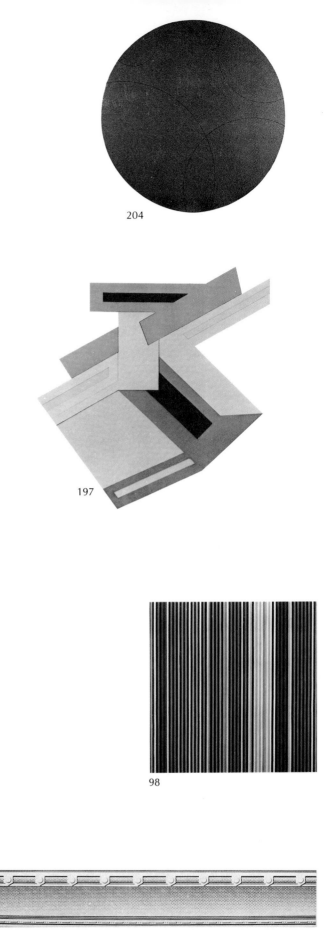

204

197

98

260/1

R R

Circle of 1975 (p. 204), in which the overt simplicity is immediately complicated by a frail but immaculate complexity. We realize that the seeming completeness of the circular format reveals a glimpse of many incomplete arcs of differing sizes that may or may not intersect; that may or may not be completed in our imagination, outside the frame; that may be only an infinitesimally small part of an almost astronomical network of circular orbits radiating forever beyond this solar system of a canvas.

Although we tend to think of the lucid forms of geometry as belonging to a realm of experience that is rational and impersonal, a shared system of order that rules out emotion, this easy generalization is constantly countered by the facts of particular works of art. Frank Stella's *Chodorow III* of 1971 (p. 197) is a case in point. At first glance, it looks like a perfectly solved jigsaw puzzle of carpentered planes that allude to the complex wooden construction of a group of provincial Polish synagogues (whose locations provided the titles for this series). But this seeming clarity of parallel, perpendicular, and diagonal axes reveals not the serenity of a geometric solution, but a kind of tense, explosive deadlock, as if a network of planes, moving in counter-directions, was suddenly jammed and frozen in an area barely large enough to contain so many contradictory signals of movement and location in space. Indeed, the surface activity is made even more complex by taking place in what is actually a shallow relief, creating not only the illusion but the physical fact of an intricate series of thinly overlapping planes, locked into precarious place in a gravity-defying collision of cardboard, canvas, felt, and Masonite that seems like an overhead view of a traffic jam in a multilane intersection. The energies are radiant and expansive, but the precision of the deadlock straitjackets them forever. If this is the serenity of geometry, it packs a crazy wallop.

Similarly, so seemingly monotonous a motif as stripes, pure and simple (or impure and complex), can immediately define a particular artist's imprint. The gallery-goer immediately knows that *Red Jumper* of 1967 (p. 98), a confrontation with nearly one hundred painted thin vertical stripes of constantly shifting colors, has to be by Gene Davis, thanks to his familiar combination of almost obsessive regularity (the repeated stripe pattern) and unpredictable chance (the complete lack of a governing pattern in the sequence of colors, which are determined by instinct as the painting progresses), and thanks also to the choice of rapidly changing hot and cold hues that vibrate with jazzy syncopation.

In fact, stripe painting was explored by many artists of the past decades, and even parodied by that master parodist, Roy Lichtenstein, whose *Entablature #1* of 1971 (pp. 260/1) stretches our eyes some sixteen feet from side to side, in a rush of parallel stripes that offer witty variations on the decorative horizontal moldings found in textbook diagrams of classical architectural elements, extended ad infinitum, and that also mimic jokingly Kenneth Noland's no less eye-stretching abstractions of

horizontal stripes from the 1960s. Sometimes these stripes can even leave the framed canvas and become part of the decor, confounding painting, architecture, and interior decoration. So it is with the work of the French artist Daniel Buren, who has made the regular beat of alternating white and colored stripes a virtual signature, now recognizable in commissions all around the globe. Characteristically, Buren lets his stripes invade an indoor or outdoor space, leaving his personal imprint behind like a series of regimented graffiti that spell out ''Buren was here''. In 1981 the Chase collection commissioned him to create his familiar environment for one of the private dining rooms at the 410 Park Avenue branch (p. 269), where his regular visual rhythm dominates this intimate space like wallpaper on the march. It is fascinating to see, too, how Buren's powerful takeover of a secluded corner in a bank interior radiates the period style of the 1970s, in contrast, say, to the period style of the 1950s, encapsulated perfectly in Sam Francis's mural of 1959 acquired for another part of the same floor (pp. 31–34). What is venerated here—despite Francis's own avowal that he was responding to the mechanized character of New York and its hard light—is the sense of an almost volcanic upheaval and irregularity, a vast, rollicking terrain thirty-eight feet long, in which the artist's irregular touch reigns and in which no shape or contour obeys any rule but disobedience to geometry and to predictable pattern. As such, it offers a deliberate rebellion against the modular, rectilinear tyranny of any modern office building of the 1950s, especially one designed by Skidmore, Owings & Merrill, planting within such walls a decorative earthquake that might become a welcome oasis in a business world of computer precision. Buren's approach of some two decades later is an about-face, in which not the handmade but the printed (here silkscreen on linen) is the medium; the message is not the mark of spontaneity but rather an assembly-line, impersonal regularity. Yet the irony is that both the Francis and the Buren emerge as brilliant displays of decoration for a bank interior. If the Francis reminds us that there is a world of ebullient freedom somewhere out there, the Buren surprisingly evokes a summery outdoor world of awnings and cloth tents, the insistent repetitive stripings almost about to flap in an imaginary breeze.

Thanks to the innovations of modern artists who explore the language of geometric shapes and patterns, our century has become especially attuned to the enjoyment of such visual languages in cultures and artifacts that have virtually no relationship to the experience of living in the great Western capitals of our time. The Chase collection could hardly reflect better this modern sensibility of plucking out of context a utilitarian or ritual object from cultures as unlike as nineteenth-century rural America and pre-Columbian Peru. As for the latter, a poncho made of feathers in Chancay (p. 217), long before Columbus was born and even before the Inca conquest, is capable of being read by us as a strange ancestor of many aspects of twentieth-century painting. Carrying

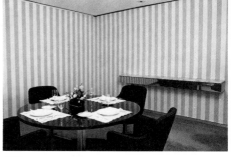

269

31-34

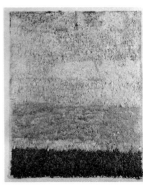

217

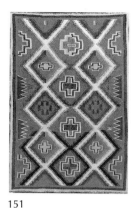

151

224

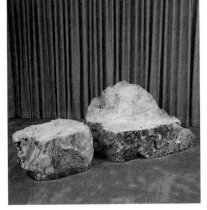

261

253

in our mind images of Albers, Rothko, or Marden, we inevitably read such an exotic artifact in the context of framed paintings in which banded zones of color make us scrutinize not only their hues but their textures. We might well wonder whether the original bearer of such a gorgeous garment would, in turn, have eyes to see the contemporary canvases that have given this poncho so rich a range of new associations.

As for the child's woolen blanket handmade in a Navajo Indian community c. 1880 (p. 151), which originally served as protection against the cold, it is hard for us not to see it as an innocent and beautiful relative of early-twentieth-century investigations of, for example, the various ways to shape crosses or to make a geometric symbol vibrate against a luminous ground. Similarly, the American cotton quilt made in some rural Yankee community c. 1900 (p. 224) seems instantly compatible as a wall hanging in the same contemporary environment that would now accommodate, say, Jasper Johns's own variations on the red-white-and-blue stars and stripes of Old Glory or Stella's tautest interlockings of angled, sharp-edged planes. And that we may respond to an object like an American game board for Parchesi of c. 1910 (p. 261), not as players about to make a move but as aesthetically minded spectators, is a tribute to the fact that we have now become accustomed to looking at such odd, asymmetrical balances of red and black rectangles and circles in abstract art. It is, indeed, ironic that such a rigorously purist pattern recalls the kind of intentionally simplistic vocabulary that Russian artists employed just before, during, and after the 1917 revolution to further the utopian dream of building a new art in a new society on the most pristine and elementary foundations, a slate wiped clean. Removed from the network of experience that originally created a game board or an article of clothing, such a utilitarian object may be reborn in unexpected visual contexts, a dialogue that is familiar within the acquisitions of the Chase collection, and that also has self-consciously been taken up by many recent artists who love to confuse conventional boundaries between the useful and the aesthetic.

A most mind- as well as eye-boggling example of this is the furniture, if it can be described with such a bland word, of Scott Burton. A chair and table by him (p. 253), acquired for the Chase collection in 1982, the year they were fabricated, rests in a corner of a carpeted floor at 410 Park Avenue, just like other tables and chairs in the bank offices. But these two objects make us blink not only because of the unfamiliar extravagance of their material—white flint—but because of their strange shapes and textures, both rough-hewn and highly polished, which conjure up almost mythical origins. These utilitarian forms might have been found in some stalactitic grotto that once housed a primitive deity. Were we to stage a new production of Wagner's Ring cycle, Burton's white flint throne and ceremonial altar might well serve Wotan; but to see such magic objects within the very unmythical context of a bank office demands an almost surrealistic flight of the imagination. Here, not

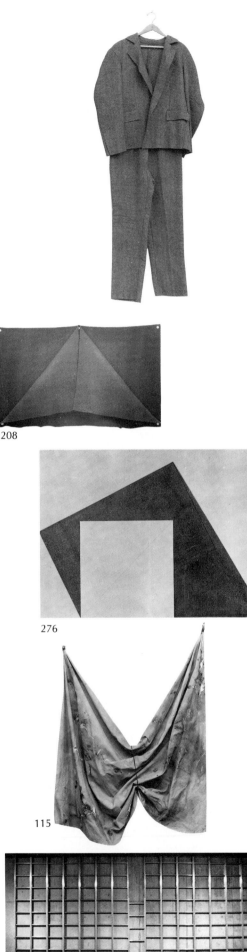

208

276

115

213

only do table and chair become strange sculptural objects in themselves, more to be looked at than sat or leaned on, but their association with a primeval utilitarian or ritual form carved out of the living rock sets up a flood of unexpected associations.

This startling crossing of familiar boundaries between the domain of art and the domain of commonplace objects and materials characterizes much art of the last decade, and the Chase collection reflects this assault on preconceptions in many ways. Just as an article of clothing from another culture, whether Japanese or pre-Columbian, can suddenly be looked at as if it were painting or sculpture, so too does clothing by the contemporary German artist Joseph Beuys (see margin) confound us, by making us look at the grimly utilitarian felt suits that he wore both as protection against the cold and as an almost shamanlike relic of his mythic self-deification as a leader of a younger generation of German artists and political thinkers. And on other levels as well, artists of the last decade may make us stop in our tracks to consider, from a fresh angle of visual contemplation or imaginative association, even something as ordinary as felt. Beuys used it for a suit, but in an untitled work of 1976 by Robert Morris (p. 208), it hangs from the wall in a thoroughly antiutilitarian way, obliging us unexpectedly to consider its strange properties, so unfamiliar to the medium of sculpture or painting. Like Dorothea Rockburne's folded linen canvas (p. 276), Morris's suspended wall relief layers its materials, which reveal the heavy slackness of felt, resisting the razor-edge precision of plane geometry, but are nevertheless ordered in a grandly symmetrical design that, with the help of the five grommets at the edges, attempts to approximate the purity of squares and right triangles. Looking at this work, we may see for the first time what a curious substance felt actually is, hovering between the shapeless and the shapable. Nor are we any the less surprised when we learn that colored paint on canvas, at least in the hands of Sam Gilliam (p. 115), need not be stretched taut at all, imprisoned in a rectangular frame, but can flop down like the huge swag of a curtain, obedient to the pull of gravity, and insistent on the fact that the canvas, which we had always considered the transparent screen upon which painted illusions were projected, could lead an unexpected physical life of its own when liberated from a stretcher.

As the Chase collection keeps demonstrating, the artist, whether from nineteenth-century Nigeria or post–World War II New York, can also be something of a magician, at times turning the commonplace into the miraculous, or domesticating the miraculous for more intimate consumption. In the domain of recent art, there are endless permutations of this role of magician-artist. There is, for one, the disarming *Ladder Drawing* by Vito Acconci (p. 213), who, like the sorcerer's apprentice, keeps multiplying ladders before our eyes. Raising all but the central one to ceiling height, up off the floor, he thereby transforms the whole into a rectilinear trellis of mural dimensions that

305

148

149

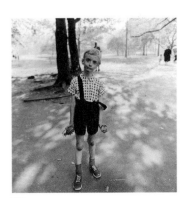

266

263

renders these commonplace objects used for climbing absolutely useless and inaccessible. We are instead puzzled into contemplating them afresh, as if they might reveal a mystery they never suggested when stored in a closet. Disorienting in a different way is one of the Korean-born Nam June Paik's many dazzling variations of what has turned out to be the most ordinary vehicle of contemporary magic in homes and bars all over our planet, television. His *Rosetta Stone, Channel 10* (p. 305) takes the wooden frame from an old Zenith set, anachronistically decorated like a nineteenth-century chest of drawers, turns the screen within this imaginary proscenium into a startling alphabet of electronic TV colors in vertical bands inscribed with an inventory of Oriental and Western hieroglyphs and thereby proclaims, as the title implies, the chromatic and verbal foundations for the rectangular illusions in this domestic theater.

Other constructions also use the theater image to work their spell. Cletus Johnson's *Oasis* (p. 148) uses that title word as the trigger for a magical escape, like the childhood memory of the oasis provided by the opening title of a movie, which, projected on the local screen, promised to waft us instantly away from the prosaic world we lived in. A comparable kind of magical theater is found in John Willenbecher's *Cenotaph* (p. 149), which locates us in a planetarium of the imagination, a strange composite of labyrinths and cones, of two- and three-dimensional abstract diagrams in a chilly, galactic night sky, evoking an extraterrestrial monument for an unnamed hero or event beyond human dimensions.

Other contemporary artists may be no less evocative, even though they work with the more traditional imagery of shared myth so often illustrated by the old masters. Such is the case in *Mars in the Air* (p. 266) by the English painter Christopher Le Brun, who, with many artists of the 1980s, is reexploring a global range of mythical subjects, from Greece and Rome to modern comic strips. Here, the classical god of war, who, like his fellow deities on Olympus, had fallen out of favor with most forward-looking twentieth-century artists, has been reborn as the grim hallucination of a blood-red ruler on a ghostly horse, a classical counterpart to the bible's apocalyptic theme of death on a pale horse and, as such, bone-chillingly appropriate to the prospect of imminent cataclysm that haunts all thinking inhabitants of our planet in the age of nuclear arms.

Such feelings of terror, here translated into an imaginative realm, can also be plunged right back to the terrestrial here and now with shocking immediacy. Nobody who looks for a second at Diane Arbus's 1962 photograph *Child with Toy Hand Grenade* (p. 263) will ever forget this shrill pinpointing of a child's warped, desperate rage, an instant of insane, primal violence that could trigger off riots, wars, and, these days, the end of the world. Our awareness of these layers of terror beneath the surface of our everyday public life is heightened in another way in

51

248

281

Thomas Lawson's *Battered Body in Freezer* of 1981 (p. 248), whose title provides the essential caption, in the manner of yellow journalism, to explain the gruesome destiny of the young girl whose photographed face, which is that of the most ordinary teenager, has been replicated in oil stick and acrylic on canvas and seen through a lurid veil of printer's-ink blue. The mixture of newspaper imagery, a totally innocuous face, and a legend that suddenly spells out a shocking fact offers a grimly ironic commentary on the banality of horror in our modern world.

Photography looms large as a vital source for many artists of the last few decades, and the Chase collection reflects the countless ways in which this has happened. The mug-shot plainness of Lawson's photographic image is used as a foil to the bizarre facts of the murder; whereas this same straightforwardness of confrontation can be used for totally different ends in the hands of a Chuck Close. In his nearly eight-foot-high reproduction of the head of his friend Philip Glass (p. 281), the now internationally renowned composer, we at first think we see nothing but the plain truth of the equivalent of an enlarged passport photo. But Close's concern with photography involves not only the image but its atomized visual components, offering the modern equivalent of Seurat's technique of painting with regularized color dots. In the case of Close's portrait drawing, we discover that it is not really a drawing at all; the image was made by what seems an infinity of fingerprints inked with a stamp pad, the staggering accumulation building up to the totality of an instantly recognizable portrait. Apart from the marvel of this strange technique (tantamount to constructing the Eiffel Tower out of toothpicks or a landscape image from typewriter print), there is the added twist of the startling discrepancy between ends and means. The artist's fingerprints, the most uniquely personal, handmade visual mark imaginable, end up creating the facsimile of a totally impersonal, machine-made photographic image.

The ordinary fused with the extraordinary in a photographic image is also found, appropriately enough, in Duane Michals's double-exposure portrait of the renowned Belgian surrealist painter René Magritte (see margin), who also looks at us with a head-on simplicity that vanishes when we realize that there is an hallucinatory second image of a photographed landscape, which hovers like a phantom dream both in front of and behind the seemingly straightforward fact of Magritte's proper outward appearance. Michals demonstrates that photography is capable of the wildest flights of imagined fantasy, and also capable, like so much contemporary art, of offering self-conscious allusions to art history, in this case displaying how a young American photographer concerned with dream imagery can create a photographic tribute to a master painter who pioneered in the transformation of the mundane into the miraculous. It is, in fact, just such a twentieth-century tradition that has permitted us to find the uncanny in endlessly unexpected places. It accounts, in part, for the Chase's acquisition of seemingly ordinary, often

257

63

249

220

105

utilitarian objects that can suddenly become part of a family of modern spooks and demons. Such is the case with the head of a mannequin crafted from pine wood in the United States, c. 1850 (p. 257). It is the kind of clothing-store prop that usually ended up in the refuse bin; but having survived its century, like a message in a bottle, it can take on a new, strange life for postsurrealist eyes like ours.

The abiding mystery of the human head has always been subject to the infinite mutations of art. It is fascinating to see, within the context of the Chase collection itself, the differences of approach between more recent artists, who appropriate the presumably more cool and detached imagery of photography, and older artists whose work was acquired at the very beginnings of the collection and reflected other attitudes. So it is with Leon Golub's *Head XXI* (p. 63), painted in 1959. The coarse, dense encrustations of paint, the sense of probing to elemental origins of emotion, give this head a powerful presence of raw feeling, as if the proprieties of outer decorum had crumbled. It is a head that reflects the preoccupations of the abstract expressionist generation, making us believe the world has regressed to an almost prehistoric environment where figures, emotions, landscape are just beginning to take shape.

This search for the primitive, for the origins of myth, of matter, of feeling, is a consistent part of our modern cultural tradition, a counterbalance to our extremes of industrialization, of computerization, of psychological repression. It is no accident that a rich part of the Chase collection displays not only the modern artists' efforts to recapture the magic of the beginnings of the universe and of human life within it, but also a wide range of objects culled from exotic cultures that preserve for us, like precious relics from another planet, that sense of mystery and magic so absent from modern urban life. One such object is an Eskimo whale fetish (p. 249) actually made from parts of a seal. Its strange composite of literal and imaginary animal forms that approximate the shape of a whale's body evokes as well, in the disposition of its rude geometries of circles, lines, and crosses, a humanoid face of intense, hypnotic power, perhaps assuring the hunter's conquest of his prey. It is telling that in the Chase collection there are recent examples of younger American artists attempting to reawaken, but from a thoroughly sophisticated vantage point, this primitive feeling for the magic of animal forms and human faces. It can be seen, for instance, in the work of Jeff Way, whose snake mask of 1976 (p. 220) might almost deceive us into thinking that its staring human eye, emerging from the crude coil of a painted snake on a plaster mask, could be identified with the deity of a remote, primitive mythology, though the whole is in fact an anthropological fiction by a young New Yorker.

Landscape as well has long been subject to this primitivist mode, as is immediately apparent in Adolph Gottlieb's *Turbulence* of 1964 (p. 105), which might almost be an illustration of the book of Genesis. Below,

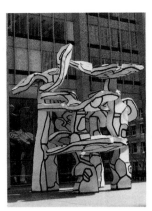

22

27

181

82

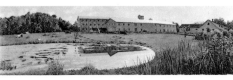

175

suggestions of some primal, unformed matter evoke earth and sea; above, three orbs of differing shapes and luminosity seem to throb in a primitive sky. The whole becomes a confrontation with the very stuff of our universe at the brink of its formation. Even more spectacularly primitivistic as a landscape is the one adventurously commissioned in 1971 for One Chase Manhattan Plaza from France's leading master of this modern throwback to prehistory, Jean Dubuffet (p. 22). In startling contrast to Skidmore, Owings & Merrill's office building, whose uninterrupted ascent of eight hundred feet of rectilinear aluminum and glass might almost symbolize the industrial era, Dubuffet's sculpture in the adjacent plaza is like a primitive shrine, a monumental archway of four interlocking trees whose gnarled, craggy contours throb with a wild animation that seems more appropriate to a Druid civilization than to Wall Street.

In some ways, Dubuffet's realization on so monumental a scale of the abiding fascination of nature as magic and enchantment offers a Gallic counterpart to one of the collection's earliest acquisitions, Charles Burchfield's large watercolor of 1959, *Pink Locusts and Windy Moon* (p. 27). This American artist's avowal that his subject matter was "the deep mystery that lurks in the depths of trees and bushes" is borne out here in a Halloween-like spectacle of a Victorian house that flashes, like a mirage, in a night sky alive with rustling leaves and branches, chirping insects, and cloud-swept moonlight, the whole becoming a spooky confirmation of a mysterious inner life in nature that constantly reminds us of the time-bound impermanence of our industrial civilization. We sense this, too, in the photographs of Ansel Adams, whose documents of the American landscape venerate no less magically the power and timelessness of nature. His silver print of 1958, *Aspens, Northern New Mexico* (p. 181), is almost ghostly in its luminosity, capturing with the photographic lens a sense of the miraculous upward energies of a forest of young, burgeoning trees, whose frail vertical shafts virtually radiate with a light that, in a less secular era than ours, would be thought of as a mirror of divinity.

For other artists, landscape need not look quite so primeval, but can simply record, in a style more like plain prose, casual rural facts that recall not the beginnings of the universe or the miracles of nature but the pleasures of a visit to the countryside. The Chase collection provides many such respites for the city dweller. Fairfield Porter's *The Sycamore in September* (p. 82) is one such painting, in which the centralized portrait, so to speak, of a sturdy tree almost camouflages the ambient countryside, where we finally discover glimpses of a white farmhouse and some red-brick chimneys merging with the cool rustling of gray-green leaves and branches. Equally matter-of-fact in its sense that what we see looks like what we think the artist saw, virtually unedited, is Rackstraw Downes's *Oxen and Draft Horses* (p. 175), whose panoramic format obliges us to scrutinize slowly, as on a long, unrushed country

walk, the unpretentious facts of farm buildings and farm animals quietly at one with the landscape. Unlike Porter's broadly dappled paint surface, which would focus on the forest rather than the trees, Downes's brushwork is of a scrupulously close-eyed precision, in which every gleam of sunlight, every irregular silhouette of roof or branch, is recorded as a cherished, unique observation. Yet both artists belong to a long and persistent tradition that assumes a direct, candid relationship between the artist and nature, between the truth of the thing seen and the truth of the thing painted.

294

Such an ostensibly innocent dialogue between the artist and nature is often subject to surprising variations, especially in the work of younger generations of artists who are more self-consciously aware of the artifice of art, of the fact that the canvas is not only a fiction but a fact. It is a viewpoint that can be seen, for instance, in Sylvia Mangold's *Long Blue Stroke* (p. 294) of 1982–83. At first glance it looks like an uneventful skyscape, with sunset light reflected in an overcast sky. But the title itself begins to suggest what the artist is also up to, for she identifies the illusion of the blue streaks of the sky as, in fact, long blue strokes of paint, and then, even more surprisingly, on the canvas itself, she sets off the side margins with what look like strips of the most ordinary of artist's materials, masking tape, suggesting that this is a work in progress, being measured and edged. Yet the masking tape is not really there, but is in itself a painted illusion, a *trompe l'oeil*, to use the familiar French phrase for this kind of deception. So complex a scrambling of the artist's facts and fictions keeps us at our wits end, so that what begins as the most straightforward image of a cloudy sky ends up as almost a philosophical dialogue between the ends and means of the making of art. Lest such complexities seem the product of the intellectual bent of a younger generation steeped in semiotics and structuralist theory, it should be quickly said that Mangold's painting also belongs to a long native tradition of *trompe l'oeil* painting, marvelously exemplified in the Chase collection by a tiny canvas, less than five inches square, by that nineteenth-century master of illusion, William M. Harnett (p. 209). Here he makes us feel that the paint tube in his studio, which helped him to paint a bunch of grapes that look so real we might reach out to pick them, is somehow hovering over the canvas, and even closer to our grasp.

209

It is one of the many pleasures of a diverse collection like the Chase's that such a rapport between an American painter of the later nineteenth century and an American painter of the later twentieth century can suddenly click into place, reminding us again that works of art establish networks of association, family kinships that extend in infinite directions. If Mangold's landscape indicates that artists often like to make explicit the tools of their trade, like a magician revealing a few secrets, other works tell us that artists also like to let us know that they are thinking about other works of art. Mark Tansey's *Purity Test* of 1982 (p. 268) may at first look like a cornball relic of a nineteenth-century Wild West

268

tradition of painting cowboys and Indians, but at second glance, the literal rendering is removed a whole degree from simple illustration by the fact that it is all painted in a monochrome sepia tone, as if imitating a vintage photo. But as a further, more up-to-date fillip, what this group of Indian chiefs is looking at is not the preindustrial landscape it gazes at in comparable pictures that hang over bars or in the homes of oil tycoons, but rather a postindustrial site—a breathtaking vista of Robert Smithson's famous earthwork in the Great Salt Lake, the *Spiral Jetty* of 1970, itself a grandly romantic and nostalgic effort, from a later phase of twentieth-century civilization, to reestablish mythic contacts with nature of a kind that came so easily to the Indian horsemen who lived in those vast, unpolluted plains. What starts off, then, as the most old-fashioned bit of Americana ends up as a delightful irony that shuffles contradictory layers of art, and confounds American past, present, and future. It is telling that, almost as a postscript to Tansey's painting, the Chase collection can offer one of Smithson's own preparatory drawings for the *Spiral Jetty* (p. 295), in which the spiraling form, which would vie with the National Parks for prehistoric grandeur, is mapped out on the site.

295

As for other family trees that seem to be burgeoning in the Chase collection, there is the whole domain of art that is either self-consciously or genuinely naïve, closer, either by choice or by default, to the language of children, of unfettered fantasy, of direct, wide-eyed imagery. In particular, in recent years a whole flood of younger artists have mimicked the look of graffiti, of primitive signs, as if to refresh yet again what Western artists have often felt as the moribund, decadent visual language they inherited from an overly complex culture. Keith Haring, for one (p. 254), has created a language of humorous stick figures that look like ancient hieroglyphs and that, when inscribed on subway walls, as they often are by the artist, can make a New York subway station resemble a prehistoric excavation. The caves of Altamira and Lascaux are also conjured up by the many variations of graffiti scribbles that flourish in recent art. In this territory, the Haitian-born Jean Michel Basquiat is a master of the sophisticated primitive, who can create a whole mythology of childlike creatures (p. 293)—demons, gods, kings—who alternate between looking crudely ferocious, like a voodoo doll, and elegantly chic, like the decor for a modern interior in tune with the twentieth century's unquenchable appetite for art that evokes a less complicated world. Whether we find these artists authentically or only mock naïve, seeing their work in the context of a bank interior provides a jolting, tonic reminder that there are systems of feeling and imagery out there that will not be suppressed by a computer civilization, even if the artist is working within one.

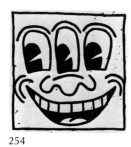

254

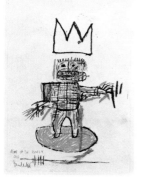

293

Such refreshing oases of innocence and directness are prominent, of course, in the language of folk art, which has always been a high priority on the list of Chase acquisitions. For most of us, folk art provides a visual Garden of Eden, a throwback to a realm of ingenuous simplicity, where

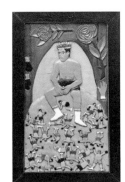

243

201

160

273

188

artists hardly knew what year or century they belonged to, where the air was pure, the vegetables were organic, and the imagination of adults seemed barely different from that of children. Its flavor seems timeless, though this can be deceptive, as in the case of a carved and painted wooden relief by Elijah Pierce, which bears the title *When Joe Became Champ* (p. 243). Were it not for the time-bound life span of the man to whom it pays reverent homage, the heavyweight boxer Joe Louis, we might not even know the country or century of its origin. And even here, calendar time is off, for the work was actually executed in 1971, a full two decades after Joe's reign as champ. Indeed, it seems as remote an image of a deity as a depiction of Zeus or Jesus found in some provincial backlands of ancient Greece or early Christianity. Seated like a mythic conqueror-giant above his tiny vanquished opponents, who tumble down helplessly below him, Joe the crowned king rules forever amid the symbols of boxing gloves and proffered roses, a secular saint in the shrine of a remarkably free and, to most of us, charmingly naïve religious imagination. We feel the same impulses at work in an anonymous homage to Simón Bolívar, piously embroidered and appliquéd by Peruvian hands, c. 1940 (p. 201). Here the nineteenth-century Latin American patriot rears on his horse, like a conquering Roman hero on a pedestal that proclaims his fame and against an enchanted background dense with tropical flowers and butterflies. And in folk art, even more commonplace subjects, like the anonymous American portrait of Ellen Margaret Keyes (p. 160), painted c. 1848, may transport us to a fairy-tale realm, in this case that of a stiff and dour little girl who keeps at bay under her simple wooden chair the blackest of cats. The flattened spaces, the awkward anatomy, the stark contrasts of white and dark might be read alternately as the defects of a provincial hack without training or the virtues of a simple eye untainted by the falsities of decadent urban art education. However we choose to value it, there is at least no doubt that such images, from the widest international sources, continue to nurture far more sophisticated contemporary artists working and exhibiting in urban centers.

The mode may be seen, for instance, in Nicholas Africano's *Studies for Johnson* (p. 273), a series of narrative images that revive something of the clarity and starkness of storytelling in folk art, or in Red Grooms's comic-serious portrait of Gertrude Stein (p. 188), an odd construction that mixes the kind of rough carpentry, flat brash coloring, and crude anatomy that might characterize an untutored sign painter or whittler in order to create an imposing confrontation with this ponderous American genius of plain but complex prose, who here seems to have hailed from the most rural Yankee roots, a relative in spirit of the portrait of Ellen M. Keyes. But in fact, the artist, Red Grooms, has attained this effect not through ignorance but through knowledge of the ironies of contemporary art. As in the case of Gertrude Stein herself, seeming simplicity is a product feigned through extreme sophistication.

227

97

300/1

It is precisely such blurring of the boundaries between the highly cultivated and the naïve that gives extra pungency to so many works of art acquired by the Chase collection, which, in a way, were made works of art by fiat, in the manner of Duchamp's early-twentieth-century declarations that this bottle rack or that bicycle wheel might, when looked at in the context of contemporary artistic activity, be seen as a visually fascinating object, totally divorced from its humble and unartistic purpose. Of course, it takes a discerning eye to follow Duchamp's path, and the eye that selects such objects is usually one familiar with the look of modern art. The ability to choose such a drearily humdrum object as a wooden ironing board, made in America c. 1900 (p. 227), and to offer it for aesthetic contemplation probably depends upon such aesthetic hindsights as a knowledge of, say, the sculpture of Louise Nevelson, represented in the collection by her *Expanding Reflection* (p. 97), acquired in 1966, the year it was constructed out of compartmented black wooden fragments that fuse mysteriously with clear Plexiglas and Plexiglas on which are printed silkscreen photo fragments of Nevelson's own wooden sculptures.

No one definition, no one category, will keep works of art in their stationary place; and it is, in fact, one of the immense pleasures of a freewheeling collection like the Chase's, whose more than nine thousand holdings, as of this anniversary year, come from such diverse times and places, that we are obliged to realize again and again that however singular a work of art may be, it exists in a constantly changing relationship with not only other works of art but with the changing experiences of the world we live in. It is probably best here to let a work of art have the last word, in which case, it might well be Jennifer Bartlett's *Graceland Mansions* of 1979 (pp. 300/1). Here the artist is giving us a lesson in the instabilities and infinite variations to which a work of art is subject, offering a quintet of related but subtly unlike images, as in a series of dictionary definitions that approach, each a bit differently, the abstraction of the word being defined. The nominal subject, a house, has been reduced to a Monopoly-set abstraction of a cube with four gables set in a landscape. But each of the five views of the house is taken from a slighly different angle and casts different shadows on the ground. Moreover, each of the five houses is executed in a different print medium—drypoint, aquatint, silkscreen, woodcut, lithograph—and each is subject to different textural variations, which range from minuscule regularity to ragged scribbles. Without words, Bartlett manages to tell us eloquently that a work of art is part of a network of endless possibilities. As we change, art changes; and though we may now stop to enjoy and to celebrate the view provided by twenty-five years of the Chase collection, we may be sure that not only future acquisitions but future spectators will alter drastically what we see.

Plates: 1959–68

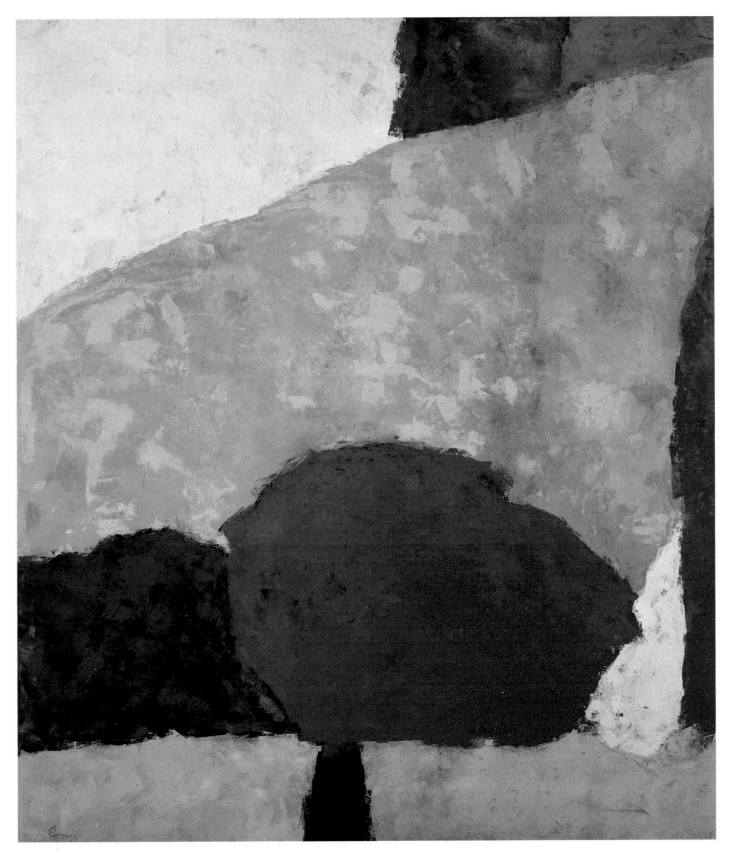

THEODOROS STAMOS
Red Sea Terrace, 1958, oil on canvas, 80 x 70" (203.2 x 177.8 cm.)

JAMES BROOKS
R-1953, 1953, oil on canvas, 82½ x 89" (209.5 x 226 cm.)

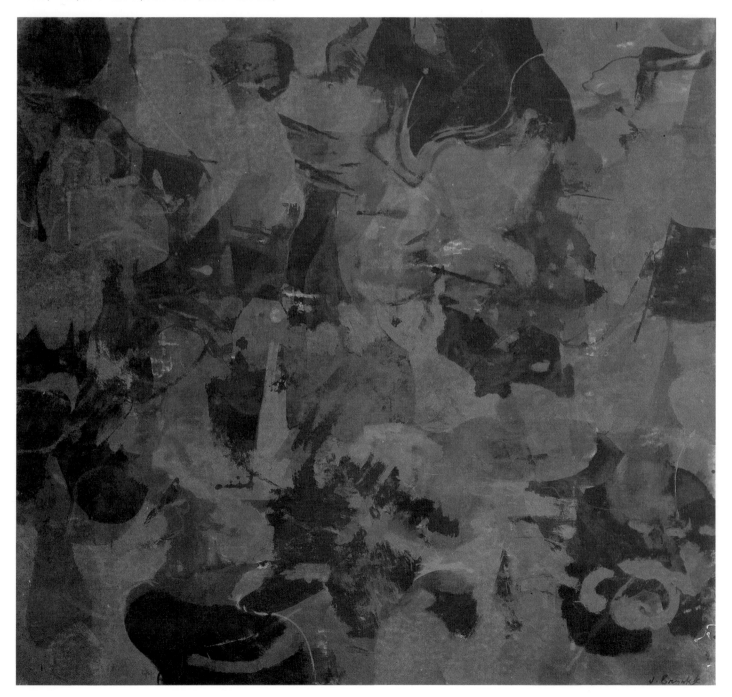

LEON GOLUB
Head XXI, 1959, oil on canvas, 42 x 52" (106 x 132 cm.)

63

JOSEF ALBERS
Homage to the Square in Late Day, 1959, oil on masonite, 40 x 40″ (101.6 x 101.6 cm.)

JACK YOUNGERMAN
Black Red, 1959, oil on canvas, 70 x 100″ (177.8 x 254 cm.)

MILTON AVERY
Sandbar, 1959, oil on canvas, 34 x 60" (86.4 x 152.4 cm.)

WALTER MURCH
Carburetor, 1957, oil on canvas, 32½ x 27½″ (82.5 x 69.8 cm.)

FRITZ GLARNER
Relational Painting, Tondo #46, 1957, oil on masonite, 45½" (115 cm.) diameter

A N O N . African/Ivory Coast
Senufo firespitter mask, 19th century, carved and polychromed wood, 40 x 15" (101.6 x 38.1 cm.)

A N O N . Peruvian/Chancay
Female figure ("Cochimilco"), c. A.D. 600, unglazed clay, 27 x 14" (68.6 x 35.6 cm.)

LARRY RIVERS
Me III, 1959, oil on canvas, 58 x 52" (147 x 132 cm.)

JOHN FREDERICK PETO
Forgotten Friends, c. 1890, oil on canvas, 15⅞ x 10⅛" (40.3 x 25.7 cm.)

CONRAD MARCA-RELLI
Runaway #5, 1959, oil on canvas with collage, 55 x 67" (139 x 170 cm.)

JOAN MITCHELL
Slate, 1959, oil on canvas, 78 x 74" (198 x 188 cm.)

M. E. BLACKMAN
Penmanship exercise, 1902, ink on paper, 23 x 32" (58.4 x 81.3 cm.)

A N O N. American
Sea bass trade sign, 19th century, mixed metals, 36 x 66 x 16″ (91.4 x 167.6 x 40.6 cm.)

3/35

JASPER JOHNS
0 Through 9, 1960, lithograph, ³/₃₅, 27 x 20½" (68.6 x 52 cm.)

PAUL DELVAUX
Le Dernier Voyage, 1959, oil on masonite, 48 x 72" (121 x 182 cm.)

ANON. American
Peafowl weathervane, 19th century, metal, 25″ (63.5 cm.) high

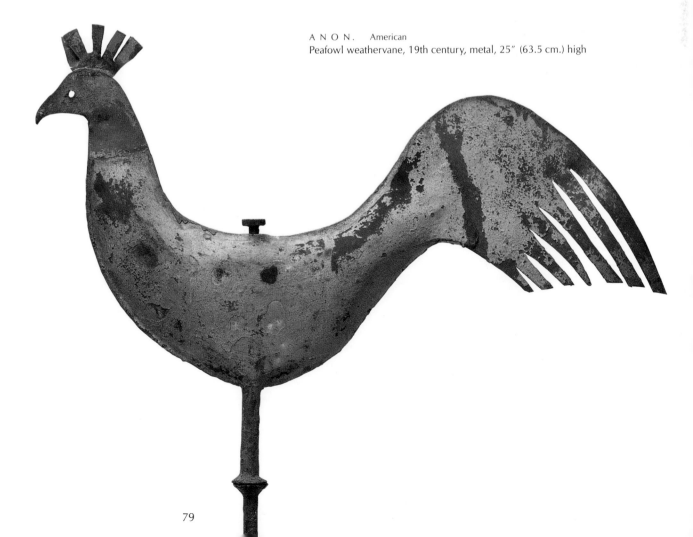

LEONARD BASKIN
Owl, 1960, bronze, 20 x 16 x 16" (50.8 x 40.6 x 40.6 cm.)

MASSIMO CAMPIGLI
Untitled, 1949, oil on canvas, 96⅛ x 405¼″ (244 x 1029 cm.)

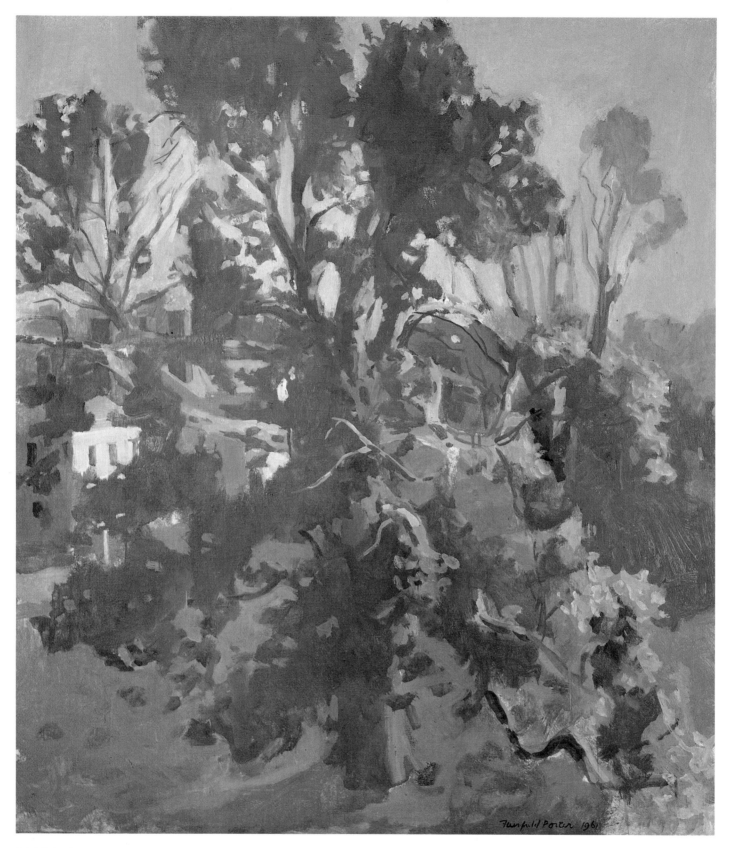

FAIRFIELD PORTER
The Sycamore in September, 1961, oil on canvas, 45 x 40" (114.3 x 101.6 cm.)

MARINO MARINI
The Juggler, 1951, bronze, ⅓, 59″ (150 cm.) high

JOSEPH CORNELL
The Owl, 1964, collage, 13½ x 10½" (34.3 x 26.7 cm.)

RICHARD LABARRE GOODWIN
Trout, Reel and Net, n.d., oil on canvas, 35 x 25″ (88.9 x 63.5 cm.)

ROBERT DASH
Long Island Farmhouse, 1963, oil on canvas, 60 x 70" (152.4 x 177.8 cm.)

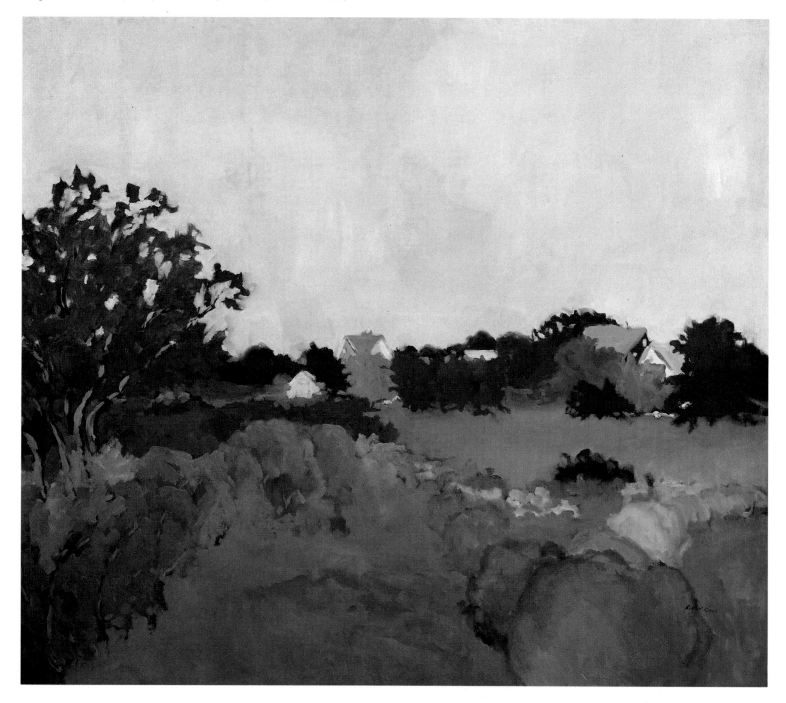

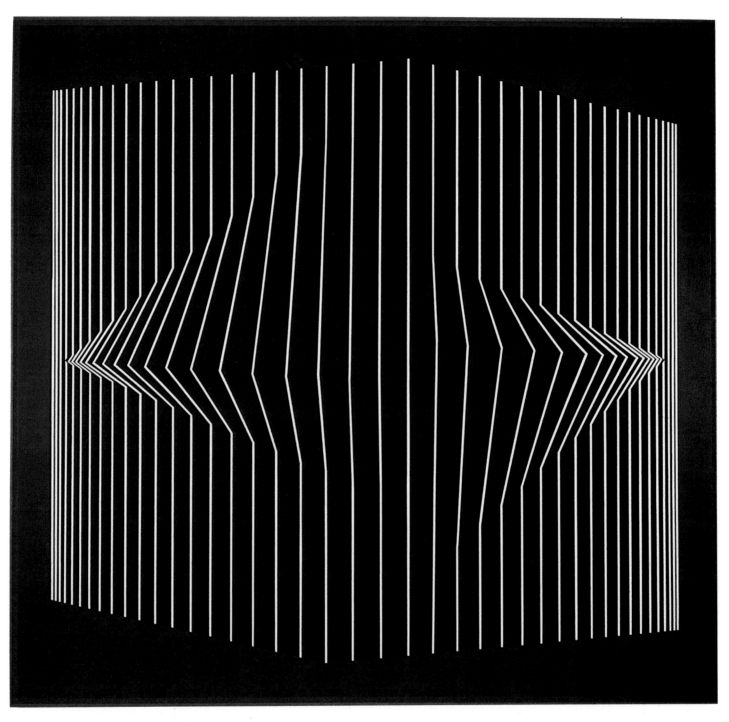

VICTOR VASARELY
Ilile, 1963, oil on canvas, 63 x 67" (160 x 170 cm.)

LUDWIG SANDER
Untitled, 1964, oil on canvas, 60 x 54" (152.4 x 137 cm.)

ROBERT INDIANA
The Marine Works, 1962, mixed media on wood, 72 x 44" (183 x 112 cm.)

YOLANDA MOHALYI
Untitled, n.d., oil on canvas, 59½ x 51½" (151 x 130.8 cm.)

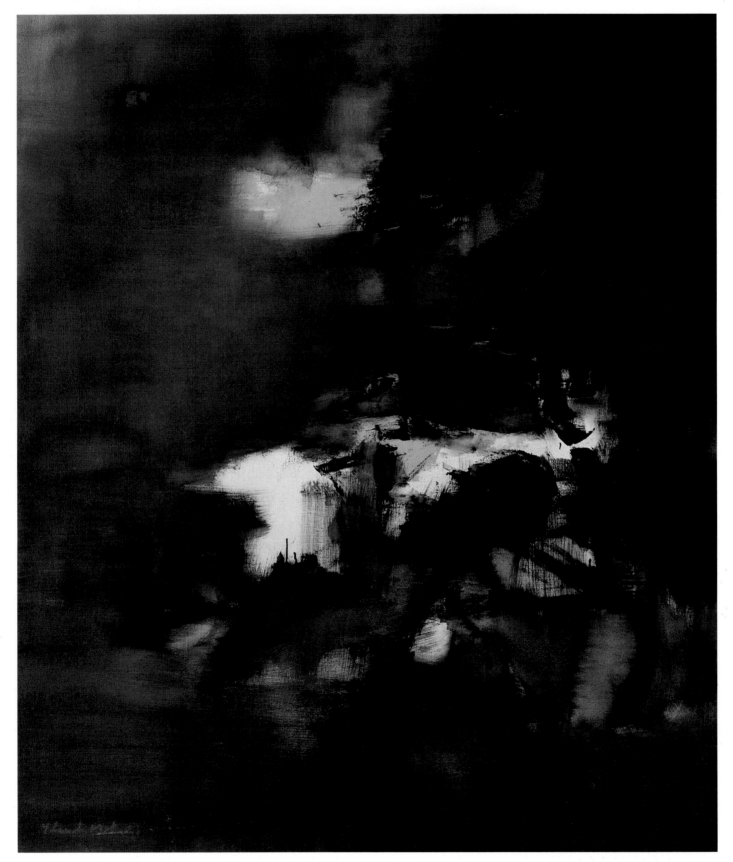

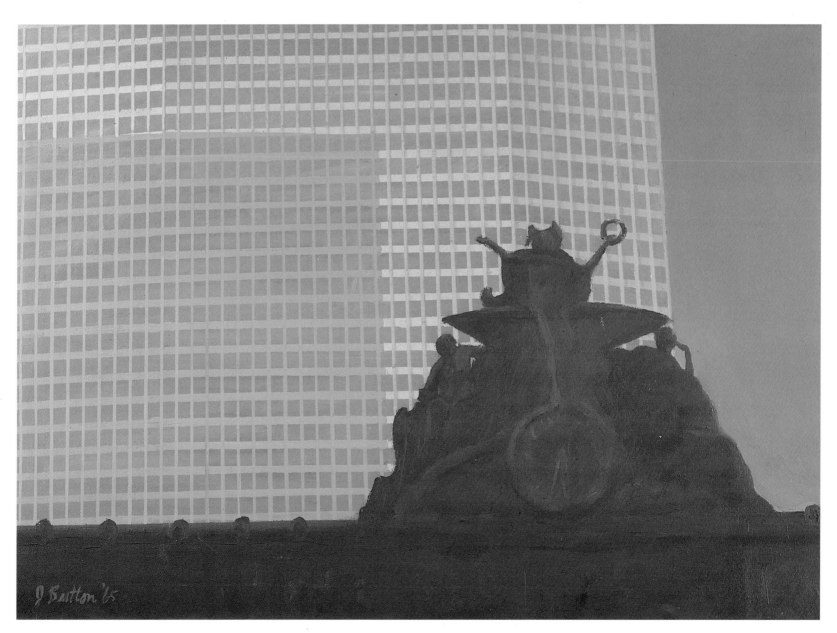

JOHN BUTTON
Grand Central, 1965, oil on canvas, 35½ x 49½" (90 x 125.7 cm.)

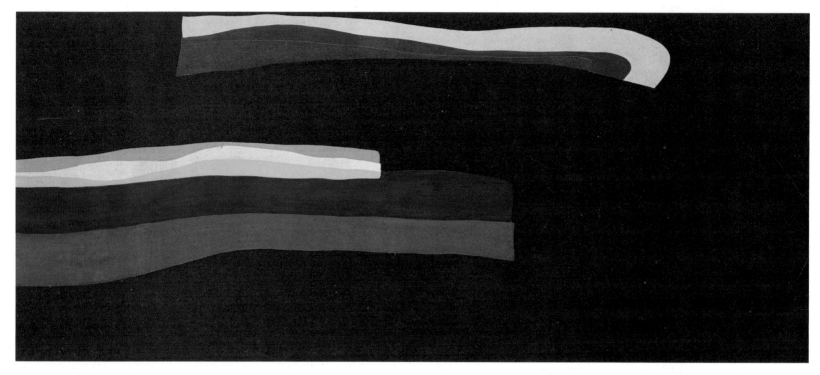

FRIEDEL DZUBAS
Hex, 1966, acrylic on canvas, 53 x 102″ (134 x 259 cm.)

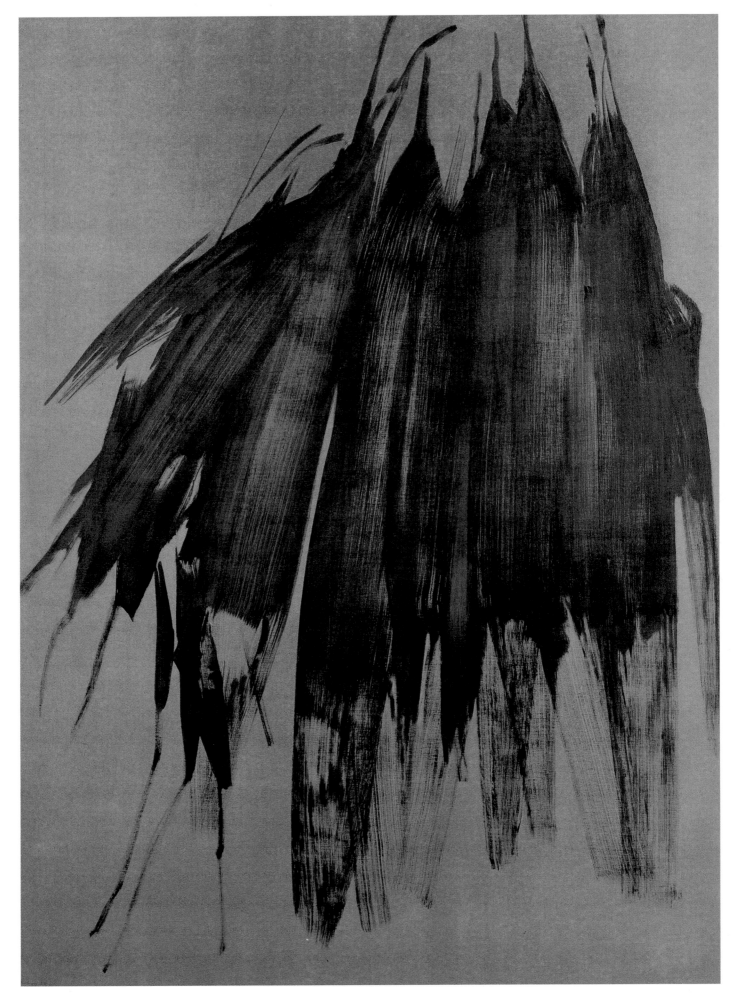

HANS HARTUNG
Composition, 1957, oil on canvas, 64 x 48" (162 x 121 cm.)

CHARLES A. MEURER
Two Dollar Bill, 1893, oil on canvas, 8½ x 15" (21.6 x 38 cm.)

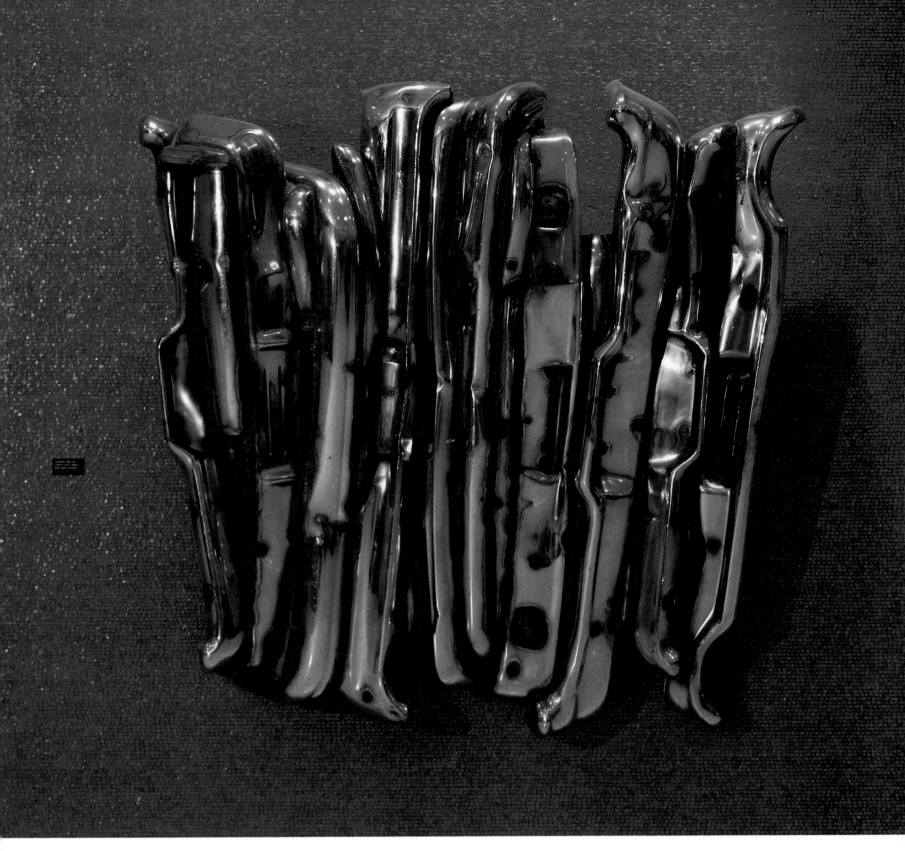

JASON SELEY
Triptych, 1964, welded steel, 78 x 78″ (198 x 198 cm.)

ALAN DAVIE
Study for BP No. 2, 1965, oil on canvas, 72 x 96" (182 x 243 cm.)

LOUISE NEVELSON
Expanding Reflection, 1966, silkscreen on Plexiglas with wood, 76 x 46 x 3" (193 x 117 x 7.6 cm.)

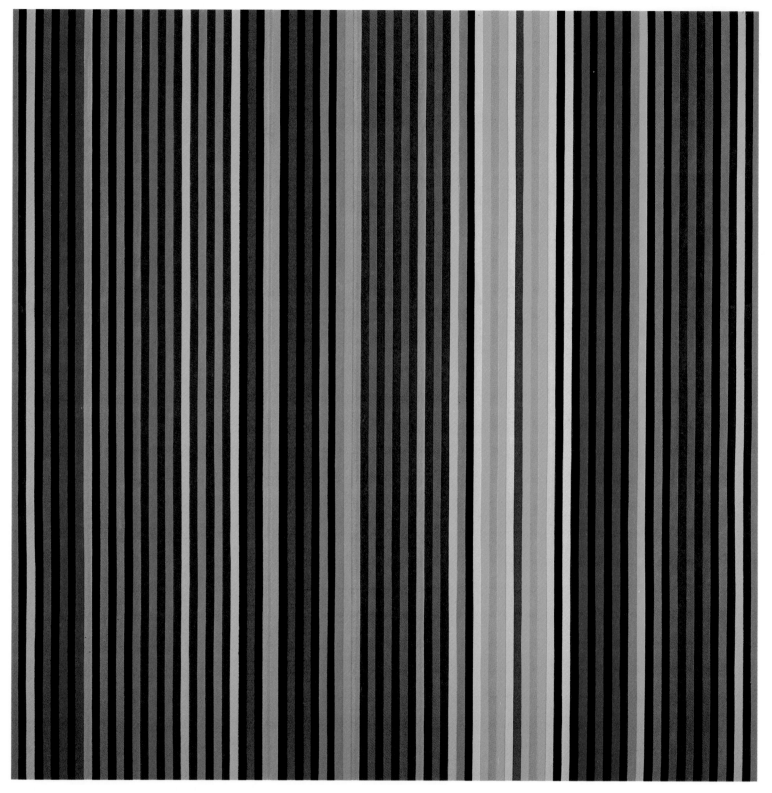

GENE DAVIS
Red Jumper, 1967, magna color on canvas, 93 x 92" (236 x 233 cm.)

ALLAN D'ARCANGELO
Proposition #5, 1966, acrylic on canvas, 72 x 72" (183 x 183 cm.)

BRIDGET RILEY
Deny 1, 1966, emulsion on canvas, 85 x 85" (215.9 x 215.9 cm.)

SAUL STEINBERG
Grand Ratification, 1966, ink on paper, 30 x 40" (76.2 x 101.6 cm.)

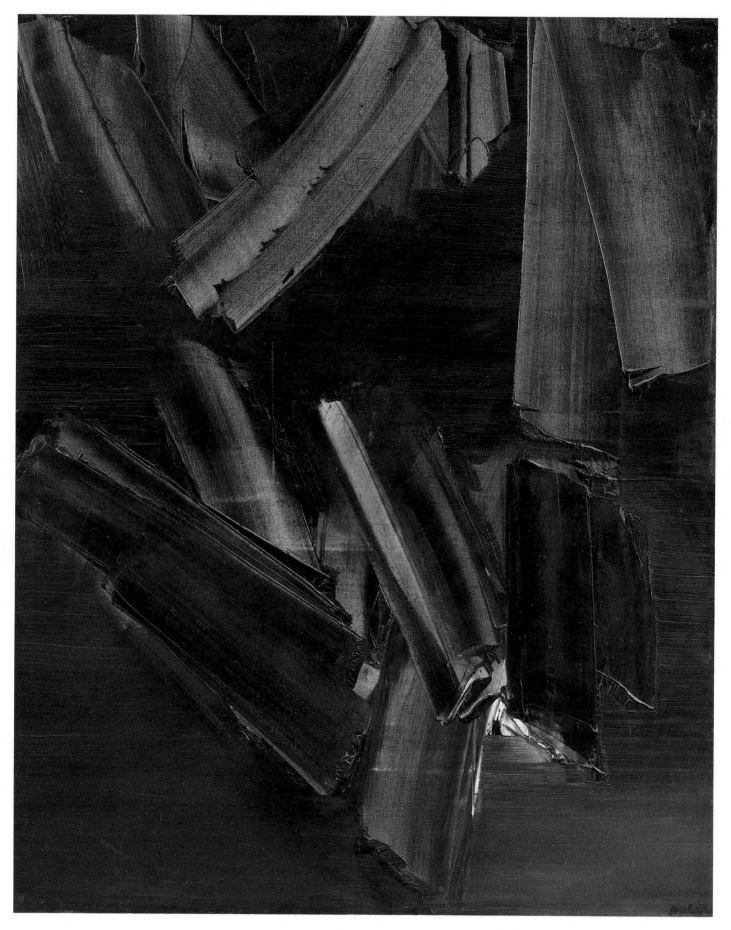

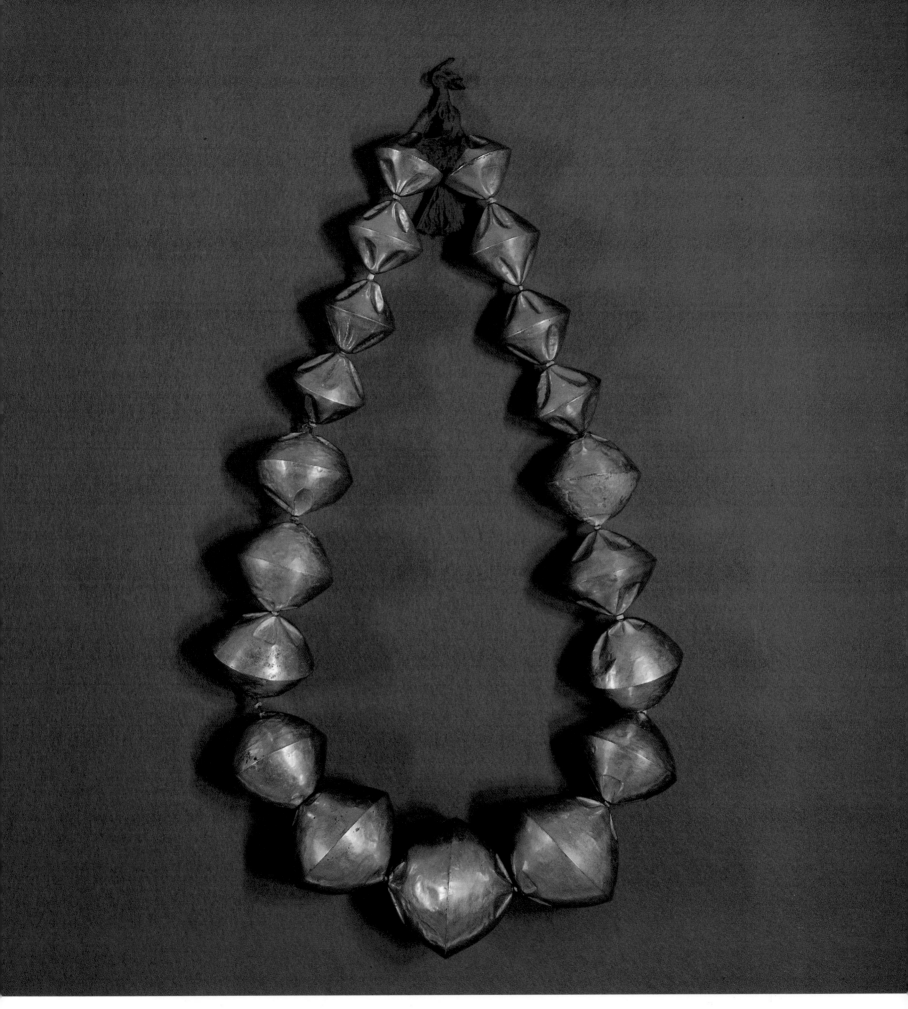

A N O N . Peruvian/Batan Grande, Lambayeque Valley
Ceremonial necklace, c. A.D. 1000–1400, 19 gold beads ranging in diameter from 2¼″ to 3¾″ (5.7 to 9.5 cm.)

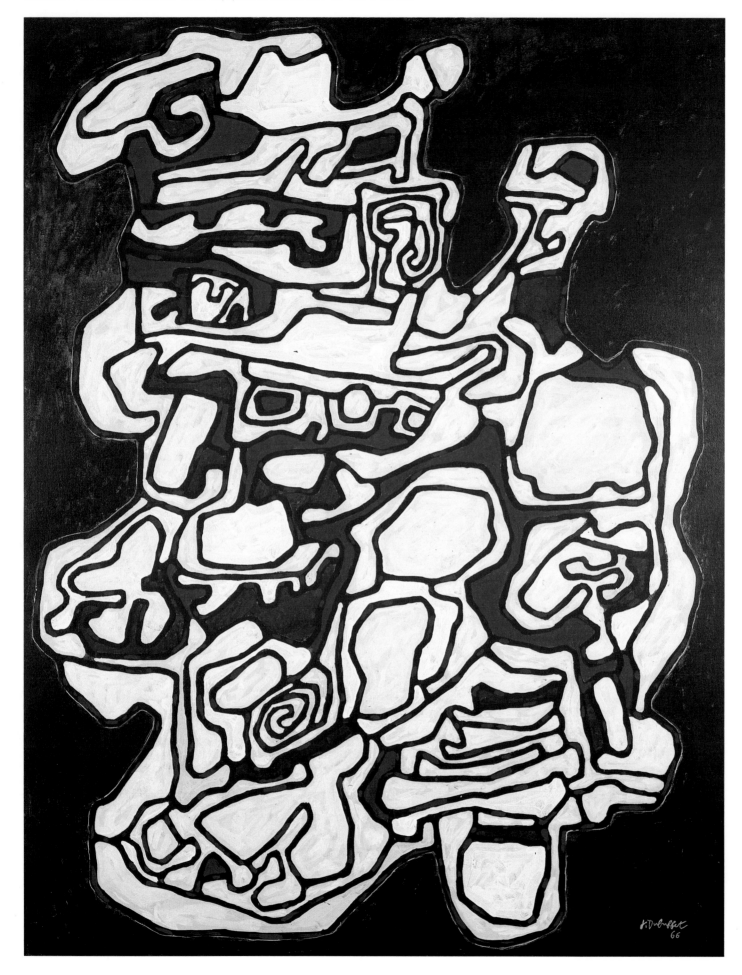

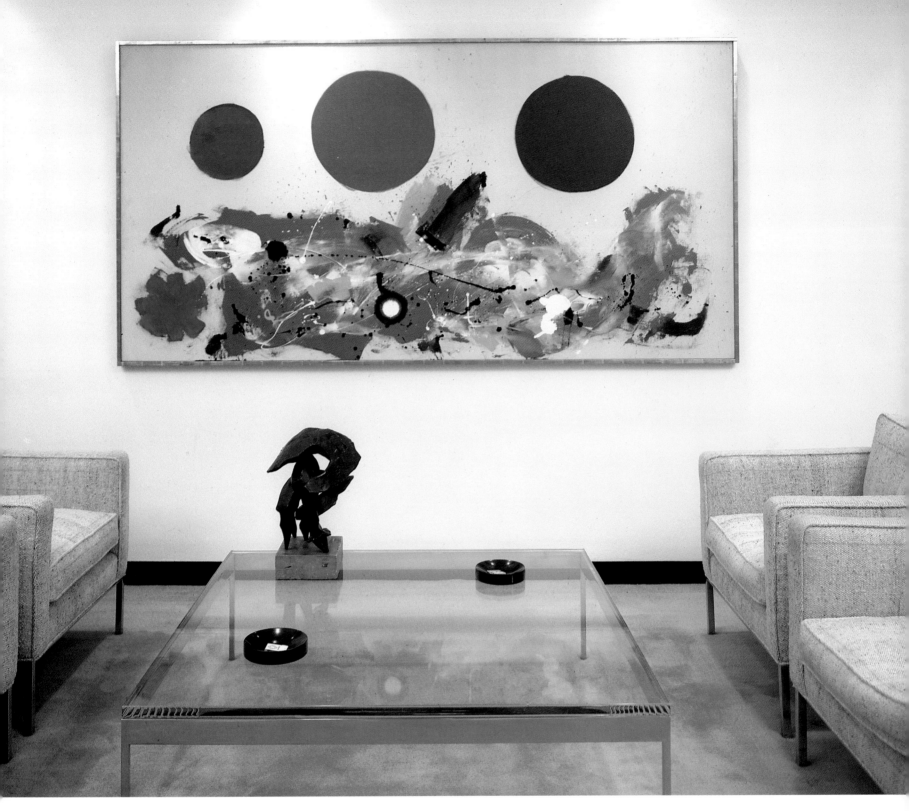

ADOLPH GOTTLIEB
Turbulence, 1964, oil on canvas, 48 x 96" (121 x 243 cm.)

GÜNTER UECKER
Rose, 1968, painted nails on board, 40 x 26″ (101.6 x 66 cm.)

ROMARE BEARDEN
Blue Interior, Morning, 1968, collage, 44 x 56" (112 x 142.2 cm.)

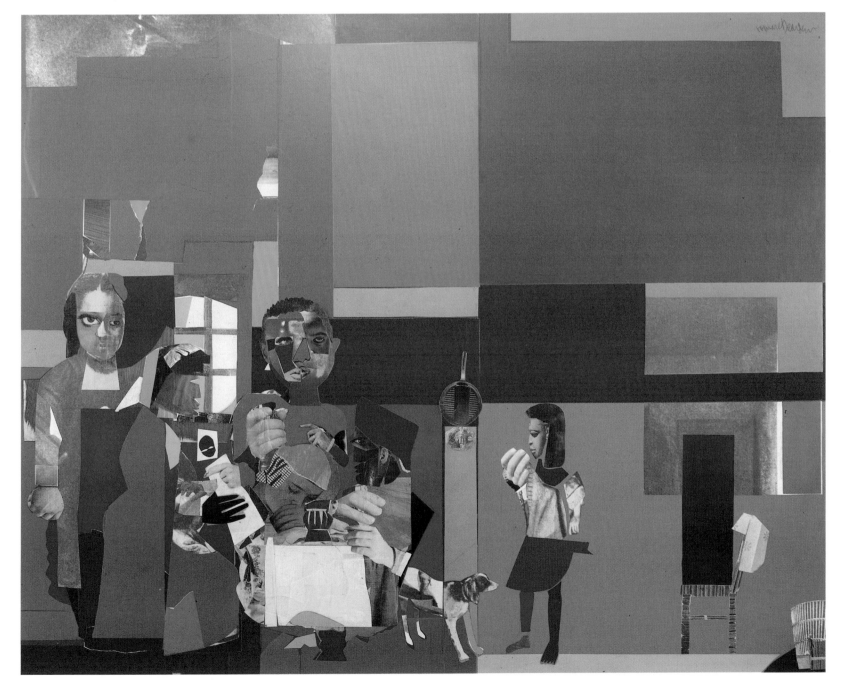

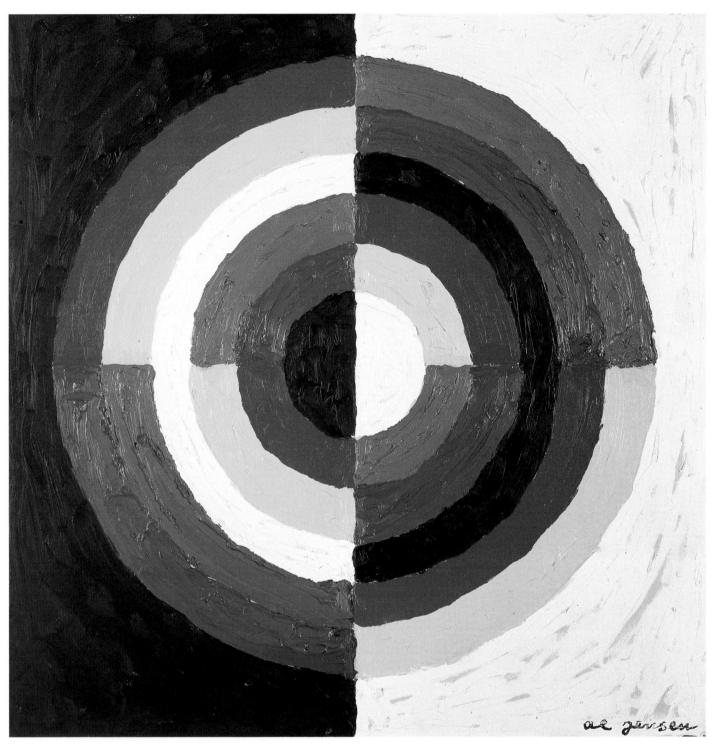

ALFRED JENSEN
Color Wheel, 1959, oil on canvas, 24 x 24" (61 x 61 cm.)

WILL INSLEY
Channel Space Reverse, 1968, pencil on ragboard, 30½ x 30½″ (77.4 x 77.4 cm.)

JACK BUSH
Swoop, c. 1969, acrylic on canvas, 81 x 42" (205.7 x 106.6 cm.)

JIRI KOLAR
Arches, 1967, collage, 78½ x 47" (199.3 x 119.3 cm.)

ILYA BOLOTOWSKY
Black and Red Vertical, 1967, oil on canvas, 70 x 50" (177.8 x 127 cm.)

SAM GILLIAM
Bow Form 1, 1970, acrylic and alum on canvas, 62 x 78" (157.4 x 198 cm.)

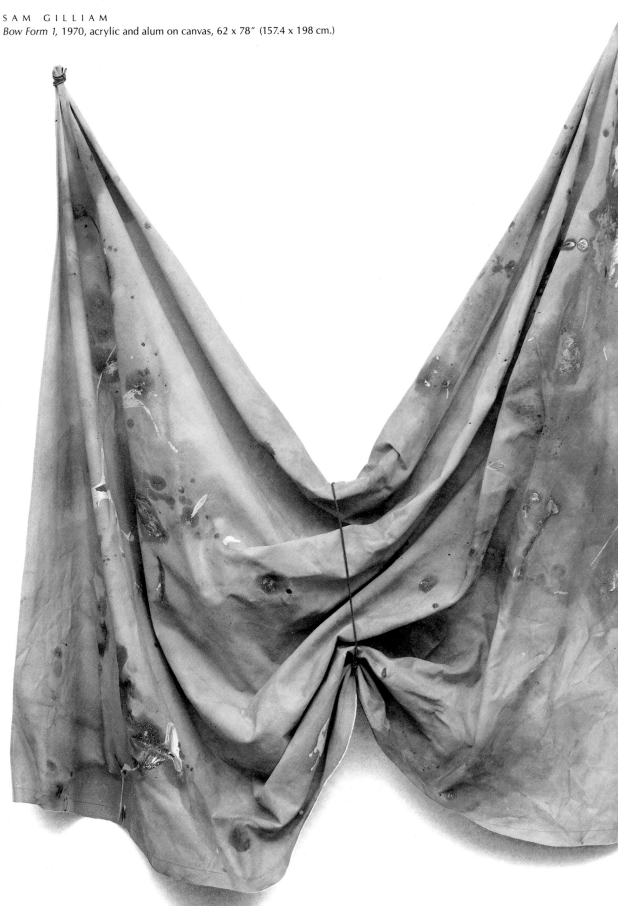

LOWELL NESBITT
Robert Indiana's Studio, 1968, oil on canvas, 45 x 45" (114.3 x 114.3 cm.)

ANTONI TAPIES
Three Orange Stroke No. 14, 1969, gouache and crayon on paper, 35 x 26" (89 x 66 cm.)

TOM PHILLIPS
Grosse Farbenverzeichnis (Das), 1970, acrylic on canvas, 17 x 77" (43 x 195 cm.)

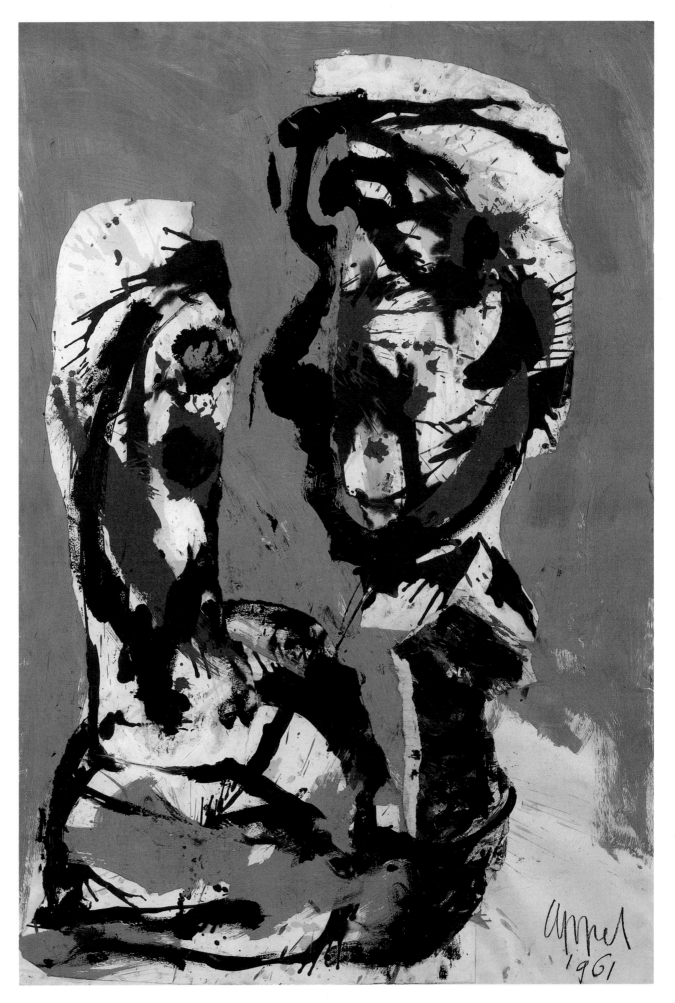

KAREL APPEL
Les Amoureux, 1961, collage on paper, 43 x 29¼" (109 x 74.3 cm.)

RICHARD STANKIEWICZ
Australia No. 13, 1969, steel, 84 x 59 x 34" (213.4 x 150 x 86.4 cm.)

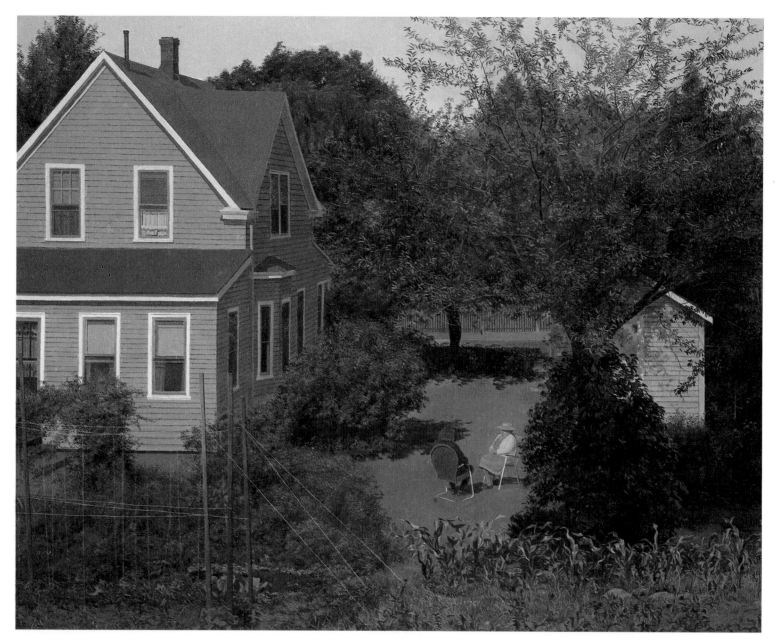

CATHERINE MURPHY
View from the Garden, 1972, oil on canvas, 33¾ x 41″ (85.7 x 104 cm.)

ROBERT NATKIN
Field Mouse, 1970, oil on canvas, 37 x 42" (94 x 106.6 cm.)

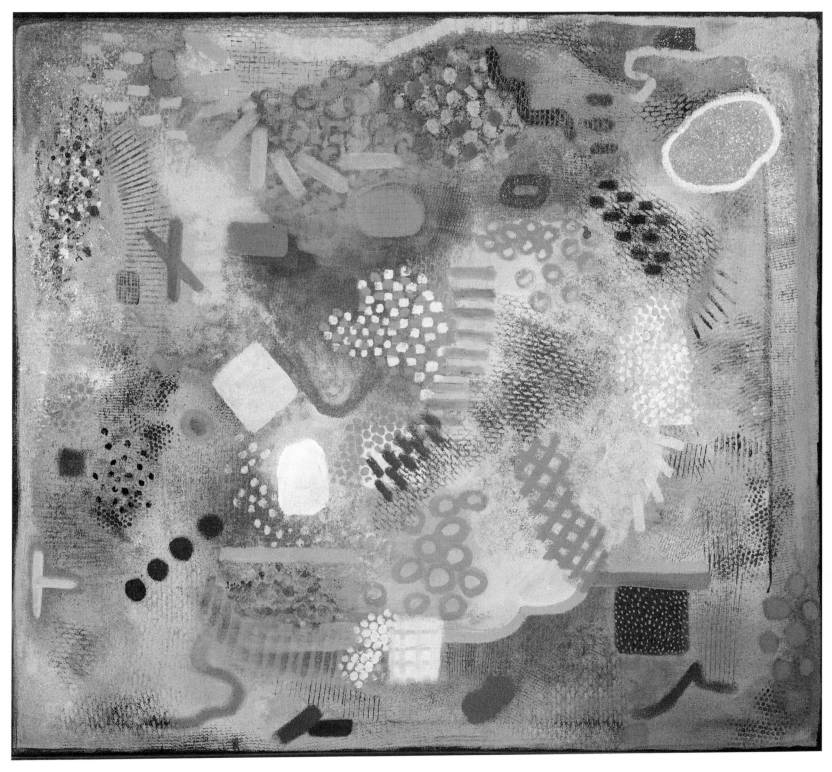

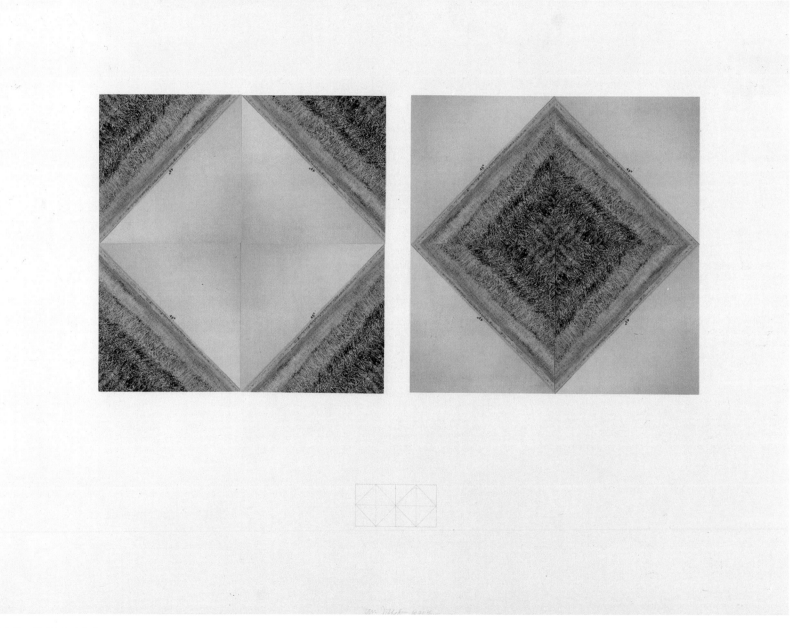

JAN DIBBETS
Untitled, 1973, collage, 2/25, 29½ x 40″ (75 x 101.6 cm.)

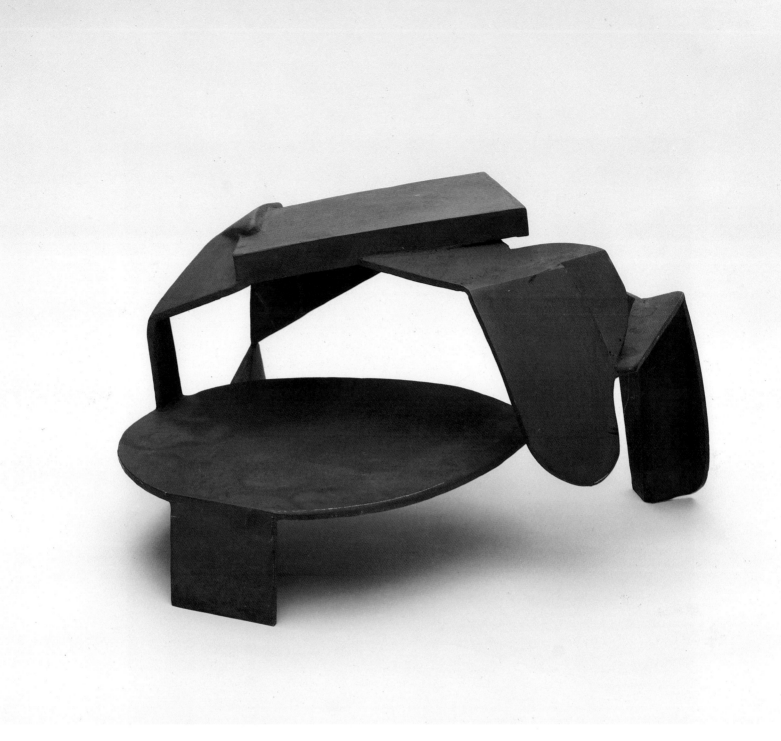

PETER REGINATO
Mix and Mingle, 1973, welded steel, 19¾ x 35½″ (50 x 90 cm.) diameter

HARVEY QUAYTMAN
Jaboticaba Orange Lima, 1973, acrylic on canvas, 86½ x 86½" (219.7 x 219.7 cm.)

CHARLES HINMAN
All Four Burners, 1973, acrylic on canvas, 59 x 95 x 6½" (150 x 241.3 x 16.5 cm.)

HOWARDENA PINDELL
Untitled, 1972, acrylic on canvas, 68 x 68" (172.7 x 172.7 cm.)

PETER DECHAR
Pears 73–5, 1973, oil on canvas, 52½ x 72" (133.3 x 183 cm.)

NEIL WELLIVER
Greir's Bog, 1972, oil on canvas, 60 x 72″ (152.4 x 183 cm.)

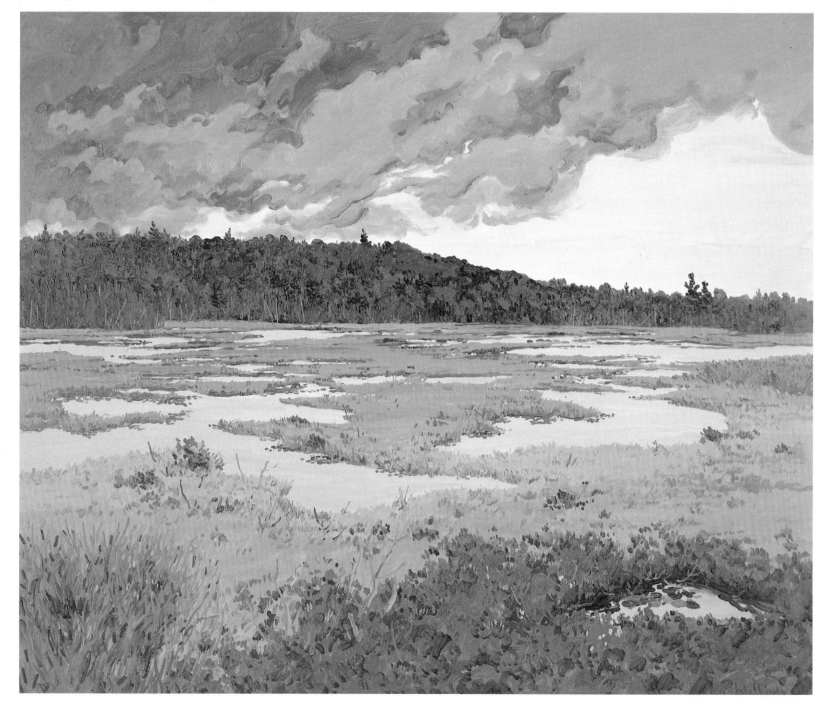

HELEN FRANKENTHALER
Yellow Vapor, 1965, acrylic on raw canvas, 69⅛ x 77¾" (175.5 x 197.4 cm.)

KES ZAPKUS
Study #1, 1972, acrylic on vinyl screen on paper, 23¼ x 36¾" (59 x 93.3 cm.)

EDWIN RUDA
Ohio Blue, 1973, acrylic on canvas, 60 x 96" (152.4 x 244 cm.)

JIM BISHOP
Untitled #1, 1973, oil on canvas, 77 x 77" (195.6 x 195.6 cm.)

JOHN TORREANO
Red Space with Blue Marks and Glass Jewels as Stars, 1973, mixed media, 32 x 32″ (81.3 x 81.3 cm.)

CHUCK FORSMAN
Nebraska School, 1972, oil on board, 30 x 48" (76 x 122 cm.)

TWO CUTS TWO FOLDS INTERRUPTED ARC OVERLAPPED

JAMES REINEKING
Two Cuts Two Folds, Interrupted Arc, Overlapped, 1973, pencil on paper with collage, 21⅞ x 35 (55.5 x 89 cm.)

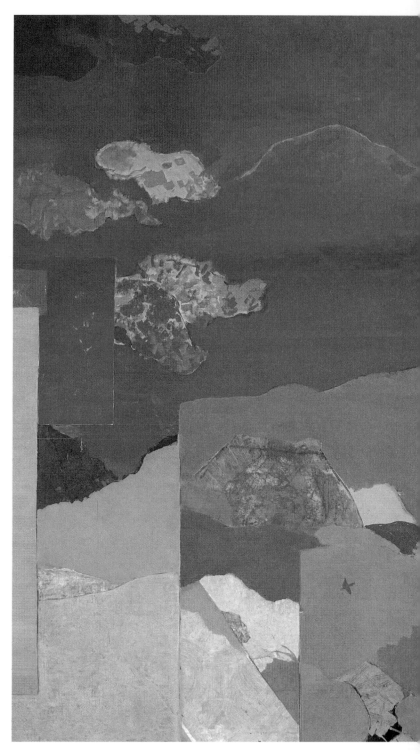

KENZO OKADA
The Seasons, 1974, oil on canvas, each 144 x 84″, (365.7 x 213.3 cm.)

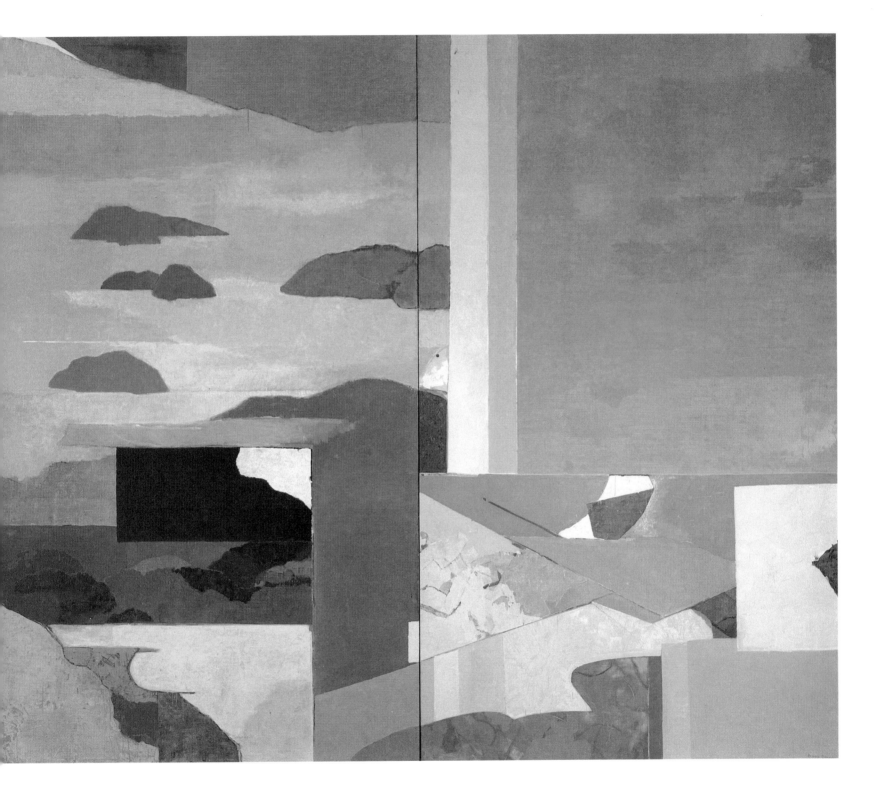

H E N R I C A R T I E R - B R E S S O N
Banks of the Marne, 1935, silver print, 9⅝ x 14⅜" (24.4 x 36.5 cm.)

JACQUES LARTIGUE
The Beach at Villersville, c. 1906, silver print, 12 x 15¾" (30.5 x 40 cm.)

BERENICE ABBOTT
Multi Beams of Light, c. 1960, silver print, 17 x 21¾" (43 x 55.2 cm.)

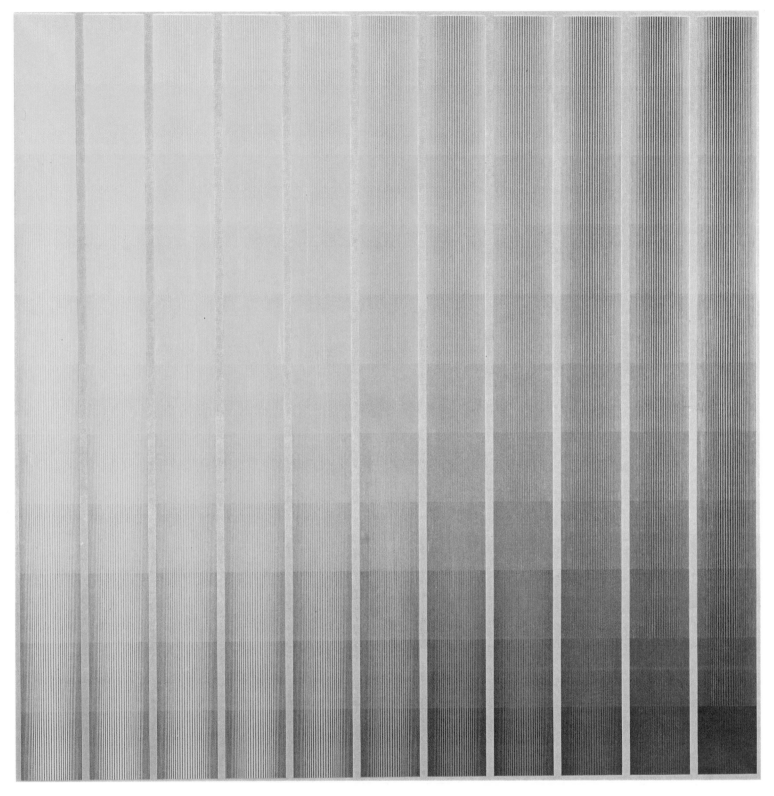

RICHARD ANUSZKIEWICZ
Reddish Yellow, 1969, acrylic on canvas, 60 x 60″ (152.4 x 152.4 cm.)

GARY STEPHEN
Alkahest H, 1973, oil on linen, 72 x 48" (183 x 122 cm.)

NORMAN BLUHM
Untitled, 1960, watercolor, 49 x 41″ (124.4 x 104 cm.)

BRUCE BOICE
Untitled, 1974, acrylic on canvas, 31½ x 91½″ (80 x 232.4 cm.)

A N O N . Korean
Eight peony wedding screen panels, 19th century, watercolor, each 55¾ x 20⅛″ (141.6 x 51.2 cm.)

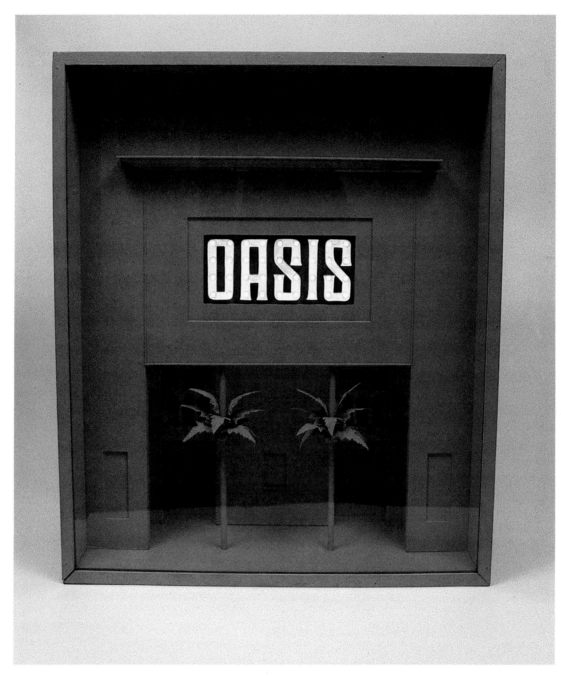

CLETUS JOHNSON
Oasis, 1974, mixed media, 29½ x 25 x 11½" (75 x 63.5 x 29 cm.)

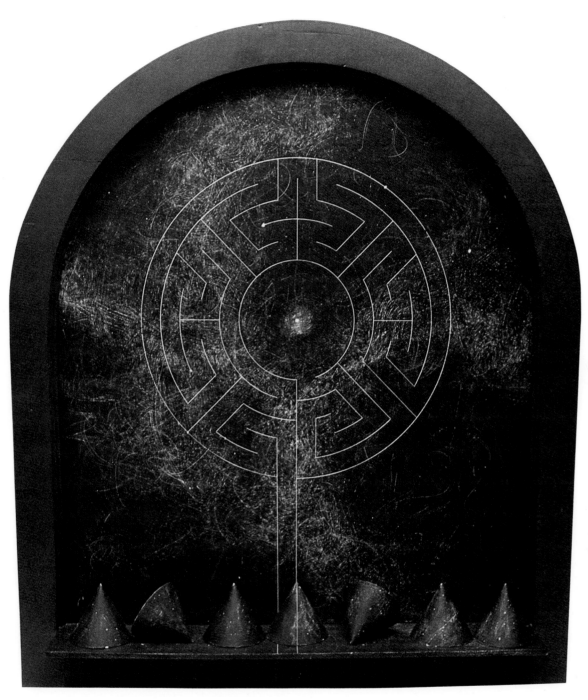

JOHN WILLENBECHER
Cenotaph, 1974, mixed media, 34 x 29¼ x 4½" (86 x 74 x 11.4 cm.)

ADJA YUNKERS
Untitled, 1960, pastel on paper, 45 x 31" (114.3 x 78.7 cm.)

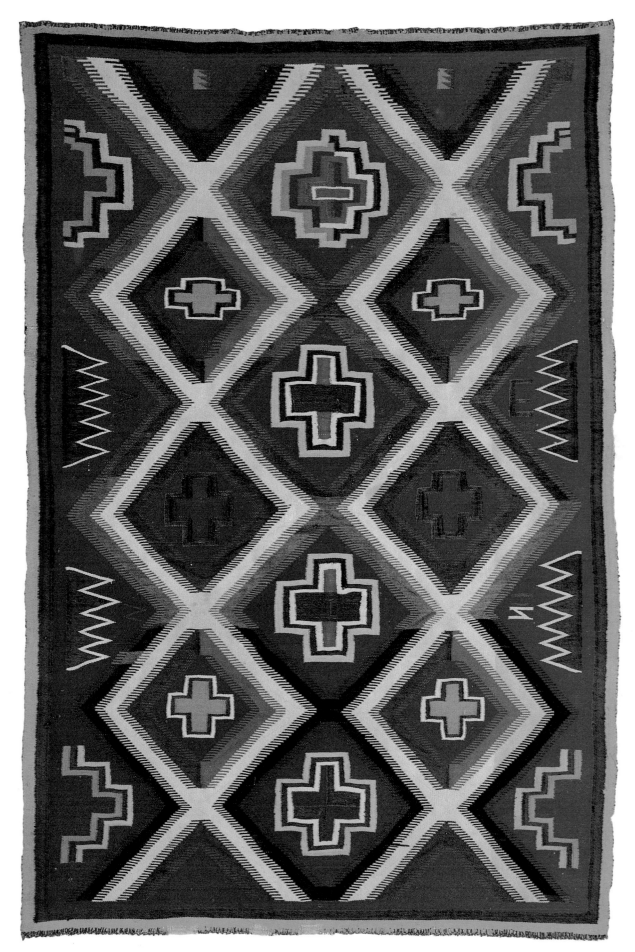

A N O N . American Indian/Navajo
Germantown Red child's blanket, c. 1880, wool, 59½ x 40″ (151 x 101.6 cm.)

HOWARD BUCHWALD
Untitled, 1974, oil on linen, 81 x 81″ (205.7 x 205.7 cm.)

JACK TWORKOV
P 73 #11, 1973, acrylic on canvas, 34 x 48" (86.4 x 122 cm.)

JOHN MOORE
Still Life with Glass of Tea, 1974, oil on canvas, 36 x 48" (91.4 x 122 cm.)

RON DAVIS
Solid Duet, 1973, acrylic on linen on board, 16 x 42″ (40.6 x 106.6 cm.)

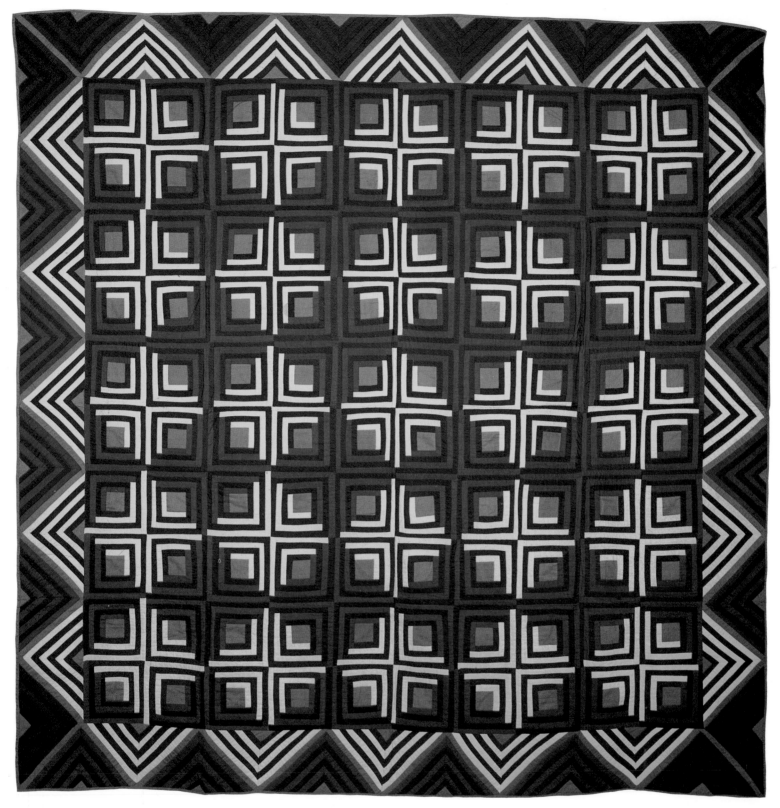

A N O N . American
Light and dark log cabin quilt, Pennsylvania, c. 1885, pieced cotton, 87½ x 87½", (222 x 222 cm.)

ANON. American
Bowtie quilt, Lancaster, Pennsylvania, c. 1920, pieced cotton, 80 x 78¼″ (203 x 198.7 cm.)

RAFAEL FERRER
Celebes, 1974, crayon on navigation chart, 44¼ x 60" (112.4 x 152.4 cm.)

RICHARD HENNESSY
14 June 74, 1974, oil on canvas, 30 x 31" (76.2 x 78.7 cm.)

A N O N . American
Portrait of Ellen Margaret Keyes, c. 1848, oil on canvas, 30 x 25" (76.2 x 63.5 cm.)

DAVID HARE
View from the Cave, 1971, oil and collage on canvas, 48 x 36" (122 x 91.4 cm.)

C H R I S T O
Package/Handtruck, 1973, mixed media with collage, 28 x 22" (71 x 56 cm.)

BIL CPLY
MAN, 1965, ink on paper, 23½ x 18½" (59.6 x 47 cm.)

ROY DeCARAVA
Bill and Son, 1968, silver print, 10½ x 13¼" (26.7 x 33.6 cm.)

A N O N . American
Hog weathervane, c. 1880, copper, 20¾ x 35 x 4½″ (52.7 x 89 x 11.4 cm.)

A N O N . American
Great Blue Heron decoy, 20th century, carved wood, 11 x 41½ x 5½" (28 x 105.4 x 14 cm.)

A N O N . American
Leaping goat carousel figure, c. 1880, carved by the Philadelphia Toboggan Company, Germantown, Pennsylvania, pine with polychrome decoration, 54 x 63 x 18" (137 x 160 x 45.7 cm.)

KATHERINE PORTER
Chile, 1975, oil on canvas, 19 x 18½" (48.2 x 47 cm.)

PAUL MOGENSEN
Untitled, 1974, watercolor, 22¼ x 30" (56.5 x 76 cm.)

ED BAYNARD
Bowls with White Structure, 1975, acrylic on canvas, 50 x 60" (127 x 152.4 cm.)

HUGH KEPETS
Riverside Drive #1 & #2, 1975, acrylic on canvas,
each 23⅞ x 23⅞" (60.6 x 60.6 cm.)

JACK WHITTEN
Alpha Group III, 1975, acrylic on canvas, 42 x 42″ (106.7 x 106.7 cm.)

JOE BREIDEL
Water Level, 1975, type C print, 16 x 20" (40.6 x 51 cm.)

JOE BREIDEL
Water Tilt #2, 1975, type C print, 16 x 20" (40.6 x 51 cm.)

JAN GROOVER
Untitled, 1976, 3 type C prints, each 14⅝ x 14⅜" (37.1 x 36.5 cm.)

RACKSTRAW DOWNES
Oxen and Draft Horses, 1974, oil on canvas, 13 x 46½" (33 x 118 cm.)

DON NICE
Wolf, 1976, watercolor, 53½ x 59″, (136 x 150 cm.)

WALTER HATKE
Interior with Light, 1974, oil on canvas, 48½ x 60½″ (123 x 153.6 cm.)

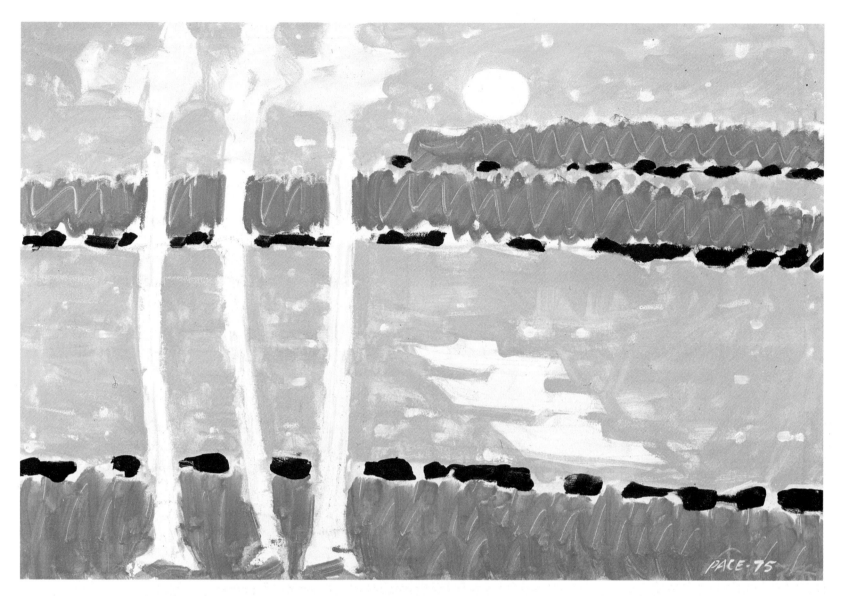

STEPHEN PACE
Maine Coast, #3, 1975, oil on canvas, 26 x 38", (66 x 96.5 cm.)

ARCHIE GILBERT
Two deer, c. 1940, carved and painted wood, each approx. 61 x 65 x 14" (155 x 165.1 x 35.5 cm.)

RALPH GIBSON
Untitled, 1975, gelatin silver print, ³/₂₅, 18 x 12″ (45.7 x 30.5 cm.)

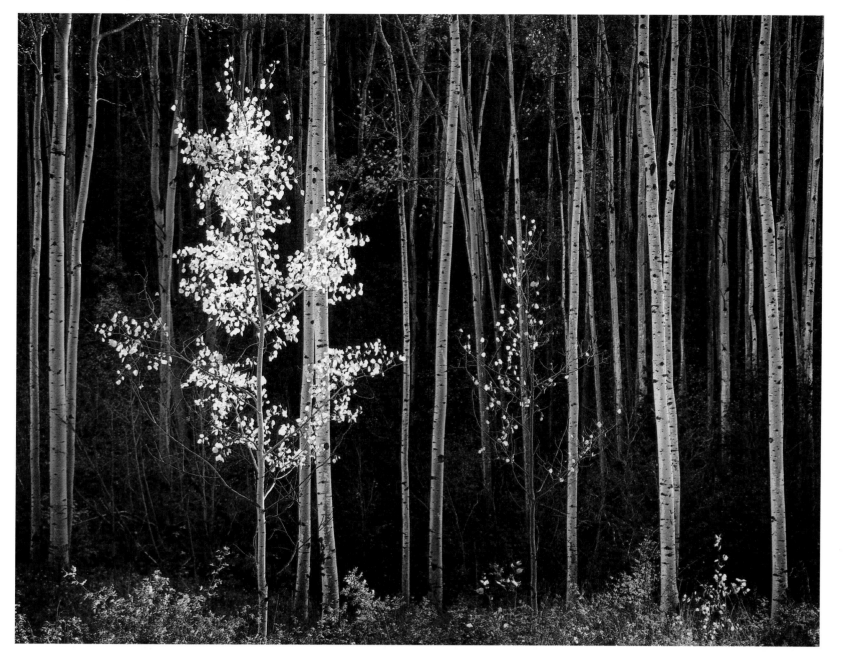

ANSEL ADAMS
Aspens, Northern New Mexico, 1958, silver print, 77/115, 17⅞ x 22¾″ (45.4 x 57.8 cm.)

SUSAN ROTHENBERG
Untitled, 1976, pencil on paper, 26½ x 36" (67.3 x 91.4 cm.)

BEN SCHONZEIT
Parrot Tulip, 1976, acrylic on canvas, 60 x 72" (152.4 x 183 cm.)

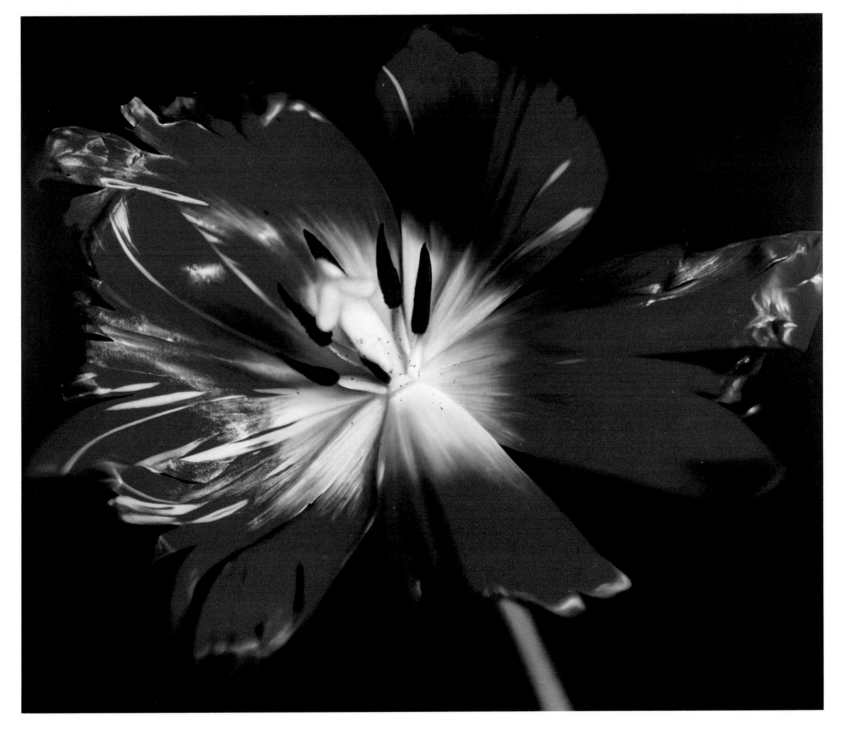

ARLENE SLAVIN
Prism I, 1976, acrylic on canvas, 48 x 72" (122 x 183 cm.)

MICHAEL SINGER
Ritual Series 1/13/75, 1975, collage, 43 x 36" (109.2 x 91.4 cm.)

JOSEPH RAFFAEL
Two Goldfish, 1977, watercolor, 35 x 45" (89 x 114.3 cm.)

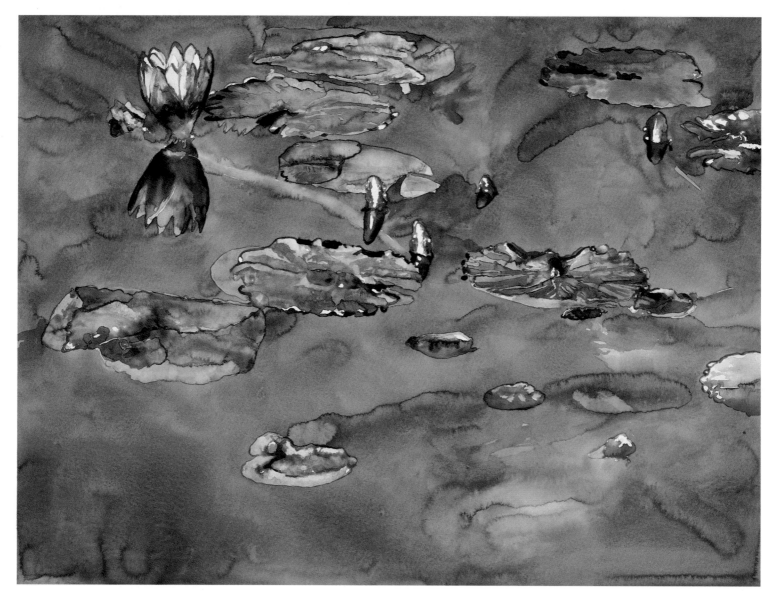

NEAL SLAVIN
Statue of Liberty, 1976, type C print, 19¾ x 15⅞″ (50 x 40.3 cm.)

RED GROOMS
Gertrude, 1975, assembled lithograph, 22/46, 19¼ x 22 x 10½" (49 x 5 x 26.6 cm.)

ANON. American
Eagle weathervane, c. 1880, copper, 73¾ x 50½ x 49½" (187 x 128 x 125.7 cm.)

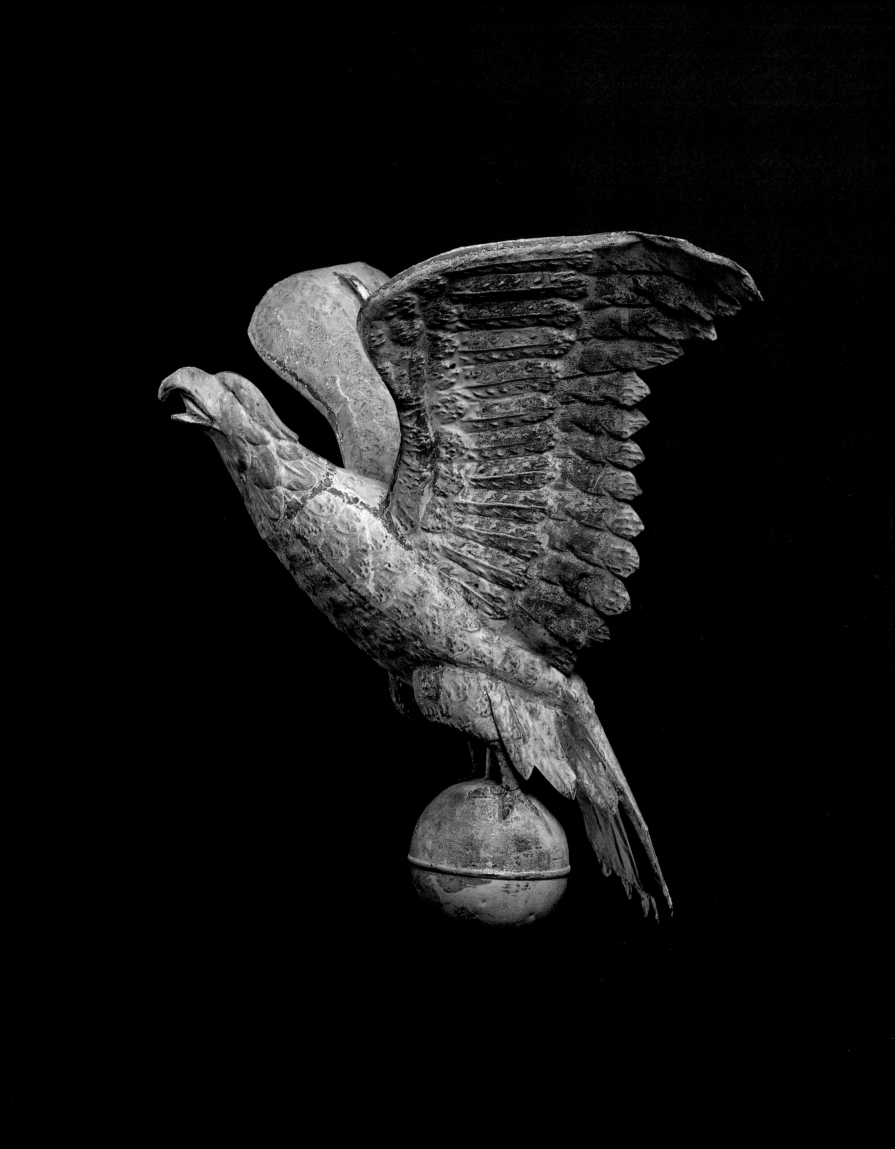

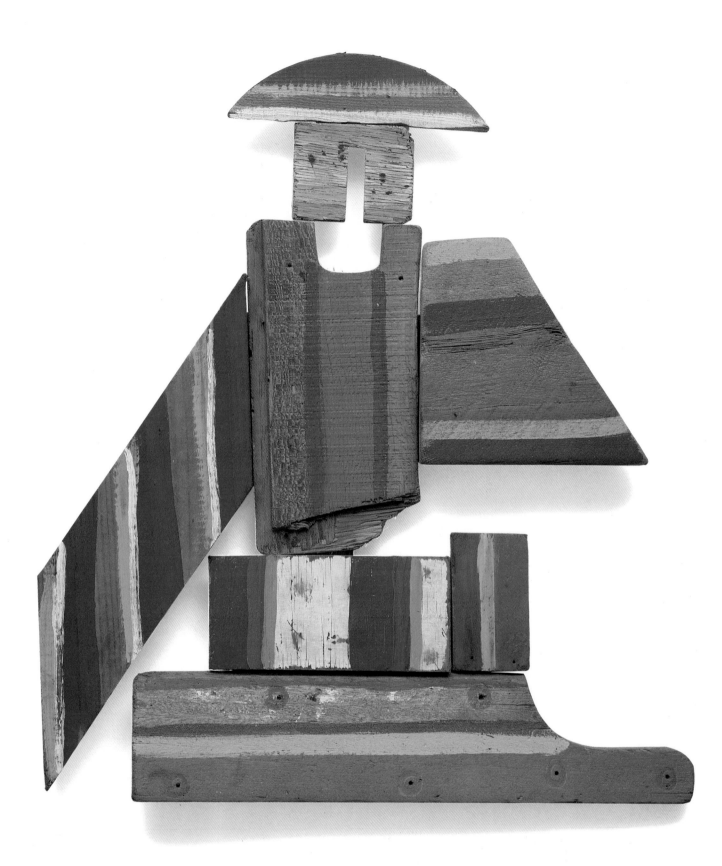

BETTY PARSONS
Chief, 1978, painted wood construction, 30 x 27" (76 x 68.5 cm.)

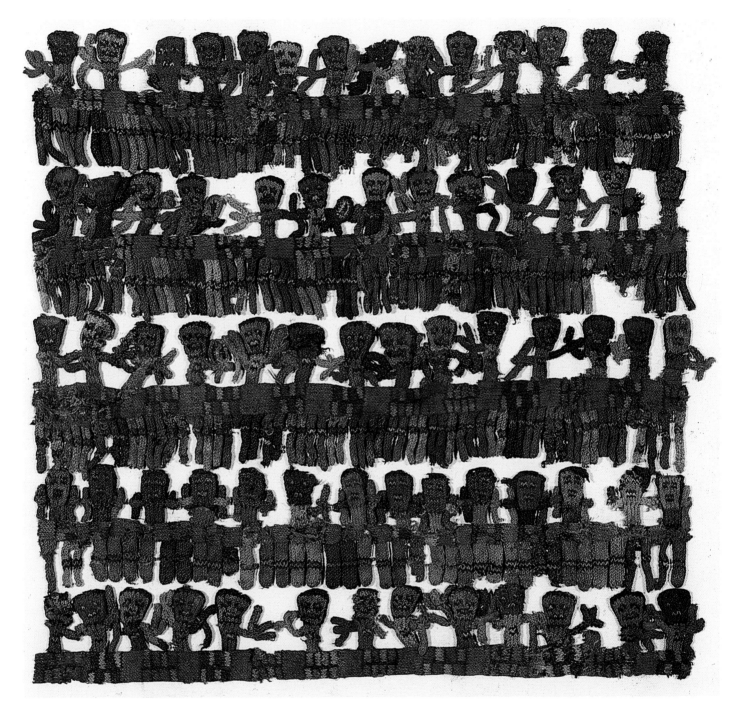

A N O N . Peruvian/Nasca
Textile, c. A.D. 400, cotton tubes, 15 x 14½″ (38 x 36.8 cm.)

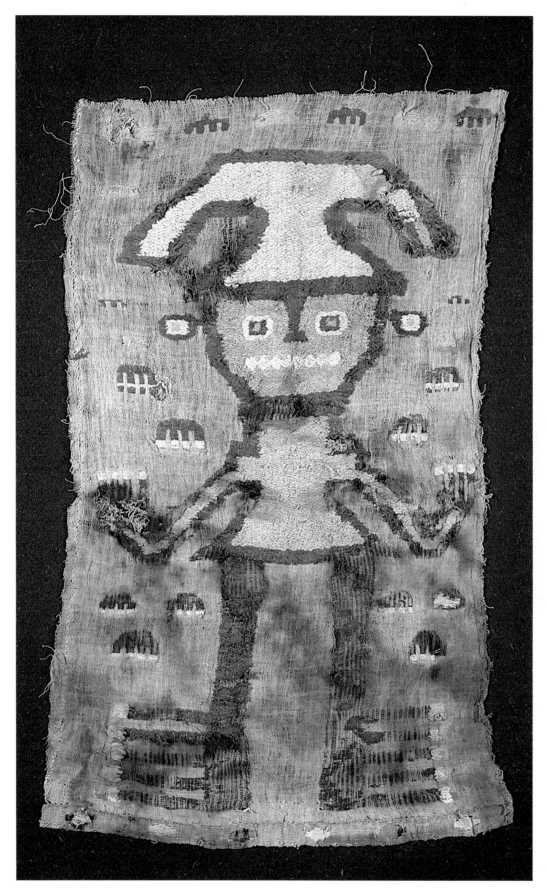

A N O N . Peruvian/Chimu
Textile, c. 1400, wool, 28 x 18" (71 x 45.7 cm.)

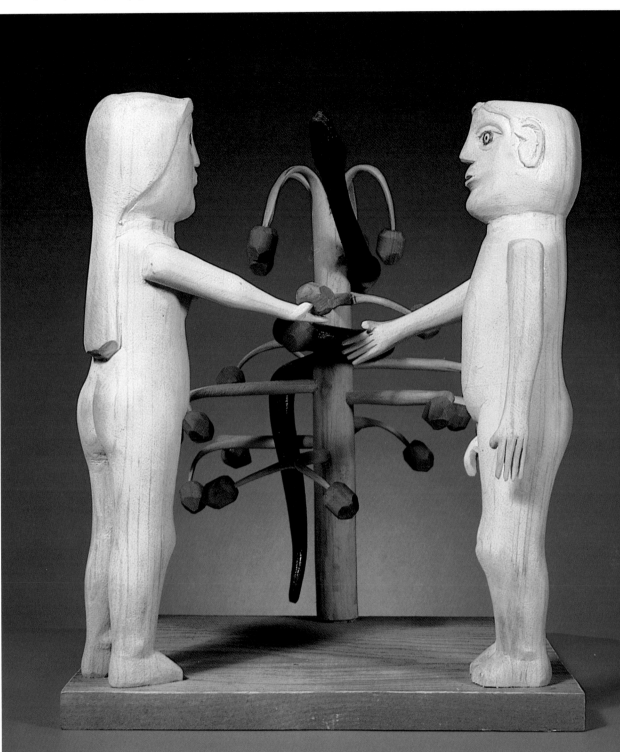

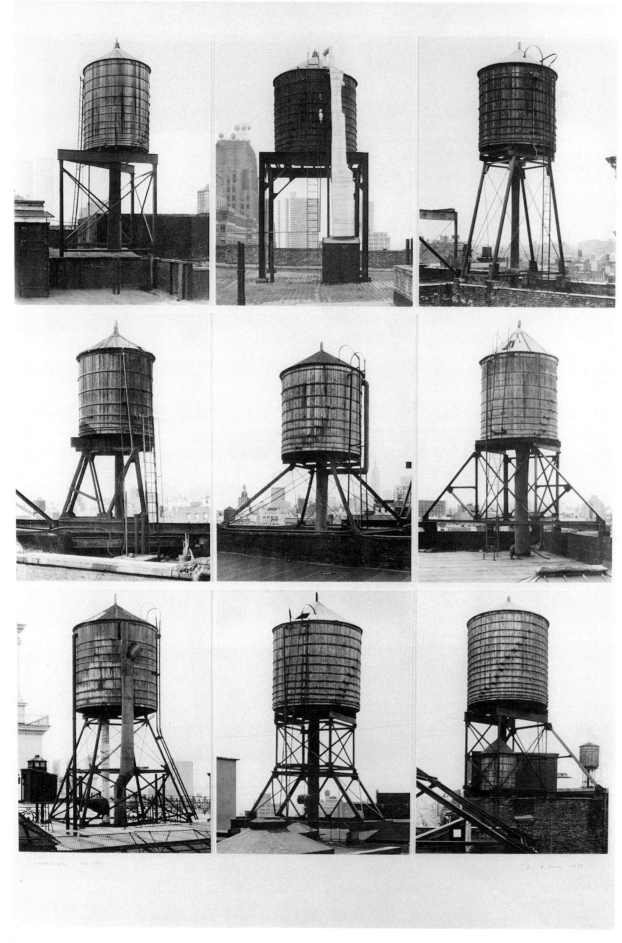

BERND & HILLA BECHER
Watertowers, New York City, 1978, 9 silver prints, 56 x 40" (142.2 x 101.6 cm.) overall

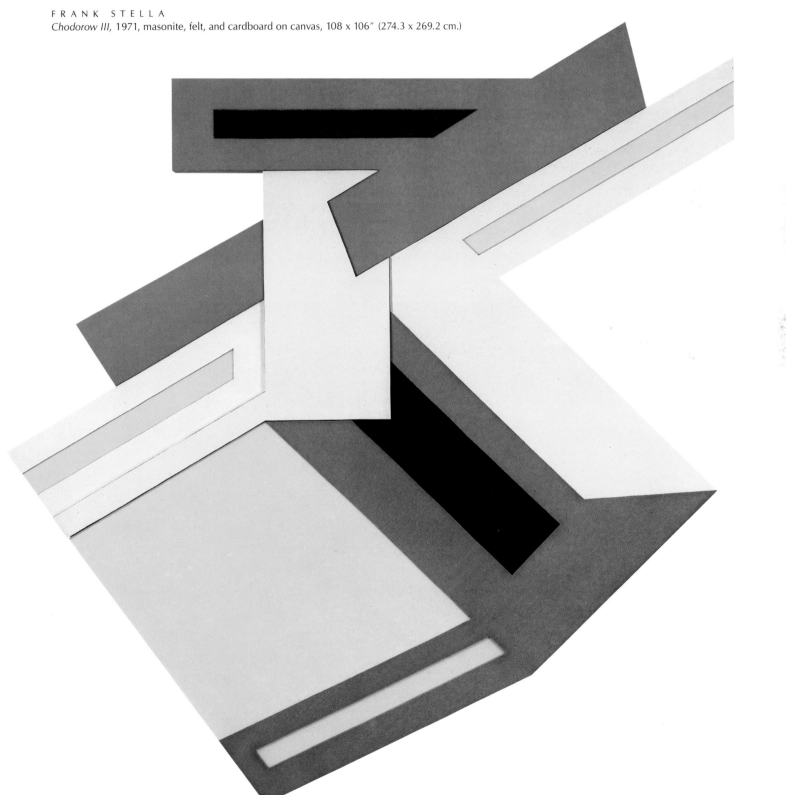

JOHN CAGE
49 Waltzes for 5 Boroughs, 1977, color pen on paper, 48 x 35½" (122 x 90 cm.)

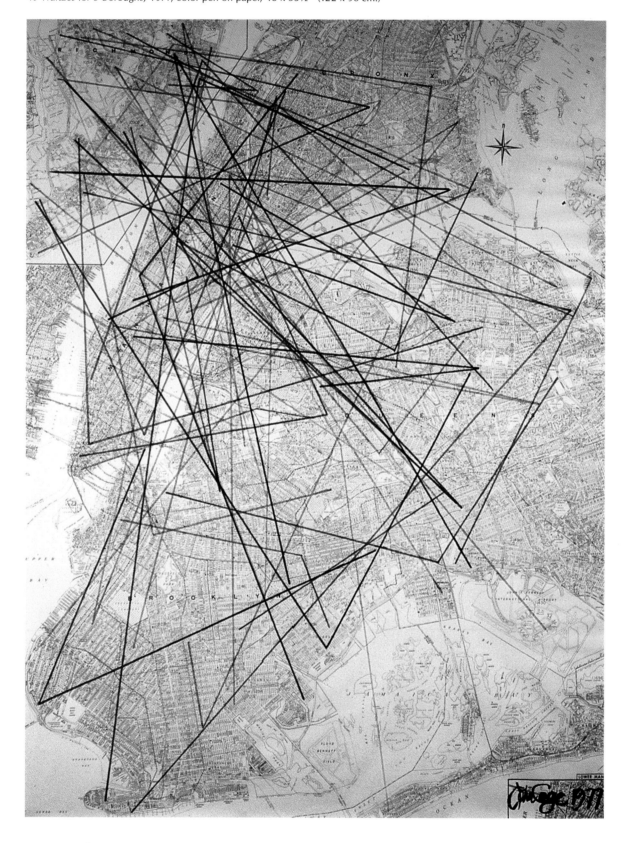

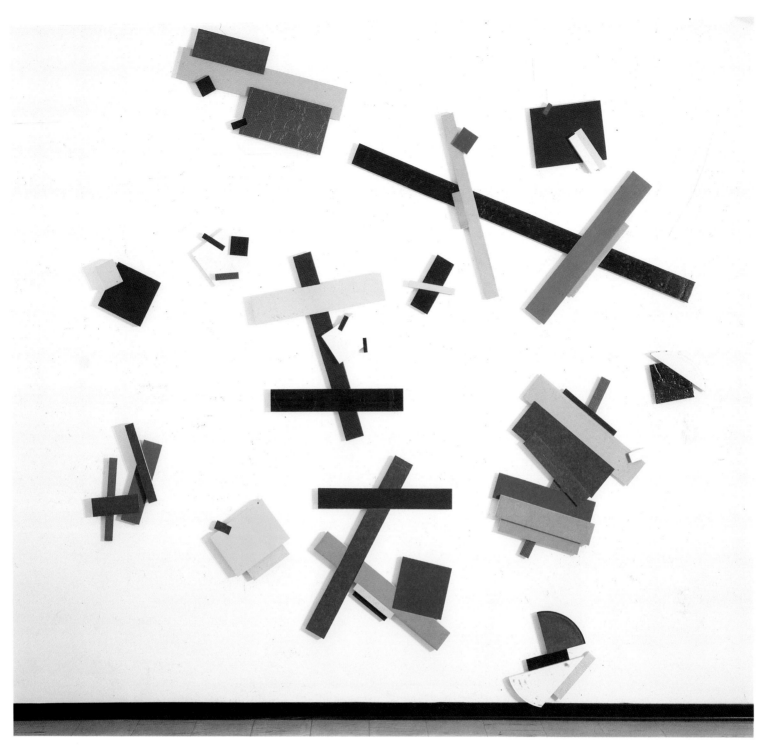

TOM HOLSTE
Number 1, 1979, 13 piece assemblage, cast Rhoplex on plywood, 105½" x 96½" (270 x 245 cm.)

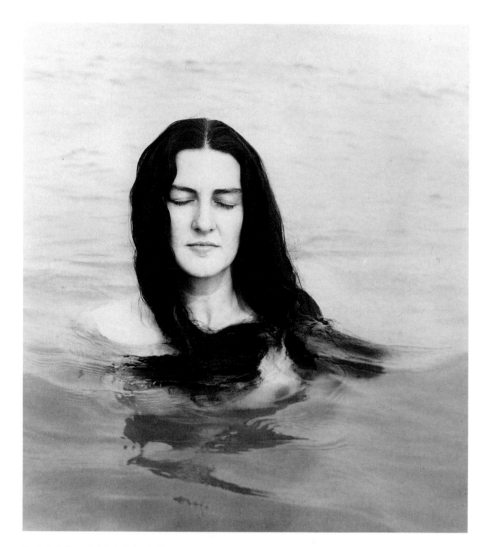

HARRY CALLAHAN
Eleanor, 1949, gelatin silver print, 14 x 11″ (35.6 x 28 cm.)

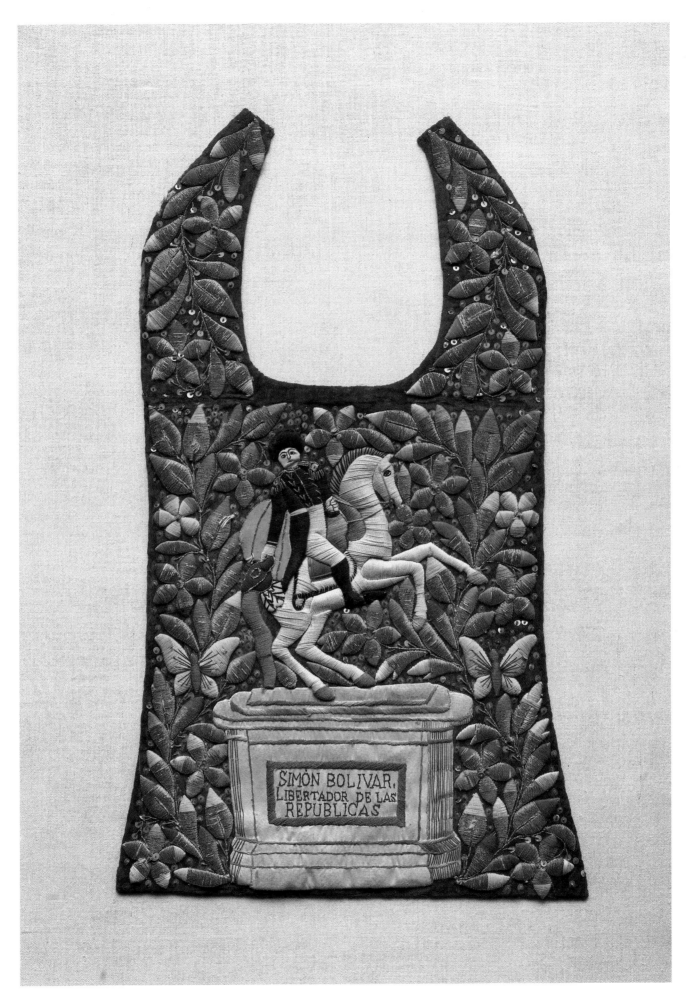

A N O N . Peruvian
Simon Bolivar, c. 1940, embroidered and appliquéd silk and wool, 28 x 18½" (71 x 47 cm.)

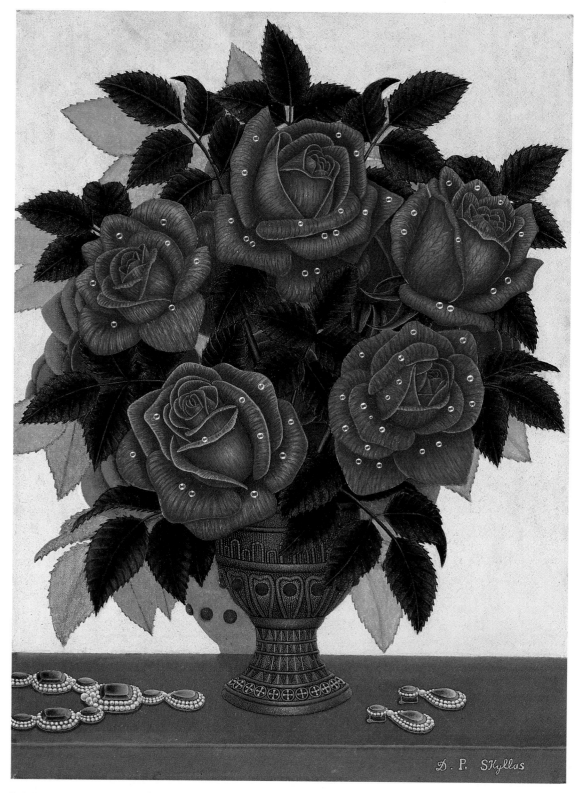

DROSSOS SKYLLAS
Roses and Emeralds, c. 1955, oil on canvas, 24⅛ x 18" (61.3 x 45.7 cm.)

ALDO ROSSI
Model for the Modena Cemetery, 1976, wood, lacquer, and brass, 27 x 47½" (68.6 x 120.7 cm.)

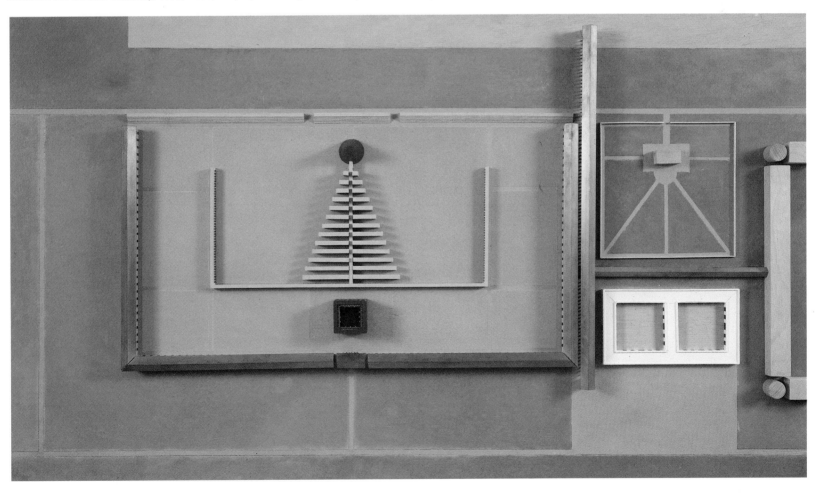

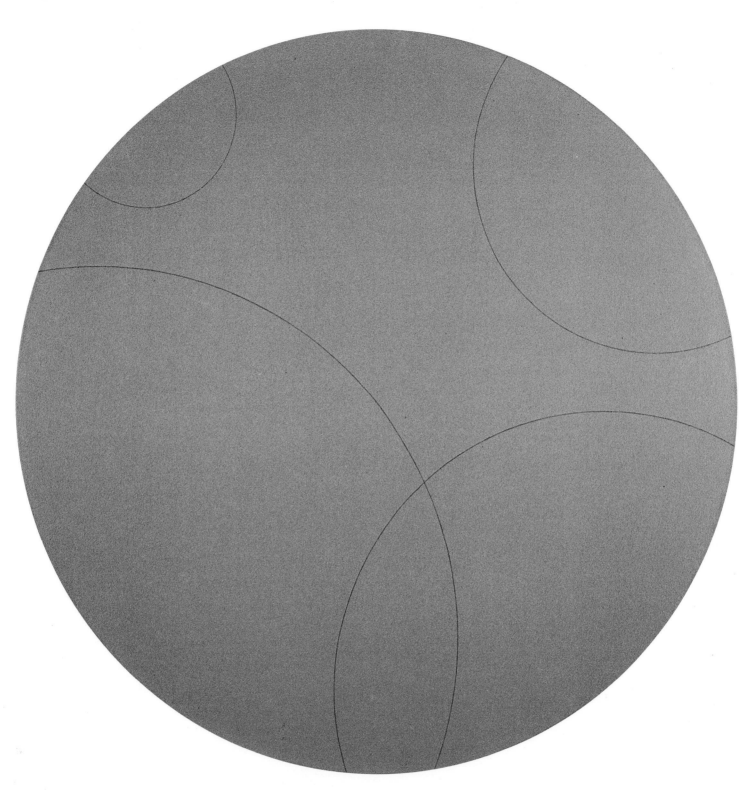

ROBERT MANGOLD
Four Arcs within a Circle, 1975, acrylic on canvas, 72" (183 cm.) diameter

ROBERT MURRAY
Spinnaker, 1979, painted aluminum, 56 x 72 x 54" (142.2 x 183 x 137 cm.)

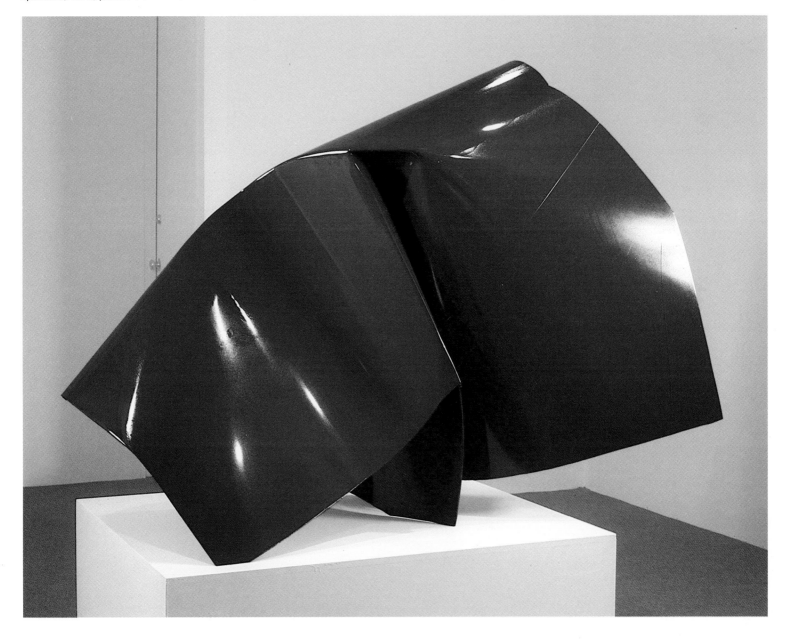

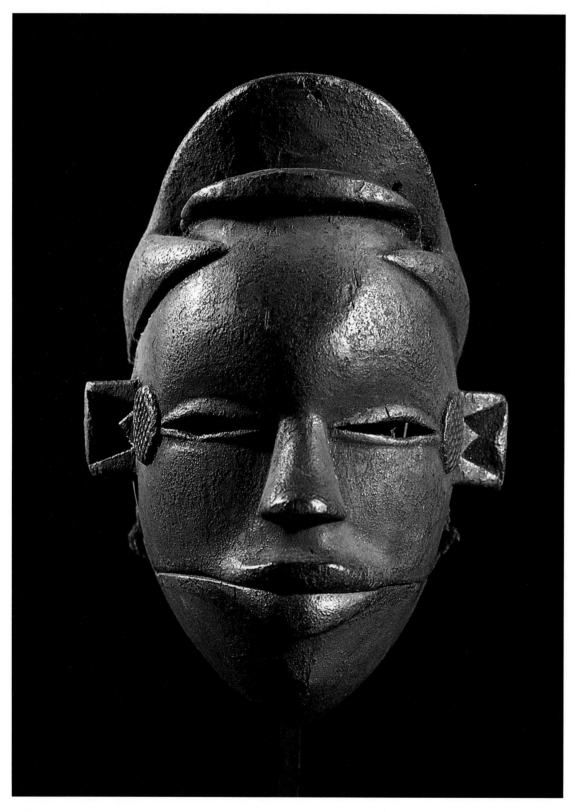

A N O N . African/Nigeria
Ibo Ogoni mask, c. 1930, carved wood, 7¼ x 5 x 4½″ (18.4 x 12.7 x 11.4 cm.)

SANDY SKOGLUND
Radioactive Cats, 1980, Cibachrome print, ¹¹/₂₀, 30 x 40" (76.2 x 101.6 cm.)

ROBERT MORRIS
Untitled, 1976, felt and grommets, 63¾ x 107" (162 x 272 cm.)

WILLIAM M. HARNETT
Paint Tube and Grapes, 1874, oil on canvas, 4¾ x 4⅞" (12 x 12.4 cm.)

R I C H A R D S E R R A
Vertical, 1979, oil stick on linen, 106 x 39" (269.2 x 99 cm.)

LAWRENCE WEINER
Hung About . . . , 1979, installation on wall, variable size

EVE SONNEMAN
Two Trees, 1978, 2 Cibachrome prints, ⁹/₁₀, each 8 x 10" (20.3 x 25.4 cm.)

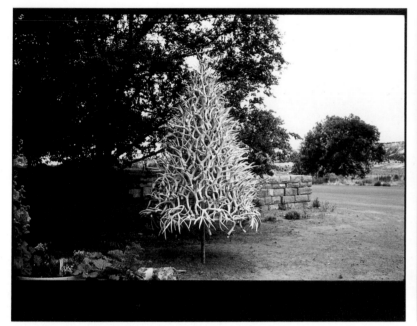

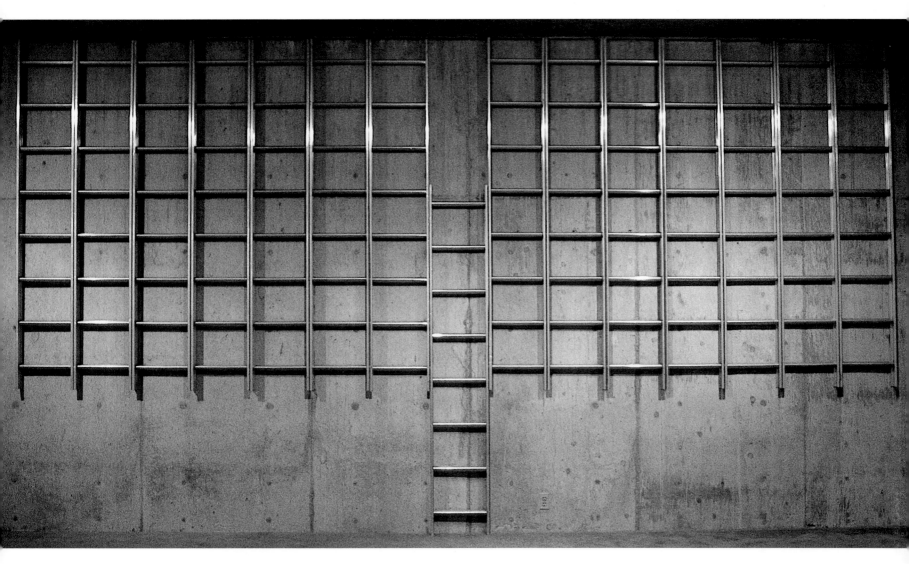

VITO ACCONCI
Ladder Drawing, 1979, fifteen aluminum ladders, each 96 x 16½″ (243.8 x 42 cm.)

ELIZABETH MURRAY
Call, 1979, oil on canvas, 54½ x 68" (138.4 x 172.7 cm.)

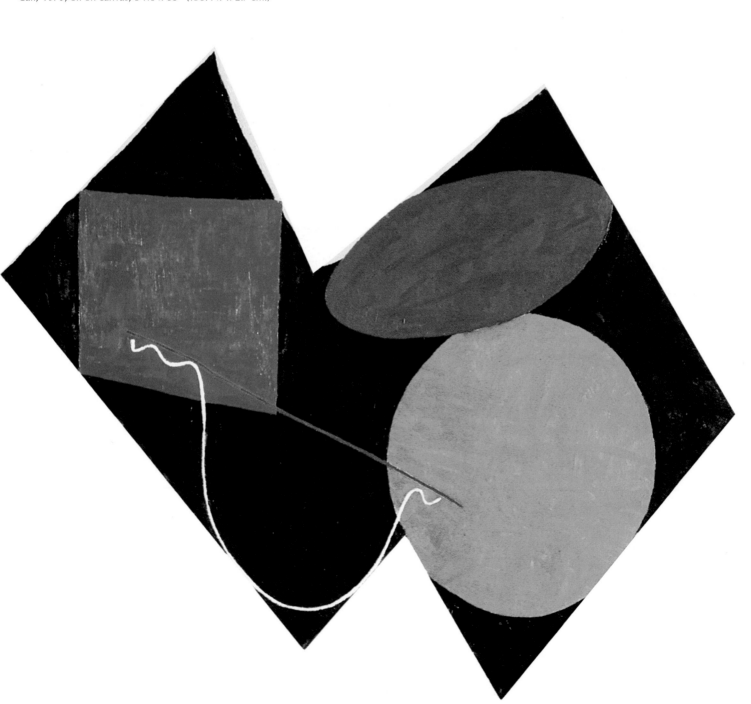

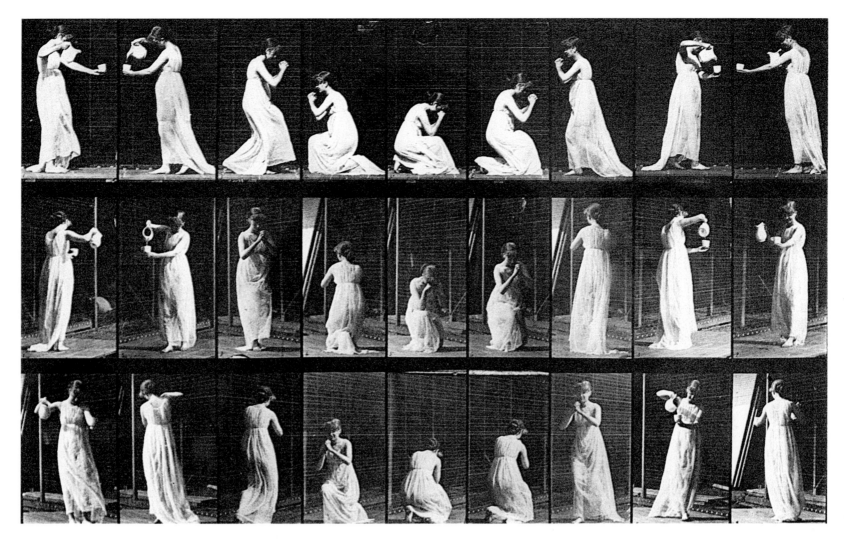

EADWEARD MUYBRIDGE
Untitled, Plate 163 from *Animal Locomotion*, 1887, collotype, 7⅜ x 15¾" (18.7 x 40 cm.)

GER VAN ELK
Tarn Waters, 1978, 3 part photo-acrylic, 57 x 33" (144.8 x 84 cm.)

A N O N . Peruvian/Chancay
Feather poncho, c. 1250, parrot feathers, 36 x 29" (91.4 x 73.7 cm.)

JONATHAN BOROFSKY
Me (I Dreamed the Letters ME were Written on my Forehead), 1975,
charcoal on canvas, 20 x 16" (50.8 x 40.6 cm.)

PAT STEIR
Being Been, 1980, oil on canvas, 9 panels, each 24 x 24" (61 x 61 cm.)

JEFF WAY
Untitled, 1976, plaster, gauze, and oil paint, 12½ x 9¼ x 4″ (31.8 x 23.5 x 10 cm.)

ROBERT MAPPLETHORPE
Tulips, New York City, 1977, silver print, ³/₂₅, 7⅝ x 7⅝″ (19.4 x 19.4 cm.)

NANCY GRAVES
Elude, 1979, watercolor and acrylic on paper, 40 x 52⅝" (101.6 x 133.7 cm.)

Installation Study #1, 1980, mixed media on paper, 50 x 38" (127 x 96.5 cm.)

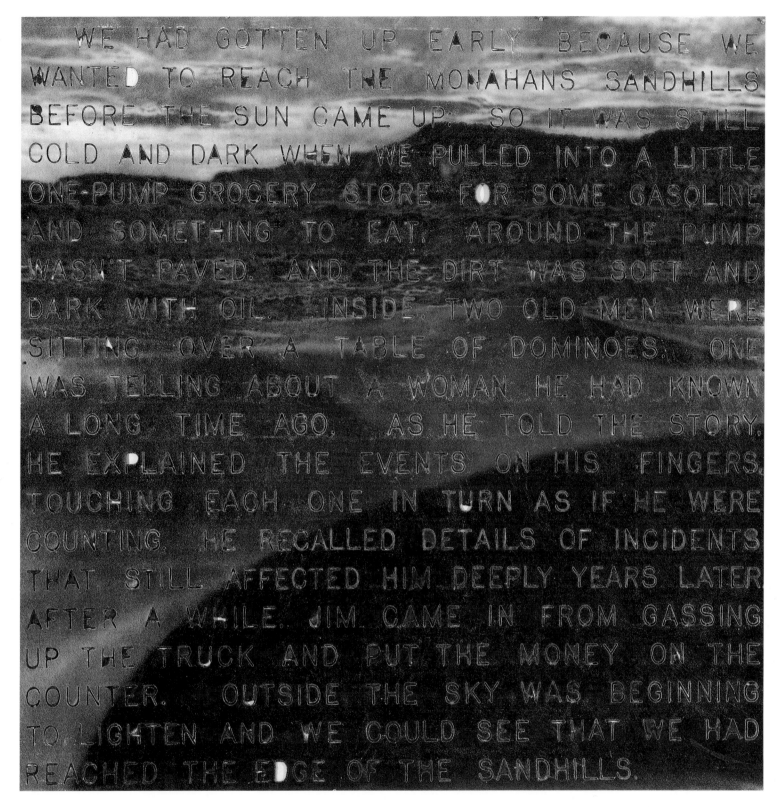

VERNON FISHER
Monahan's Sandhills, 1976, acrylic on laminated paper, 74 x 74" (188 x 188 cm.)

A N O N . American
Red, white, and blue star quilt, Ohio, c. 1900, cotton, 80½ x 87" (204.5 x 221 cm.)

JOSEPH BEUYS
Elk, 1975, lithograph on Butten, 21¼ x 29½″ (54 x 75 cm.)

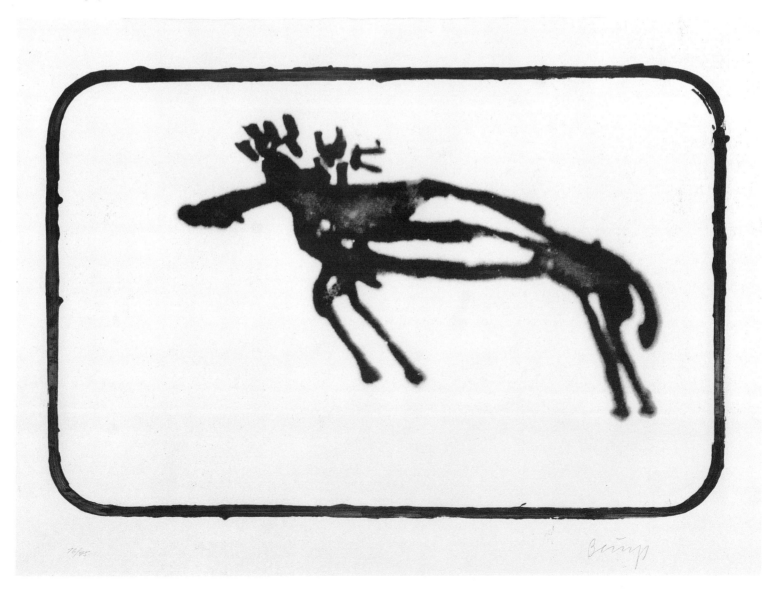

ANSELM KIEFER
Der Kyffhausser, 1980, photo paper with oil, 43 x 30" (109 x 76.2 cm.)

ANON. American
Chest armor, c. 1915, steel, 15 x 18 x 11½" (38 x 45.7 x 29.2 cm.)

ANON. American
Ironing board, c. 1900, wood, 66 x 15" (167.6 x 38 cm.)

PAUL SHARITS
Frozen Film Frame: Shutter, 1975, color film and Plexiglas, 30½ x 53¼" (77.5 x 135.3 cm.)

DOMINICO PALADINO
Viaggiatori Della Notte, 1980, oil and papier-mâché on canvas, 3 panels, 79 x 143″ (201 x 363 cm.) overall

STEVE GIANAKOS
Running Nose, 1981, acrylic on canvas, 30 x 24" (76.2 x 61 cm.)

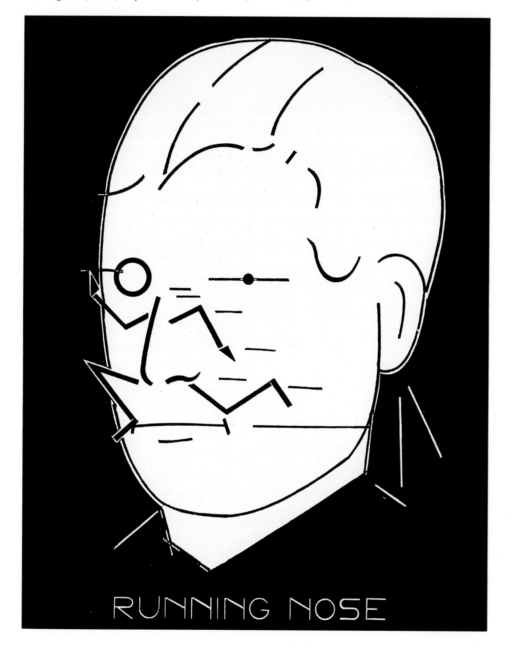

DONALD JUDD
Untitled, 1972, brass, 14½ x 76½ x 25½" (36.8 x 194.3 x 64.8 cm.)

A N O N . American Indian/Navajo
Chief's blanket, c. 1885, wool, 68 x 82″ (172.7 x 208 cm.)

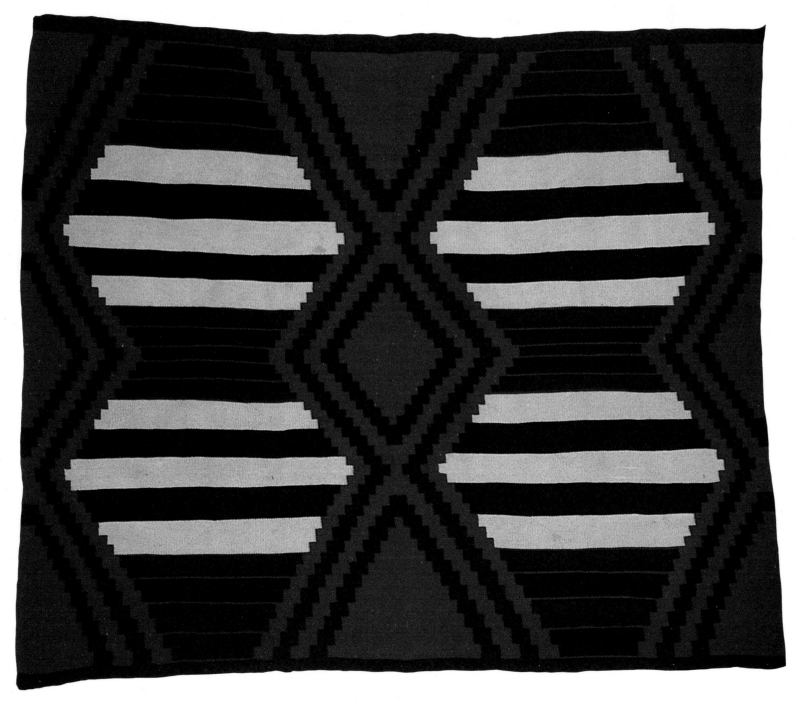

WILLIAM COUPON
Social Studies Six: Urban Indian, 1980, gelatin silver print, ²⁄₅₀, 13⅝ x 13½" (34.6 x 34.3 cm.)

A N O N . American
Anvil/Tin stake, 19th century, steel, 18 x 39 x 3" (45.7 x 99 x 7.6 cm.)

A N O N . New Guinea
Asmat warrior shield, 20th century, wood, 71 x 18″ (180.3 x 45.7 cm.)

PUR·PLE *noun* **1** A color of mingled red and blue, between crimson and violet; in ancient times, the color obtained from the murex, properly a crimson. **2** Cloth or a garment of this color, worn formerly by sovereigns, especially the emperors of Rome; hence, royal power or dignity; pre-eminence in rank or wealth. **3** The office of a cardinal: from the official red hat and robes; also, the episcopal dignity: from its purple insignia.
—*verb* [**PUR·PLED** (–pld), **PUR·PLING**] To color or imbue with purple; become purple.
—*adj.* **1** Of the color of purple. **2** Hence, imperial; regal. **3** Conspicuously brilliant or ornate; said of language.

JOSEPH KOSUTH
Purple, 1966, photostat on cardboard, 48 x 48″ (122 x 122 cm.)

YOU HAVE TO MAKE THOUSANDS OF
PRECISE AND RAPID MOVEMENTS TO
PREPARE A MEAL. CHOPPING, STIRRING
AND TURNING PREDOMINATE. AFTERWARDS,
YOU STACK AND MAKE CIRCULAR
CLEANING AND RINSING MOTIONS. SOME
PEOPLE NEVER COOK BECAUSE THEY
DON'T LIKE IT. SOME NEVER COOK
BECAUSE THEY HAVE NOTHING TO EAT.
FOR SOME, COOKING IS A ROUTINE,
FOR OTHERS, AN ART.

JENNY HOLZER
Plaque, 1981, anodized aluminum, ¹⁄₂₀, 10 x 12″ (25.4 x 30.5 cm.)

ROBERT LONGO
Percival Completed, 1978, pencil and emulsion on canvas, 84 x 96" (213 x 243.8 cm.)

BOYD WEBB
Laurentian, 1981, type C print, 38¾ x 30⅞" (98.4 x 78.4 cm.)

AARON SISKIND
Chicago 1960, 1981, gelatin silver print, ⁴⁄₇₅, 10 x 13″ (25.4 x 33 cm.)

GILBERT & GEORGE
London, 1980, 16 part hand-colored photograph, 96 x 80″ (244 x 20.3 cm.)

LONDON

Gilbert and *George*

1980

MANUEL ALVAREZ BRAVO
Un Poco Alegre y Graciosa, 1942, silver print, 6½ x 9½" (16.5 x 24.1 cm.)

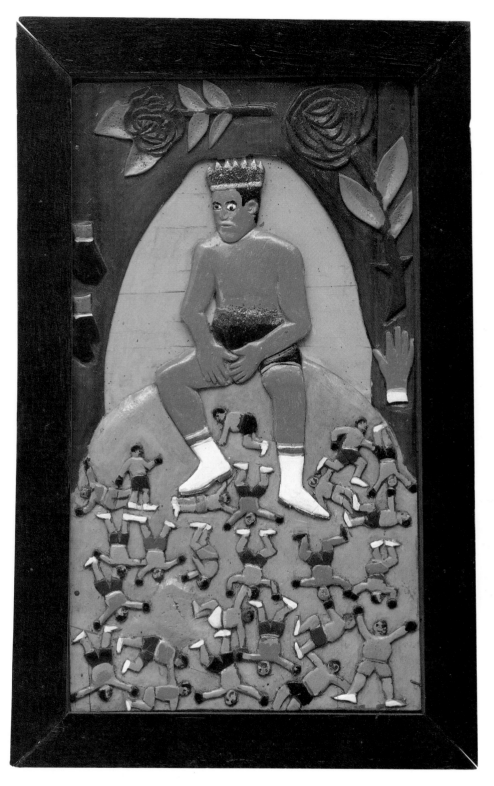

ELIJAH PIERCE
When Joe Became Champ, 1971, carved and painted wood, 21¼ x 13¼" (54 x 33.6 cm.)

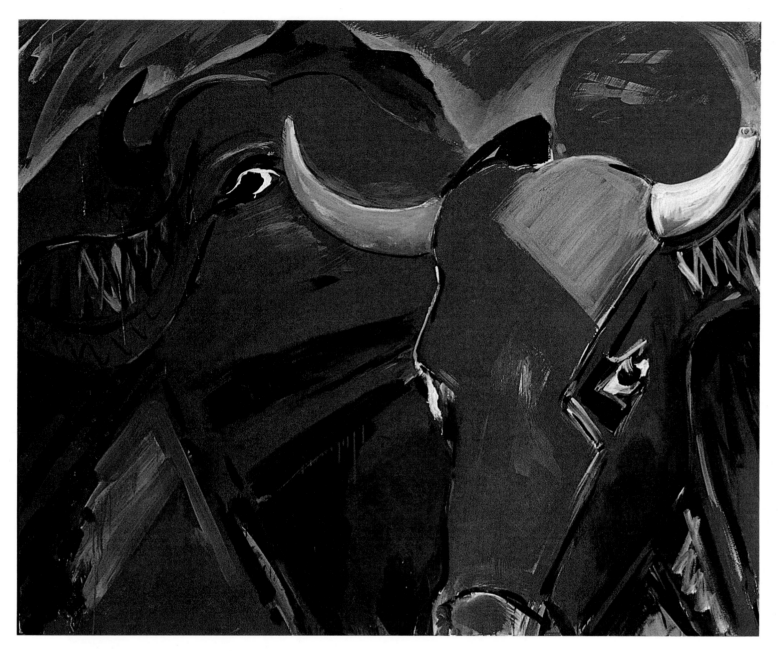

BERND ZIMMER
Kuhe in der Abendsonne, 1980, acrylic on canvas, 64½ x 80½" (163.8 x 204.5 cm.)

EDWARD S. CURTIS
Flathead Type, Plate 227 from *The North American Indian,* 1910, gravure, 21½ x 17¼" (54.6 x 43.8 cm.)

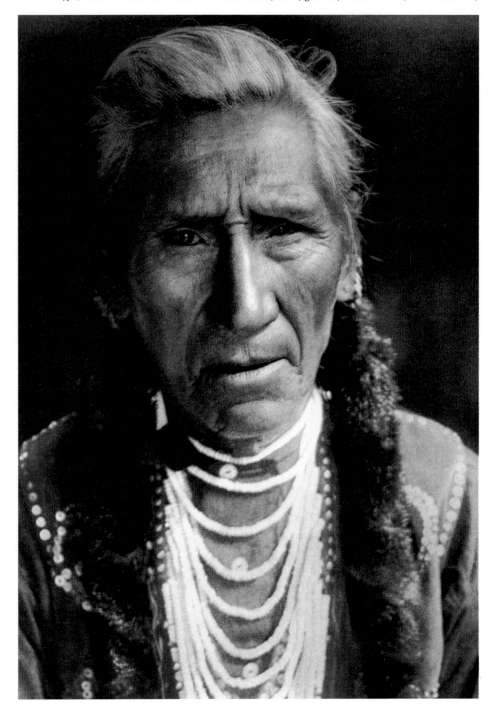

RALPH STEINER
Typewriter Keys, 1921, silver print, 8 x 6" (20.3 x 15.2 cm.)

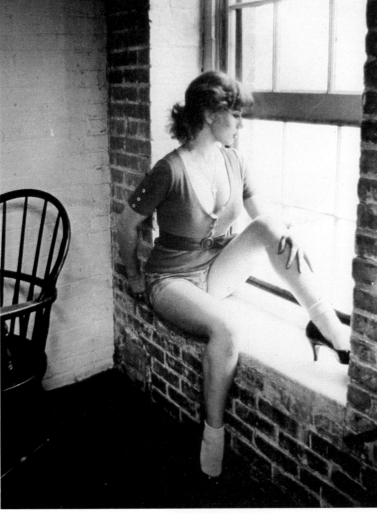
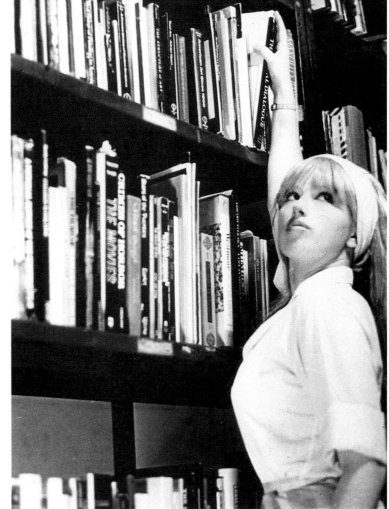
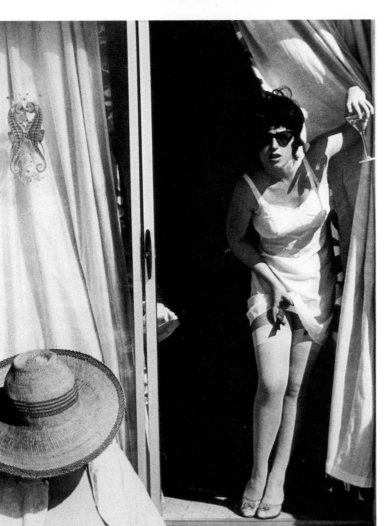

THOMAS LAWSON
Battered Body in Freezer, 1981, oil stick and acrylic on canvas, 48 x 48″ (122 x 122 cm.)

A N O N .　American
Eskimo whale fetish, 1860, seal bladder and skin, 7 x 14″ (17.8 x 35.6 cm.)

A N O N .　American
Eskimo talking mask, 17th century, wood, 7 x 6 x 1½″ (17.8 x 15.2 x 3.8 cm.)

249

A N O N . American
Swan, 1920, carved and painted wood, 31 x 23 x 10″ (78.7 x 58.4 x 25.4 cm.)

EARL STALEY
The Story of Acteon II, 1977, acrylic on canvas, 60 x 120" (152.4 x 304.8 cm.)

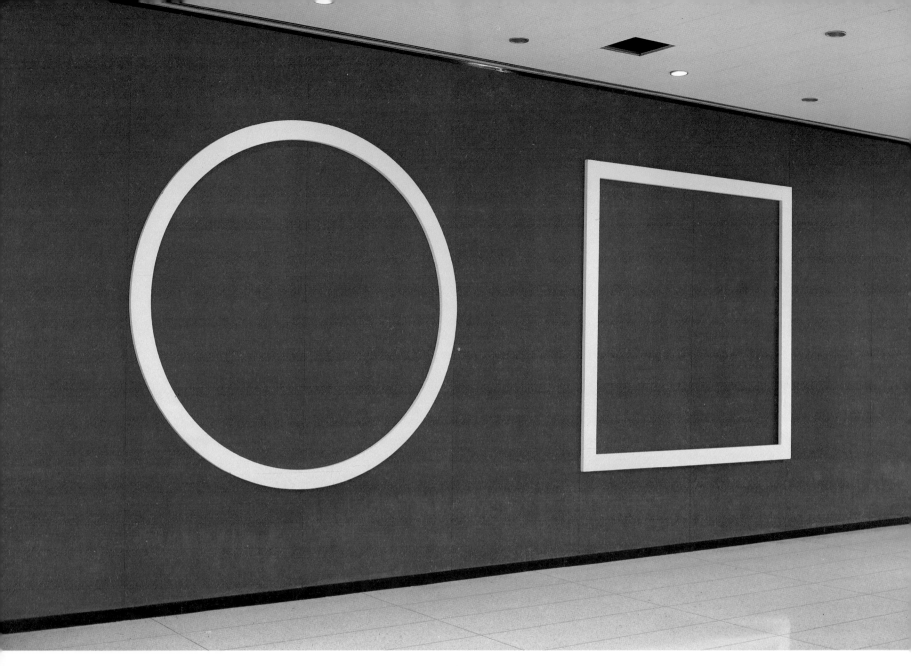

SOL LeWITT
Square & Circle, 1977, white laquer on wood, each 93 x 93" (236 x 236 cm.)

SCOTT BURTON
White Flint/Chair and Table, 1982, white flint, chair 36 x 58 x 48" (91.4 x 147 x 122 cm.),
table 17 x 35 x 25" (43 x 89 x 63.5 cm.)

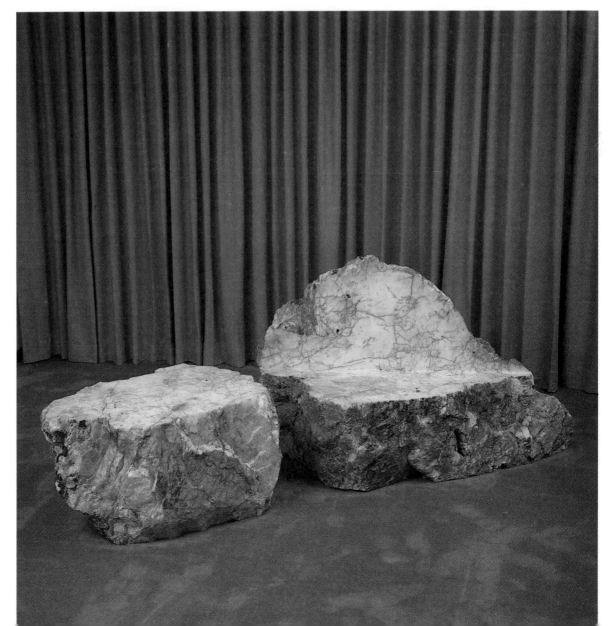

KEITH HARING
Untitled, 1981, enamel on metal, 48 x 48" (122 x 122 cm.)

JACKIE FERRARA
Solstrip, 1982, poplar wood, 4¾ x 48 x 19½″ (12 x 122 x 49.5 cm.)

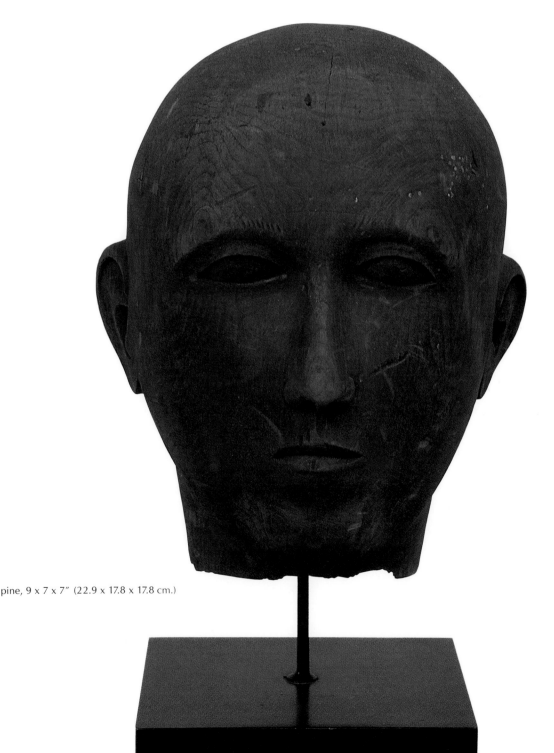

A N O N . American
Mannequin head, c. 1850, pine, 9 x 7 x 7" (22.9 x 17.8 x 17.8 cm.)

BRICE MARDEN
From Bob's House #1, 1970, oil and wax on canvas, 70 x 61½" (177.8 x 156 cm.)

WILLIAM ALLAN
Untitled Salmon, 1981, watercolor, 31 x 41" (78.7 x 104 cm.)

ROY LICHTENSTEIN
Entablature #1, 1971, oil and magna on canvas, 26 x 168" (66 x 426.7 cm.)

A N O N . American
Parchesi game board, c. 1910, painted wood and brass, 18 x 18″ (45.7 x 45.7 cm.)

JOAN SNYDER
Symphony V, 1982, mixed media on canvas, 72 x 96" (183 x 244 cm.)

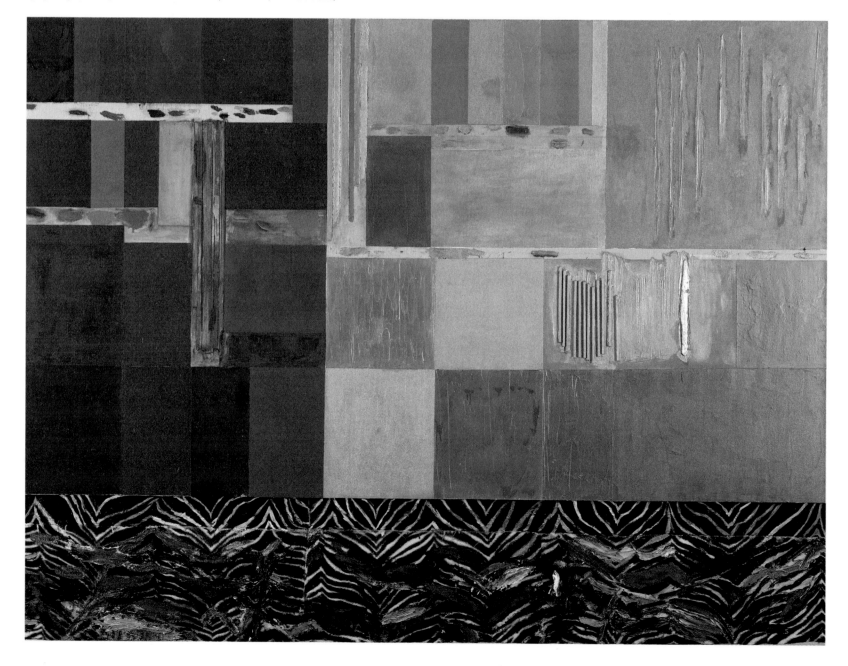

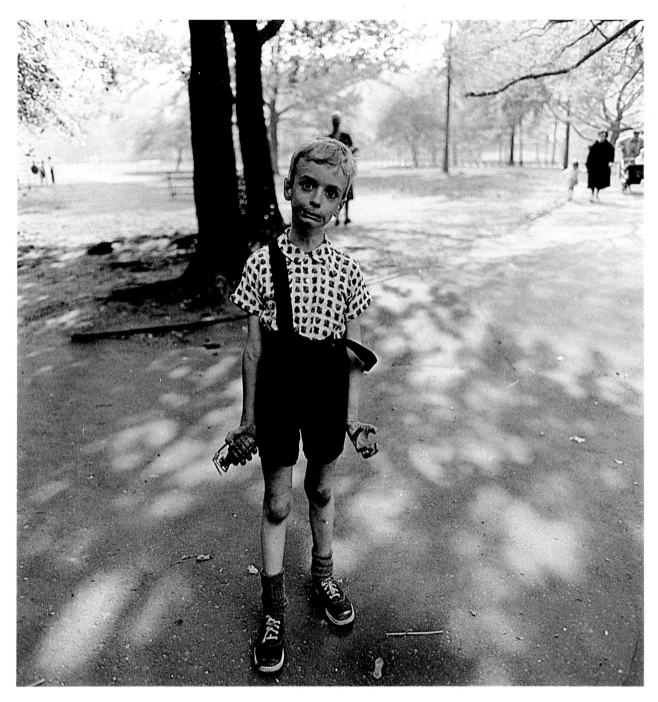

DIANE ARBUS
Child with Toy Hand Grenade in Central Park, New York City, 1962, silver print, 14 x 11" (35.6 x 28 cm.)

WILLIAM WEGMAN
Man Ray: Contemplating the Bust of Man Ray, 1978, silver print, $^5/_{20}$, 7 x 7" (17.8 x 17.8 cm.)

AGNES MARTIN
Untitled #4, 1980, gesso, acrylic and pencil on canvas, 72 x 72" (183 x 183 cm.)

CHRISTOPHER Le BRUN
Mars in the Air, 1981, oil on canvas, 102 x 118″ (259 x 300 cm.)

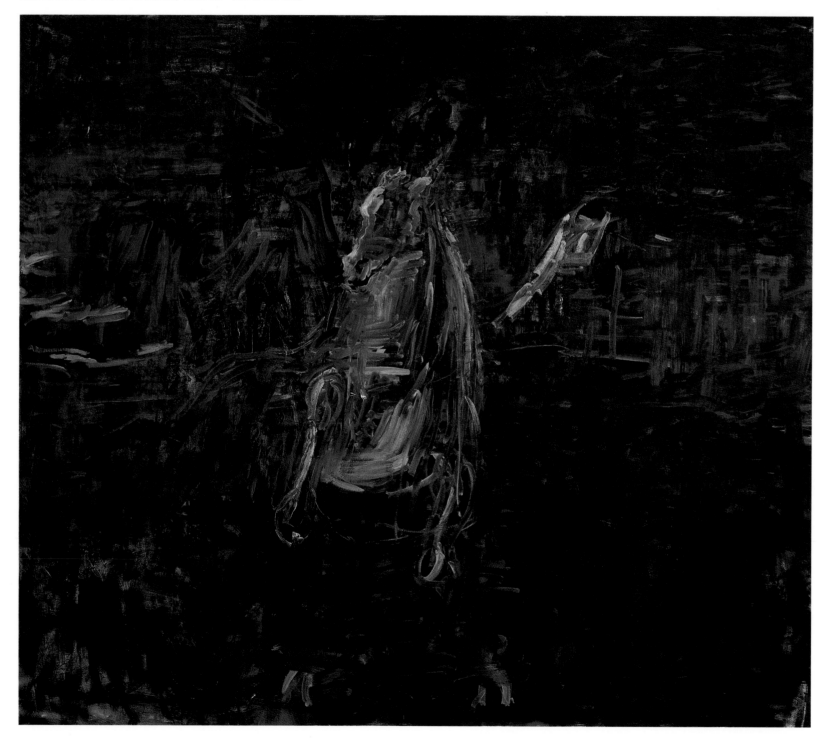

ANON. Chinese
Phoenix, c. 1850, carved camphor wood, 14 x 29 x 8″ (35.6 x 73.7 x 20.3 cm.)

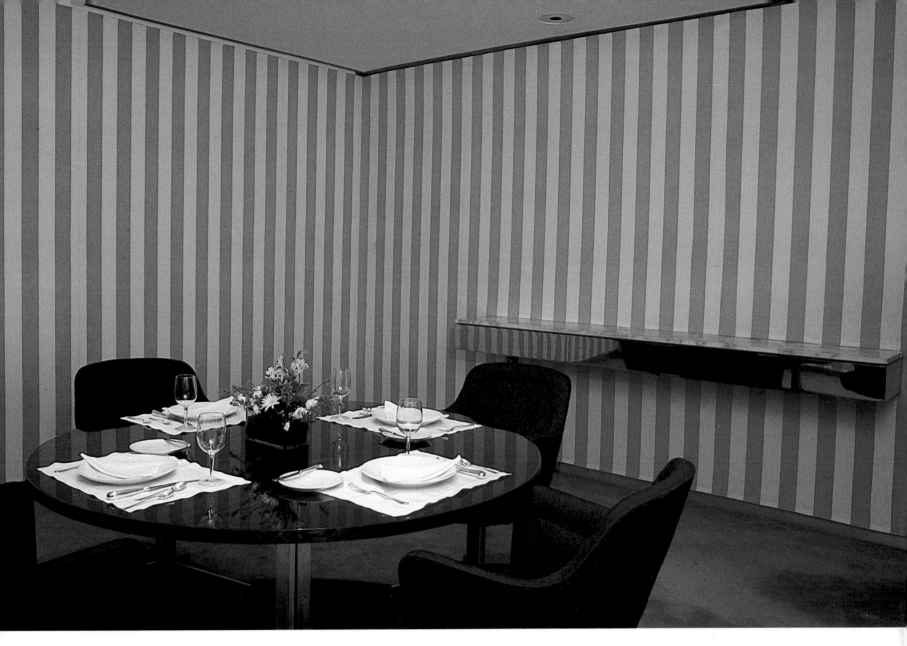

DANIEL BUREN
In The Dining Room, 1982, silkscreen on linen, size varies

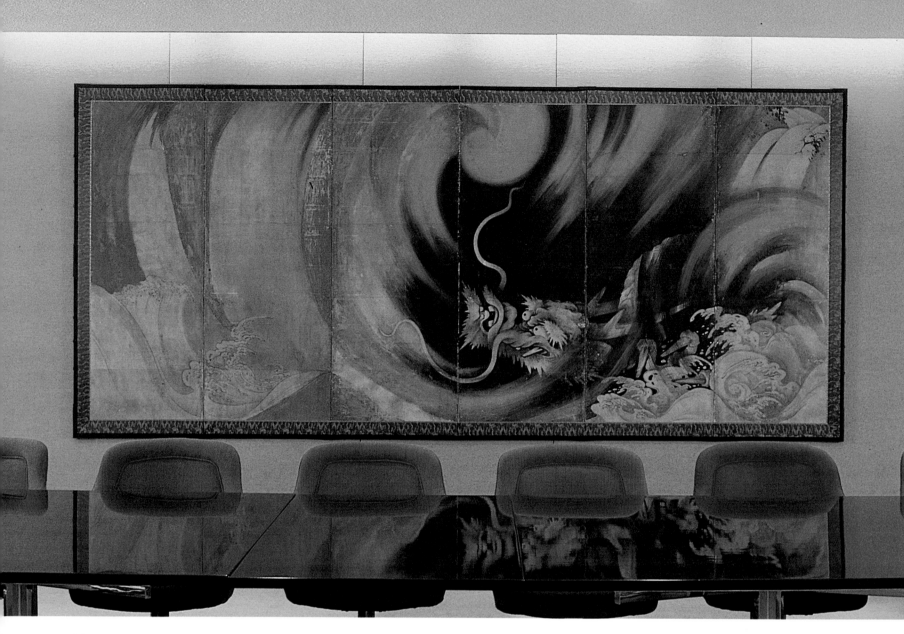

A N O N . Japanese
Screen, c. 1700, ink on paper, 66 x 150" (167.6 x 381 cm.)

ROBERT RAUSCHENBERG
Change, 1982, mixed media with collage, 43 x 31 x 2½" (109.2 x 78.7 x 6.4 cm.)

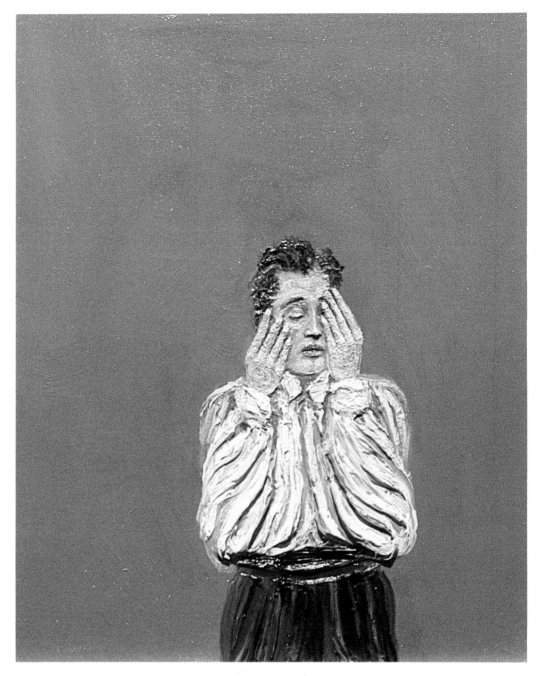

NICHOLAS AFRICANO
Studies for Johnson, 1982, oil, acrylic, and magna on canvas, one of 3, each 24 x 20" (61 x 51 cm.)

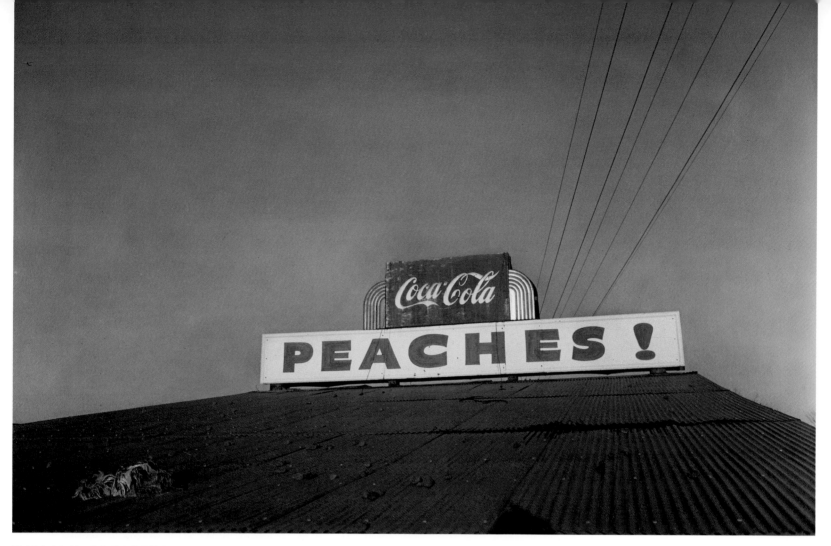

WILLIAM EGGLESTON
Peaches, c. 1971, dye transfer print, 21¾ x 32" (55.2 x 81.3 cm.)

LEE FRIEDLANDER
Jazz & Blues: John Coltrane, 1982, dye transfer print, ⁴/₅₀, 13¾ x 9⅜" (35 x 23.8 cm.)

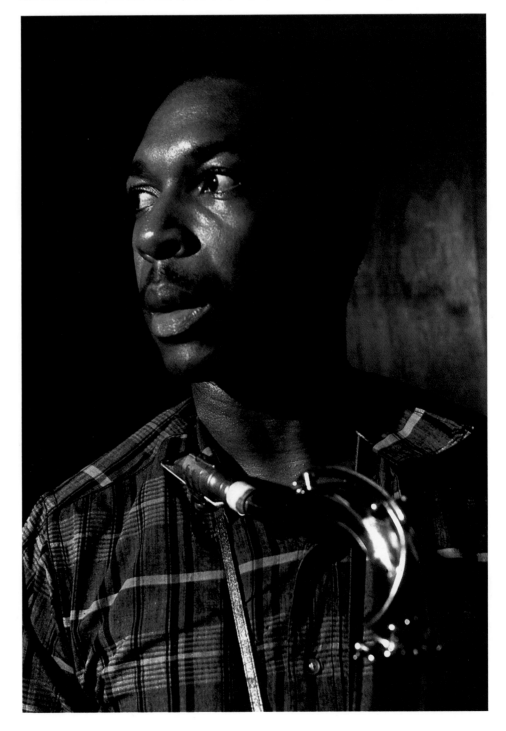

DOROTHEA ROCKBURNE
Golden Section, 1974, gesso on folded linen, 54½ x 88″ (138.4 x 223.5 cm.)

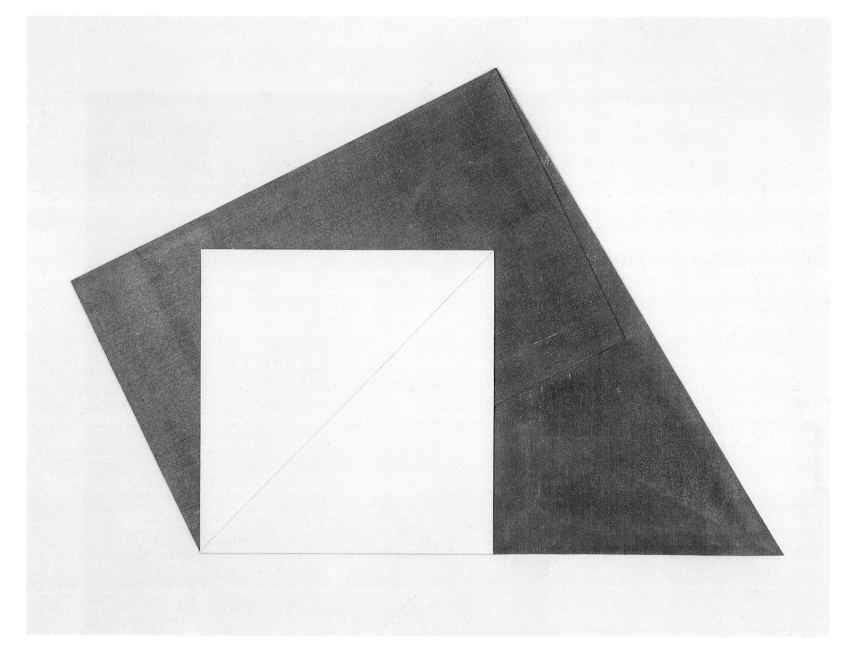

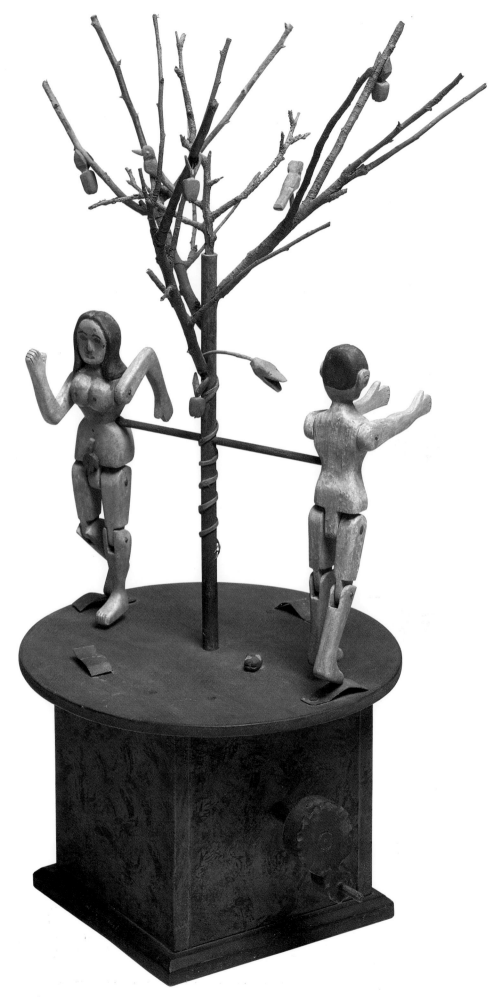

A N O N . American
Mechanical Adam and Eve, c. 1880, carved and polychromed wood, 28 x 10½ x 7½″ (71.1 x 26.7 x 19 cm.)

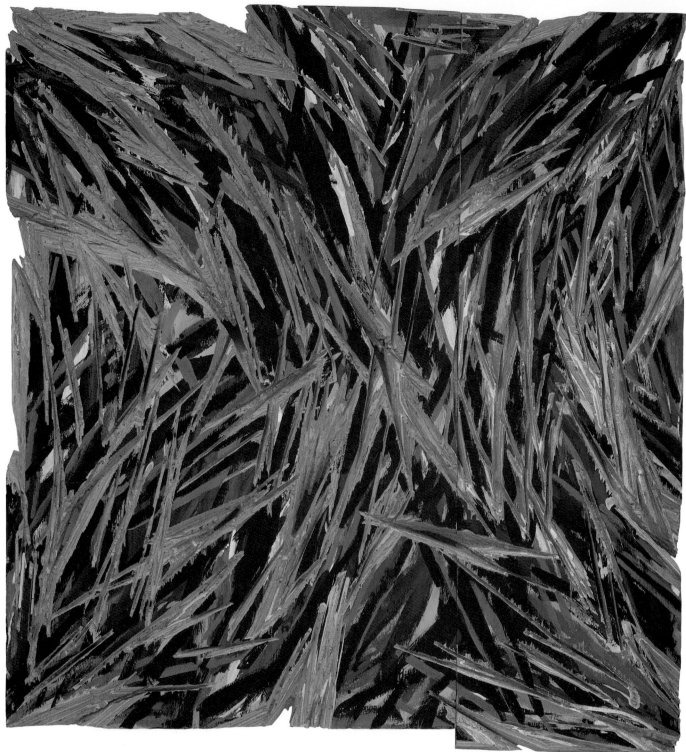

CHARLES ARNOLDI
Untitled, 1982, acrylic on plywood, 72 x 78" (183 x 198 cm.)

RICHARD HAMILTON
Guggenheim, 1982, 3 vacuum formed reliefs, each 23¼ x 23¼ x 3⅞" (59 x 59 x 10 cm.)

JOHN HEJDUK
Berlin Masque, 1981, pencil and colored pencil on paper, 59 x 39½″ (150 x 100.3 cm.)

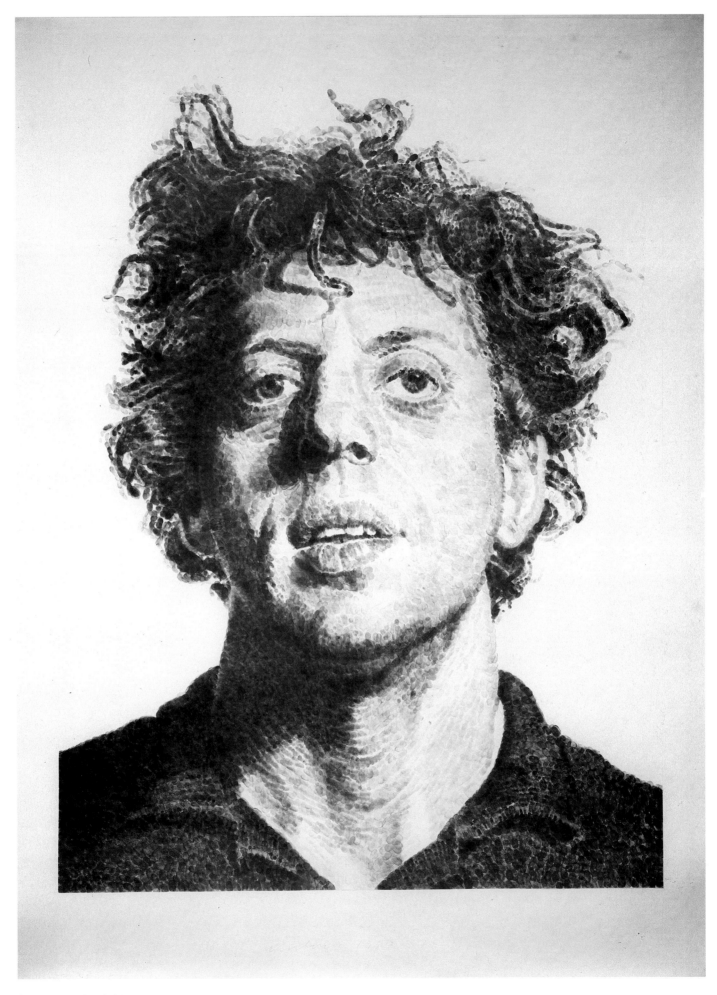

CHUCK CLOSE
Phil/Fingerprint, 1980, stamp pad ink on paper, 93 x 69" (236 x 175 cm.)

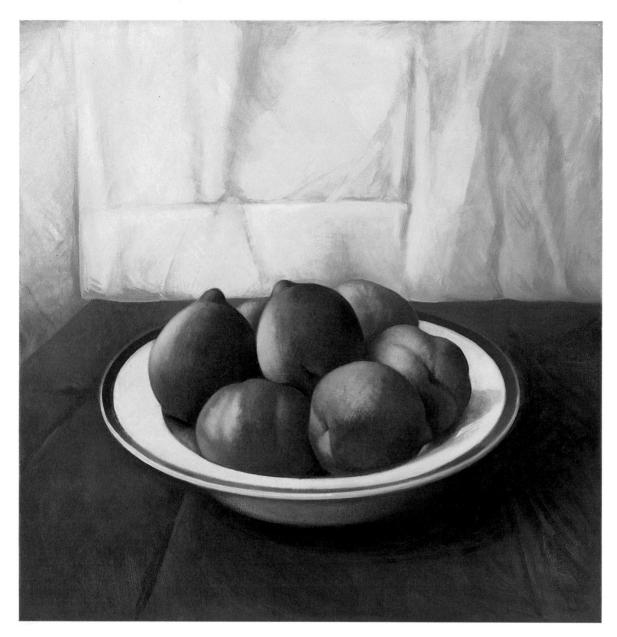

RICARDO GARABITO
Plato con Duraznos y Mandarinas, 1982, oil on canvas, 23½ x 23½″ (59.7 x 59.7 cm.)

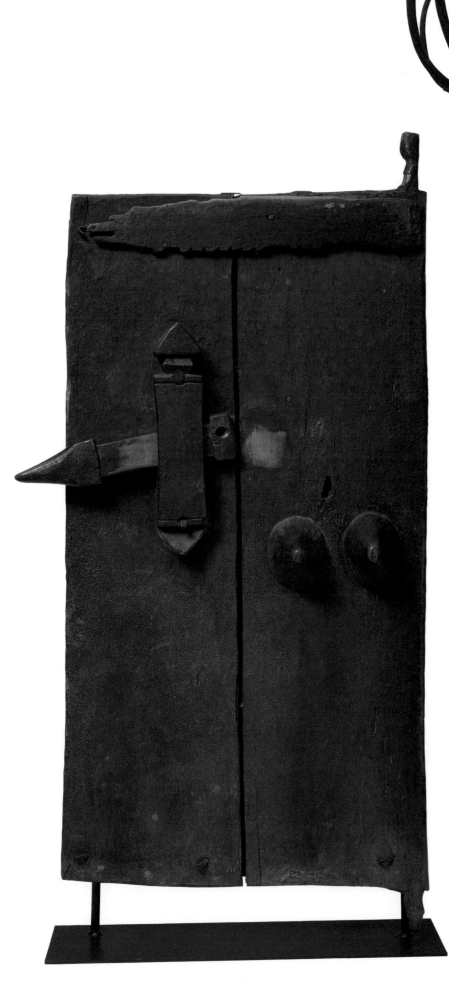

A N O N. American
Cresset, 19th century, forged iron, 21 x 12 x 15" (53.3 x 30.5 x 38 cm.)

A N O N. African/Mali
Dogon granary door, c. 1900, wood, 51 x 27 x 4" (129.5 x 68.6 x 10 cm.)

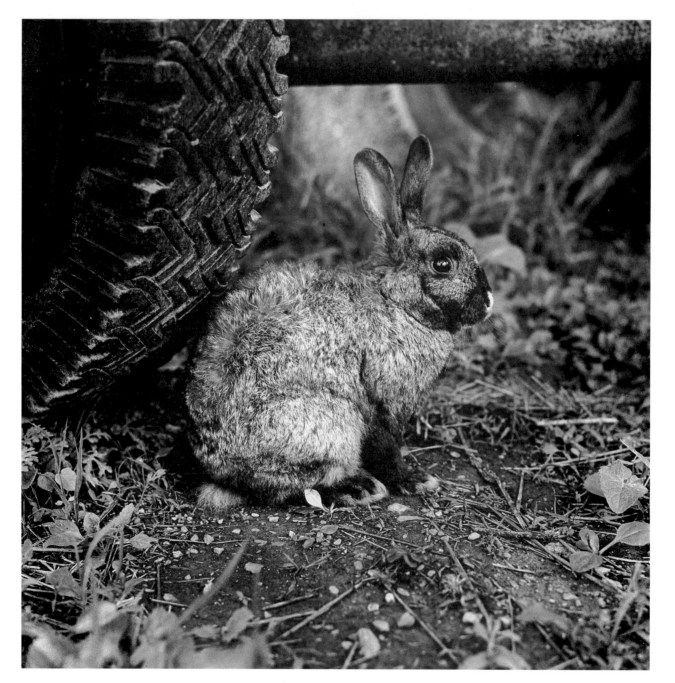

PETER HUJAR
Rabbit, 1978, gelatin silver print, ⁴/₁₅, 16 x 20" (40.6 x 50.8 cm.)

A N O N . American
Eagle, c. 1870, painted wood with glass eyes, 17 x 21 x 9″ (43 x 53.3 x 22.9 cm.)

A N O N . American
Umbrella rack, 19th century, bottle caps, 32 x 17½″ (81.3 x 44.5 cm.)

ANON. American
Clothier's shop sign, c. 1890, carved and polychromed wood, 84 x 21½ x 1" (213.4 x 54.6 x 2.54 cm.)

A. R. PENCK
Untitled, n.d., ink on cardboard, 30½ x 42" (77.5 x 106.7 cm.)

GERARD GAROUSTE
Les Incendiaires, 1982, graphite on paper, 48 x 56" (122 x 142 cm.)

JUDITH SHEA
Holding It In, 1983, cast iron, 15 x 9 x 3½" (38 x 22.9 x 8.9 cm.)

TOM BUTTER
T.B., 1983, fiberglass and resin, 95" (241.3 cm.) high

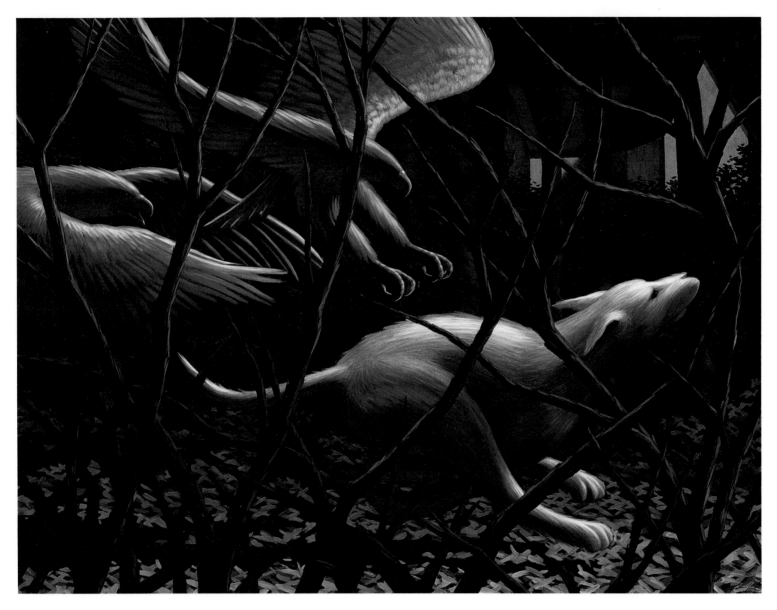

LEONARD KOSCIANSKI
Expulsion, 1983, oil on canvas, 48 x 64" (122 x 162.6 cm.)

JEREMY GILBERT-ROLFE
H Goes to Rome, 1983, oil on canvas, 51 x 48″ (129.5 x 122 cm.)

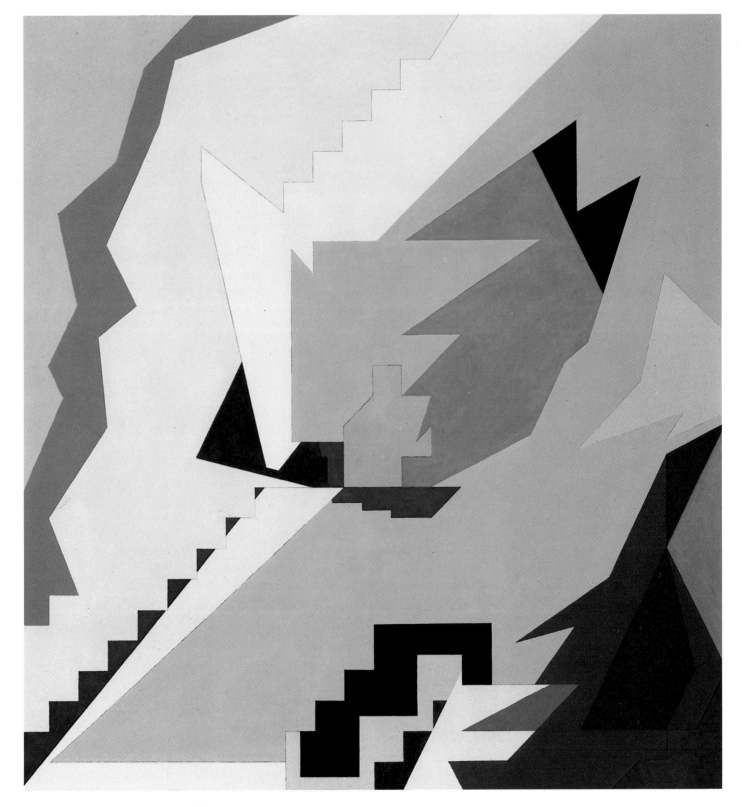

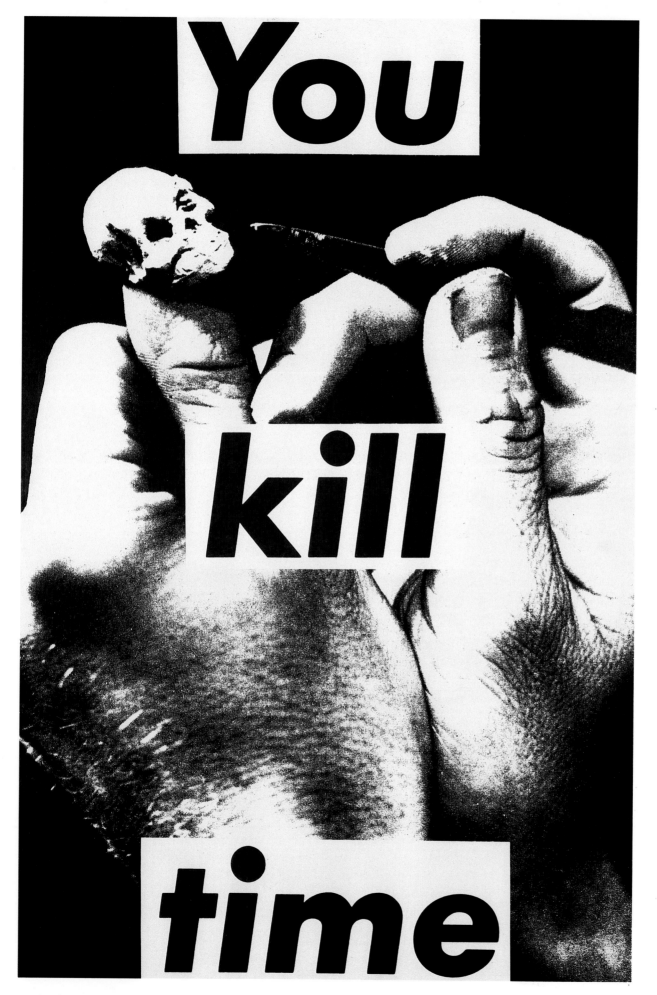

BARBARA KRUGER
Untitled, 1983, silver print, 72 x 48″ (183 x 122 cm.)

SYLVIA MANGOLD
Long Blue Stroke, 1982, oil on linen, 60 x 120" (152.4 x 304.8 cm.)

ROBERT SMITHSON
Drawing for Spiral Jetty, 1970, pen on paper, 9 x 12" (22.9 x 30.5 cm.)

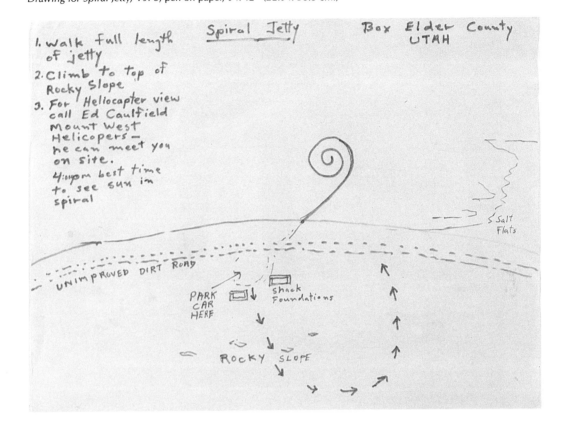

DAVID HOCKNEY
Brooklyn Bridge, November 28, 1982, photographic collage, 109 x 58" (277 x 147 cm.)

ROBERT FRANK
Cape Cod, 1962, gelatin silver print, 12¾ x 8½" (32.4 x 21.6 cm.)

LOIS LANE
Untitled, 1980, pencil on paper, 43 x 30½″ (109 x 77.5 cm.)

RALP'H HUMPHREY
Woods, 1983, acrylic and paste on wood, 48 x 48 x 4″ (122 x 122 x 10 cm.)

JENNIFER BARTLETT
Shadow, 1983, oil on canvas, 4 panels, 84 x 240" (213 x 610 cm.) overall

JENNIFER BARTLETT
Graceland Mansions, 1979, drypoint, aquatint, silkscreen, woodcut, lithograph, 24/40, 5 panels, 24 × 120" (61 × 304.8 cm.) overall

A N O N . American Indian/Hopi
Longhair Kachina mask, c. 1900, horse hair and leather, 21 x 7⅞ x 2" (53.3 x 20 x 5 cm.)

A N O N . American Indian/Hopi
Mocking Kachina mask, c. 1920, leather and wood, 10 x 15 x 16" (25.4 x 38 x 40.6 cm.)

R O B E R T W I L S O N
the CIVIL warS, 1982, graphite on paper, 2³⁄₈ x 5⁷⁄₈" (6 x 14.9 cm.)

WALKER EVANS
Furniture store sign, Alabama, 1936, gelatin silver print, 16 x 20" (40.6 x 50.8 cm.)

NAM JUNE PAIK
Rosetta Stone, Ch. 10, 1983, oil on canvas and wood, 31 x 42½" (78.7 x 108 cm.)

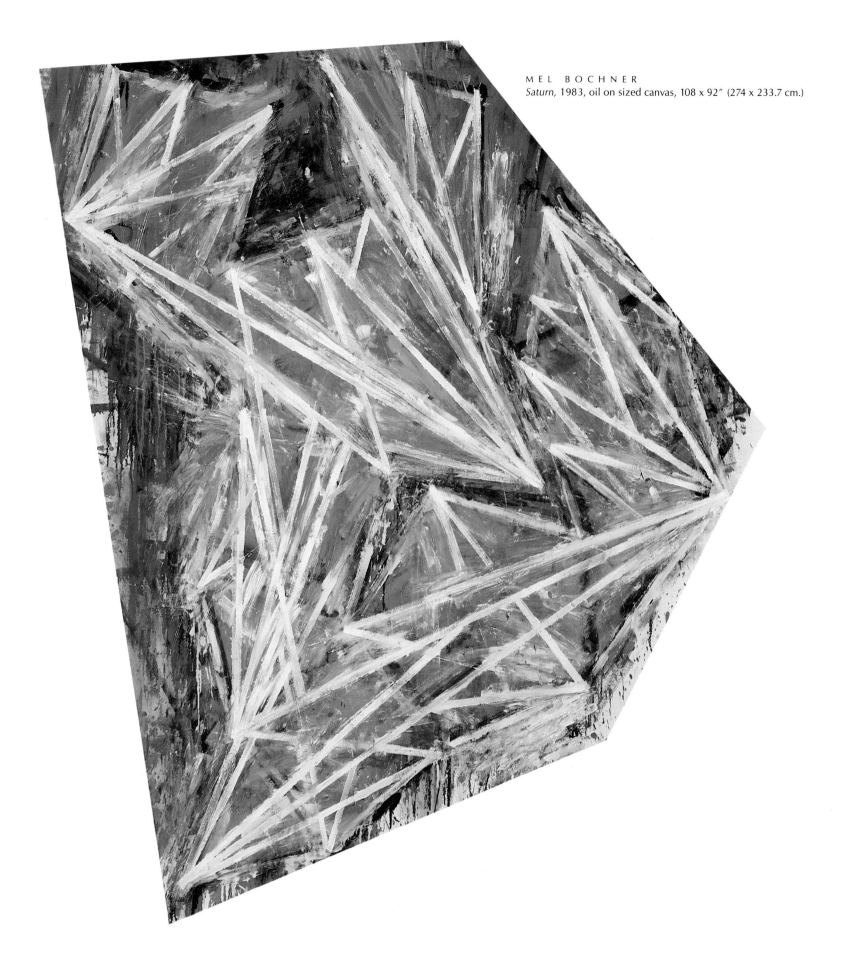

ROSS BLECKNER
From 6:00 to 6:45, 1983, oil on canvas, 90 x 72″ (228.6 x 183 cm.)

APPENDICES

Artists represented in the Chase collection

A

AACH, Herbert
AAKRE, Richard
ABBOTT, Berenice
ABRAHAM, Raimund
ABRAHAMS, Ivor
ABULARACH, Rodolfo
ACCONCI, Vito
ACKROYD, Norman
ADAIR, Hilary
ADAMS, Alice
ADAMS, Ansel
ADAMS, Casey
ADAMS, Robert
ADAMSKI, Hans Peter
AFRICANO, Nicholas
AGAM, Yaakov
AGHA
ALBERS, Anni
ALBERS, John
ALBERS, Josef
ALBIZU, Olga
ALCOSSER, Murray
ALECHINSKY, Pierre
ALEXANDER, Peter
ALLADIN, M. P.
ALLAN, William
ALLEN, Richard
ALLEN, Terry
ALLIEVI, Fernando
ALLORVAN
ALMYDA, Joseph
ALQUILAR, Maria
ALSOP, Adele
ALVIANI, Getulio
AMANO, Kunihiro
AMATEAU, Michele
ANASTASI, William
ANDERSON, Harriet
ANDERSON, Ross
ANDERSON, Stan
ANDRÉ, Carl
ANDREWS, Benny
ANSELL, Michael
ANTES, Horst
ANTIC, Miroslav
ANTONAKOS, Stephen
ANTREASIAN, G.
ANUSZKIEWICZ, Richard
ANZAI, Shigeo
APPEL, Karel
APPEL, Thelma
AQUILINO, Donald
ARAKAWA

ARAUJO, Emanoel
ARBUS, Diane
ARCHULETA, Felipe
ARGOV, Michael
ARICO, Rodolfo
ARLEN, Nancy
ARMAJANI, Siah
ARNAIZ
ARNOLDI, Charles
ARONS, Joyce
ARP, Jean (Hans)
ARTSCHWAGER, Richard
ARUGA, Yutaka
ASANO, Yae
ASHBAUGH, Dennis
ASHER, Dan
ASO, Kaji
ATGET, Eugene
ATPICOVE
AUDUBON, John James
AUGUSTO, Nelson
AVEDISIAN, Edward
AVERY, Milton
AVON, Neal
AVRIL, Pam
AXELROD, Eileen
AYCOCK, Alice
AZUMA, Norio
AZUR, Judith

B

BABER, Alice
BAECHLER, Donald
BAIER, Jean
BAILEY, Oscar
BAILEY, William
BAIRD, J.
BAKER, David
BAKER, Joe
BAKISH, Rosette
BALLARD, Richard
BALOSSI, John
BALTZ, Lewis
BANDEIRA, A.
BANERJEE, Bimal
BANFIELD, J.
BANNARD, Walter Darby
BARANIK, Rudolf
BARD, J.
BARDAZZI, Peter
BARDON, Marcel

BARIL, Tom
BARK, Jared
BARKER, George
BARKLEY, Gregory T.
BARNARD, George
BARNET, Will
BARON, Susan
BARR, Paula
BARR, Victoria
BARREDA, Ernesto
BARRY, Robert
BARTH, Frances
BARTH, Jack
BARTLETT, Jennifer
BASELITZ, Georg
BASHAM, Charles
BASKIN, Leonard
BASQUIAT, Jean Michel
BATES, Leo
BATLLE, Georgette
BATTAGLIA, Carlo
BAUER, Ruth
BAUERMEISTER, Mary
BAUM, Rich
BAXTER, Glen
BAXTER, Robert J.
BAYER, Herbert
BAYER, Javan
BAYLES, David
BAYNARD, Ed
BAZIOTES, William
BEAL, Jack
BEARD, David
BEARD, Mark Stewart
BEARDEN, Romare
BEATTY, Frank
BEAUCHAMP, Robert
BEAULIEU, P. J.
BECHER, Bernd and Hilla
BECHTLE, Robert
BECKETT, Richard
BECKLEY, Bill
BECKMANN, Hannes
BECKWITH, H. S.
BEDEL, Jacques
BEDEL, Jaime
BELL, Bonnie
BELL, Larry
BELVILLE, Scott
BENDER, Gretchen
BENEDIT, Luis F.
BENES, Barton Lidice
BENGLIS, Lynda

BENGURIA, Silvina
BENJAMIN, Anthony
BENNETT, H. H.
BENNETT, Mick
BENTON, Thomas Hart
BENVENUTI, Henry
BERG, Peter
BERG, Siri
BERGH, Anette
BERKELEY, Pamela
BERKENBLIT, Ellen
BERMAN, Zeke
BERNIK, Janez
BERNSTEIN, Shirley
BERTANI, Ernesto
BERTOIA, Harry
BERTRAND, Gaston
BEUYS, Joseph
BHAVSAR, Natvar
BIALA, Janice
BIANCHEDI, Remo
BIANCO, Pamela
BIASI, Alberto
BICKEL, Karl
BIEDERMAN, James
BIERNE, Bill
BIERSTADT, Albert
BIESER, Natalie
BILIK, Paul
BILL, Max
BILLOPS, Camille
BIRKETT, Richard
BIRMELIN, Robert
BIROLLI, Renato
BISCHOF, Peter
BISCHOFF, Elmer
BISHOP, Jim
BISSOLINO, Carlos
BLACKBURN, Ed
BLACKMAN, M. E.
BLAINE, Nell
BLAIR, Dike
BLAKE, Peter
BLECHMAN, R. O.
BLECKNER, Ross
BLELL, Dianne
BLUHM, Norman
BLUM, Charles
BLUMBERG
BOBBIO, Pablo
BOCHNER, Mel
BODEN, Arthur
BOETTI, Alighiero

BOGDANOVE, A. J.
BOHMAN, Janet
BOHNEN, Blythe
BOICE, Bruce
BOLEN, Jack
BOLOMEY, Roger
BOLOTIN, Jay
BOLOTOWSKY, Ilya
BOLTANSKI, Christian
BOMPARD, J. M.
BONALUMI, Agostino
BONEVARDI, Marcelo
BONI, Paolo
BONK, Keiko
BONTECOU, Lee
BOODHOO, James
BOOTHE, Power
BORIS, Bessie
BORNET, John
BOROFKSY, Jonathan
BORTAGARAY, Adelia Borda
BOSHIER, Derek
BOSIN, Blackbear
BOSMAN, Richard
BOSSE, Janet
BOSSON, Jack
BOTERF, Check
BOTTGER, Nicky
BOTTONI, Joe
BOTTS, Gregory
BOURDON, Robert
BOURGEOIS, Louise
BOURNE, Samuel
BOURSIQUOT, J. D.
BOWER, Gary
BOWERS, Lynn
BOWLING, Frank
BOXER, Stanley
BOYD, Michael
BOYDEN, Martha
BOYER, R.
BOYLE, Kevin
BRACH, Paul
BRADFORD, Anne
BRADY, Carolyn
BRAINARD, Joe
BRANDES, Fred
BRANDT, Bill
BRANDT, Warren
BRANNIGAN, Sheila
BRAQUE, Georges
BRASSAI
BRAUNER, Victor
BRAUNTUCH, Troy
BRAVE BULL, Regina
BRAVO, Manuel Alvarez
BREER, Robert
BREHME, Hugo
BREIDEL, Joe
BREIGER, Elaine
BREMER, Uwe
BRENNAN, Archie
BRETT, A.
BREUER, Lee
BREWERTON
BRICKHOUSE, Farrell
BRIDGES, Marilyn
BRIEM, John
BRITO, Frank
BRIZZI, Ary
BROD, Stan
BRODERS, Roger
BRODZKA, Krystyna
BROODTHAERS, Marcel

BROOKS, James
BROSE, Morris
BROWN, Cynthia
BROWN, David
BROWN, David Lee
BROWN, Fredrick J.
BROWN, Gebe
BROWN, Harry Collins
BROWN, James
BROWN, Larry K.
BROWN, Roger
BROWNE, Vivian
BRUENING, Peter
BRUMER, Miriam
BRUMUND, Marie
BRUN, Donald
BRUNNER, Wil
BRUSCA, Jack
BRUSH, Daniel
BRYSON, Alvin C.
BUCHWALD, Howard
BUCKLAND, David
BUCKLEY, Stephen
BUCZAK, Brian
BUDD, David
BUENO, Rafael
BUFFET, Bernard
BULKELEY, Morgan
BULL, Clarence Sinclair
BULL, Randi
BULLATY, Sonia
BURCHFIELD, Charles
BURCHFIELD, Jerry
BURCKHARDT, Rudy
BURDEN, P. John
BUREN, Daniel
BURG, Patricia Jean
BURGIN, Victor
BURNLEY, Gary
BURNS, Harrison
BURNS, Michael John
BURRAGE, Mildred
BURRI, Alberto
BURSON, Nancy Siegel
BURTON, Scott
BURWITZ, N.
BURY, Pol
BUSH, Jack
BUSSE, Dieter
BUTHE, Michael
BUTTER, Tom
BUTTON, John
BUXBAUM, Robert
BYZANTIOS, P.

C

CABE, Carlos Albertos
CACEROS, José Maria
CADÈRE, André
CADY, Arthur
CADY, Sam
CAFFIERI
CAGE, John
CAIN, Charlotte
CALAWAY, Loren
CALCAGNO, Lawrence
CALDER, Alexander
CALDERON
CALDWELL, Bill
CALDWELL, James
CALE, Robert
CALFEE, William

CALLAHAN, Harry
CALLAHAN, Kenneth
CALLERY, Mary
CALLIS, Joann
CALYO, Nicolino
CAMARGO, Sergio
CAMBLIN, Robert
CAMPBELL, Gretna
CAMPIGLI, Massimo
CAMPUS, Peter
CANEVA, Giacomo
CANIN, Martin
CANRIGHT, Sarah
CAPOGROSSI, Giuseppe
CAPOGROSSI, Paul
CAPPELLETTO, Marina
CARACCIO, Kathy
CARDENAS, Santiago
CAREY, Ellen
CARIGIET, Alois
CARLSON, George
CARPENTER, James
CARPENTER, Miles
CARSMAN, Jon
CARSON, Karen
CARTER, Clarence Holbrook
CARTER, John
CARTER, John Randolph
CARTIER-BRESSON, Henri
CARTLEDGE, Ned
CARVIN, Robert
CARZOU, Jean Marie
CASADO, Julian
CASARELLA, Edmond
CASCELLA, Andres
CASS, Gilbert
CASTELLANI, Enrico
CASTELLI, Luciano
CASTILLA, Americo
CASTORO, Rosemarie
CASTRO-CID, Enriqué
CATLIN, George
CAULFIELD, Patrick
CAVALLERO, Juan
CAVALLON, Giorgio
CAVAT, Irma
CEESAY, Momodou
CELMINS, Vija
CEROLI, Mario
CHAE, Seokchi
CHAGALL, Marc
CHALFANT, Henry
CHAMBERLAIN, John
CHAMBERS, Thomas W.
CHAMBI, Martin
CHAN, Luis
CHANG, Carlisle
CHANG, Chieh
CHAPMAN, Lois
CHARLESWORTH, Sarah
CHASE, Louisa
CHEN, Yu-Tao
CHERY, J. R.
CHEVALIER, Jack
CHEW, Qwek Wee
CHEW, Wong Moo
CHI, Lee Shi
CHIE, Chang Da
CHILDERS, Malcolm
CHILDS, Lucinda
CHILLA, Benigna
CHILLIDA, Eduardo
CHINNI, Peter
CHIN-SHEH-FU

CHISMAN, Dale
CHI-YUAN, Wang
CHOU, Yu-Tung
CHRISTENBERRY, William
CHRISTENSEN, Dan
CHRISTO
CHRISTOPHER, William
CHRYSSA
CHU, Wei-Bai
CHUANG, Che
CHUN, Kwang Young
CHUN, Sung Woo
CHUN, Yin
CHUPACK, Jeanette
CHURCHILL, Diane
CIRY, Michel
CLAISSE, Genevieve
CLAPSADDLE, Jerry
CLARK, Edward
CLARK, Elizabeth K.
CLARK, I.
CLARKE, Ed
CLARKE, John Clem
CLARKE, Leroy
CLATWORTHY, Robert
CLAY, S.
CLERK, Pierre
CLIFT, William
CLOAR, Carroll
CLOSE, Chuck
CLOUGH, Charles
CLUTZ, William
COARDING, Gerald
COATES, E. C.
COATES, Ross
COBURN, A. L.
COBURN, Ralph
COGGESHALL, Calvert
COHEN, Elaine Lustig
COHEN, George
COHEN, Lynne
COHEN, Mark
COHEN, Merrilee
COHEN-GAN, Pinchas
COLE, Donald
COLE, J. F. A.
COLLA, Ettore
COLMER, Roy
COLUMBINO, Carlos
COMTOIS, Louis
CONNELLY, Arch
CONSAGRA, Pietro
CONVERSE, Rhea
COOK, George S.
COOKE, Kathleen
COOPER, Miriam Shapiro
COOPER, Ruffin
COPE, George
COPELLO, Francesco
COPLEY, Billy
COPPOLA, Mario
CORBETT, Edward
CORDIOLI, Marco
CORNEILLE
CORNELL, Joseph
CORPORA, Antonio
COSGROVE, Bob
COSTA, Toni
COSTANZO, Tony
COTANI, Paoli
COTE, Alan
COUPON, William
COWELL, W. Wilson
COWIN, Jack

CPLY, Bil
CRAGG, Tony
CRAVO, Mario
CREECY, Herbert
CREMONINI, Leonardo
CRILE, Susan
CRIPPA, Roberto
CRISTIANO, Renato
CRISTOFARO, Cris
CRUSPINERA, Juan
CRUM, David
CRUZ, Luis Hernandez
CUCCIONI, Tommaso
CULLOM, Adrienne
CUMMING, Robert
CUMMINGS, David
CUNNINGHAM, Imogen
CUPPAIDGE, Virginia
CURRIER and IVES
CURTIS, Edward S.
CUTFORTH, Roger

D

DA COSTA, Waldemar
DAILEY, Dan
DALAL, Naina
DALBY, Marcia
DALGLISH, Jamie
DALI, Salvador
DALLEGRET, François
DALLMAN, Daniel
D'ALMEIDA, George
DANTZIC, Jerry
D'ARCANGELO, Allan
DARGER, Henry
DARTON, Chris
DASH, Robert
DAUCHOT, Gabriel
DAUMIER, Honoré
DAVID, Michael
DAVIDOVICH, Jaime
DAVIE, Alan
DAVIES, Hanlyn
DAVIES, Margaret
DAVIS, Brad
DAVIS, Gene
DAVIS, Ron
DAVIS, Stephen Springer
DAVIS, Theo R.
DAVIS, Warren
DAVISON, Robert
DAY, Bob
DAY, John
DAY, Lucien
DEAN, Peter
DEBENJAK, Riko
DEBUTLER, Jacqueline
DE CARAVA, Roy
DECHAR, Peter
DE COINTET, Guy
DEDECKER, Scott
DE FELICE, Hope
DE GRAILLEY, Victor
DE GROOT, Nanno
DEHNER, Dorothy
DEITZEL, Fred
DE JUAN, Ronaldo
DE KNIGHT, Avel
DE KOONING, Willem
DELACROIX, Eugène
DELAUNAY, Sonia
DE LAURA, Angela

DELLA VOLPE, Ralph
DELVAUX, Paul
DE MARIA, Walter
DE MONTE, José
DE MOULPIED, Deborah
DENBY, Jillian
DENES, Agnes
DE NIRO, Robert
DENNIG, K. H.
DENNY, Robyn
DERIAN, André
DE ROUGEMENT, Guy
DESPIERRE, Jacques
D'ESTIENNE, Christiane
DE TIBERIO
DEUTSCH, David
DEVILLE, Guiscart
DE VITO, Fred
DEWASNE, Jean
DE WINTÈRE, Marc Honoré
DIAMOND, Martha
DIAO, David
DIBBETS, Jan
DICIERVO, Jorge
DICK, A.
DICKSON, Jennifer
DICKSTEIN, Alvin
DIEBENKORN, Richard
DIERINGER, Ernest
DILMAGHANI, Dennis
DINE, Jim
DINGUS, Rick
DINNERSTEIN, Harvey
DIODATO, Baldo
DI PRETE, Danilo
DISLER, Martin
DI SUVERO, Mark
DIVOLA, John
DOBSON, John Crane
DODD, Lois
DOGANCY, Burhan
DOISNEAU, Robert
DOLBIN, B. F.
DOLE, William
DOMOTO, Hisao
DONATI, Enrico
DONIS, Roberto
DORAZIO, Piero
DOVE, Toni
DOW, Jim
DOWNES, Rackstraw
DREIBAND, Laurence
DRAPELL, Josef
DRISCH, Russell
DROUNGAS, Achilles
DRUMMOND, Sally Hazelet
DUBSKY, Mario
DUBUFFET, Jean
DUCH, Timothy
DUDLEY, Don
DUENAS, Olga
DUFF, John
DUFY, Raoul
DUMITRU
DUNCAN, E.
DUNHAM, Carroll
DUNKELMAN, Loretta
DUPUY, Hal
DURA, Muhan
DURAN, Bob
DURHAM, James
DUTTON, T. G.
DUVAL, Constant
DWYER, Nancy

DWORZAN, George
DZUBAS, Friedel

E

EAGLE, Arnold
EAKIN, Jane
ECHARD, Jean Claude
ECHEVARRIA, Federico
ECKELL, Ana
ECONOMOS, Michael
EDELSON, Mary Beth
EDGE, Michael
EDGERLY, Josiah
EDGERTON, Harold
EDLICH, Stephen
EDWARDS, Ethel
EDWARDS, Marianne
EDWARDS, Mel
EFRAT, Penni
EGGLESTON, William
EGUIA, Fermin
EHRY
EISENBERG, Marc
EISENMAN, Michael
ELISOFON, Eliot
ELLIOTT, Dennis
ELLIOTT, Ronnie
ELMES, Willard Frederic
ELONZO, Garrett Carlton
ENDICOTT
ENGEL, Jules
ENGELSON, Carol
EPSTEIN, Mitch
ERLEBACHER, Martha Mayer
ERNST, Jimmy
ERNST, Max
ESHOO, Robert
ESKOLA, Lea
ESPINOSA, Manuel
ESPLEY, Tom
ESTES, Richard
ETKIN, Suzan
ETROG, Sorel
EUGENE-JEAN
EVANS, Andrea
EVANS, Garth
EVANS, James
EVANS, Jan
EVANS, Ned
EVANS, Tom
EVANS, Walker
EWING, Lauren

F

FAB FIVE FREDDY
FADEN, Lawrence S.
FAHLEN, Charles
FAHLSTROM, Oyvind
FALCONE, Michael
FANGOR, W.
FARBMAN, Robin
FARES, William
FARMANFARMAIAN, Monir
FARMER, Frank
FASNACHT, Heide
FASSOLAS, John
FATTAH, Ismail
FAUCHEUX, A.
FAUCON, Bernard
FAULKNER, Frank

FAZZINI, Pericles
FEELEY, Paul
FEINER, Elaine
FEITO, Luis
FELDMAN, Barry
FELDMAN, Walter
FERBER, Herbert
FERGUSON, Tom
FERNANDEZ, Agustin
FERNANDEZ, Rudy
FERNANDEZ-MURO, José A.
FERNANDO, Charles
FERRARA, Jackie
FERRELL-HERO, Barbara
FERREN, John
FERRER, Rafael
FERREZ, Marc
FESENMAIER, Helen Marie
FESTA, Tano
FIARD, Danielle
FICHTER, Robert
FILIPOWICZ, John David
FILIPOWSKI, Richard
FINSTER, Howard
FINK, Aaron
FIORE, Joe
FISCHER-LUEG, Konrad
FISCHL, Eric
FISH, Janet
FISHER, Vernon
FISHMAN, Louise
FISHMAN, Richard
FITZGERALD, Astrid
FLAVIN, Dan
FLAVIN, Sonja
FLEISCHMANN, Adolf
FLICK, Robbert
FLOOD, Edward
FLORSHEIM, Richard
FLOWERS, Thomas E.
FLY
FONG, Chung-Ray
FONTANA, Domenico
FONTANA, Lucio
FOPPIANI, Gustavo
FORD, Hermine
FORSMAN, Chuck
FOSS, Stephen
FOSSIER, Christian
FOSTER, Gus
FOSTER, Kathleen
FOUQUET, P.
FRAHM, Klaus
FRAMPTON, Hollis
FRANCESCHI, Edgardo
FRANCIS, Sam
FRANCIS, Tom
FRANK, Doug
FRANK, Robert
FRANGELLA, Luis
FRANKENTHALER, Helen
FRANKLIN, Richard
FRANSIOLI, Thomas
FRASCONI, Antonio
FRASER, Hamilton
FRAZER, Jim
FRECKELTON, Sondra
FREDENTHAL, Ruth Ann
FREDERICK, Robbie
FREED, David
FREI, Linae
FREILICHER, Jane
FRENCH, Leonard
FRIAS, Gato

FRIEDBERG, Richard
FRIEDLAENDER, Bilge
FRIEDLAENDER, Johnny
FRIEDLANDER, Lee
FRINK, Elisabeth
FRITH, Francis
FUDGE, John
FUJIMURA, Kimiko
FUJISAWA, Akira
FUKUI, Nobu
FULLER, Buckminster
FULLER, Emily
FULLER, Sue
FULTON, Hamish
FUN, Hon Chi
FUNASAKA, Yoshisuke
FUNK, Mitchell
FUTURA 2000

G

GABRIELSON, Walter
GAINES, Charles
GALKOWSKA, Stochel
GALVEZ, Armando
GAMMON, Reginald
GARBE, William
GARCIA, Domingo
GARDINER, F. J. H.
GARDNER, Alexander
GARABITO, Ricardo
GAREL, Leo
GARET, Jedd
GAROUSTE, Gerard
GARREAUD, Gaston
GASSISI, Joan
GATCH, Lee
GATES, Irving
GATEWOOD, Maud
GAUL, Winfred
GAVIN, Alain
GEAR
GECHTOFF, Sonia
GEERLINGS, Gerald K.
GEIGER, Anna Bella
GEIGER, Rupprecht
GEK, Ng Lee
GENN, Nancy
GENTRY, Herbert
GEOFFREY, J. Iqbal
GEORGE, Richard
GEORGE, Thomas
GEPPERT, Jan
GERSON, Barry
GERSTNER, Karl
GIACOMETTI, Alberto
GIANAKOS, Steve
GIBBONS, Arthur
GIBSON, Ralph
GIL, Juan
GILBERT, Andrea
GILBERT, Archie
GILBERT, Lionel
GILBERT and GEORGE
GILBERT-ROLFE, Jeremy
GILES, William
GILHOOLY, David
GILLETTE, Frank
GILLIAM, Sam
GILULA, Stan
GINSBERG, Elizabeth
GIOBBI, Edward
GIORGI, Bruno

GIRARDET, P.
GIROUARD, Tina
GITLIN, Michael
GIULIANO, Luis
GLARNER, Fritz
GLATTFELDER, Hansjoerg
GLAZER, Milton
GLIER, Michael
GODIN, Raymonde
GODWIN, Judith Whitney
GOELL, Abby
GOLD, Sharon
GOLDBECK, E. O.
GOLDBERG, Michael
GOLDBLATT, Joel
GOLDENBERG, Thomas
GOLDERMAN, Mark
GOLDSLEGER, Cheryl
GOLDSTEIN, Jack
GOLUB, Leon
GOMEZ-QUIROZ, Juan
GONZALEZ, Juan
GONZALEZ-TORNERO, Sergio
GOODMAN, Ken
GOODMAN, Robert Lang
GOODNOFF, Alan
GOODNOUGH, Robert
GOODWIN, Guy
GOODWIN, Richard Labarre
GOPAL-CHOWDHURY, Paul
GORCHOV, Ron
GORDON, Bonnie
GORDON, Jan
GORDY, Robert
GORNIK, April
GORRIARENA, Carlos
GOTTFRIED, Arline
GOTTLIEB, Adolph
GOTTSCHO, Samuel
GOUREVITCH, Jacqueline
GOYA, Francisco José de
GRAESER, Camille
GRAFTON, Rick
GRAMMATOPOULOS,
 Constantine
GRANDJEAN, Raymond
GRASS, Peter
GRASSMAN, Marcello
GRAVES, Bradford
GRAVES, Michael
GRAVES, Nancy
GRAVESEN, Oluf
GRAY, Eileen
GREAVES, Derrick
GRECO, Anthony
GREEN, Denise
GREEN, George
GREEN, Randy
GREENBERG, Marilyn
GREENE, Ralph
GREENE, Stephen
GREENFIELD, Lois
GREENFIELD-SANDERS, Timothy
GREENIDGE, Knolly
GREENMAN, Paula
GREENWOOD, Philip
GREIG, Rita
GREY, Richard
GRIEFEN, John
GRIFFIN, Phil
GRIFFITH, Denny
GRIGORIADIS, Mary
GRILO, Sarah
GROOMS, Red

GROOVER, Jan
GROSS, Julie
GROSS, Rainer
GROSVENOR, Robert
GRUAU
GRUBER, Aaronel
GRUEN, John
GRUHLER, Paul
GU, Mu
GUBERMAN, Sidney
GUERRERO, José
GUEST, George
GUIFFREDO, Mauro
GULGEE
GUMMER, Don
GUNDELFINGER, John
GUNTER, L.
GURSOY, Ahmet
GUSTON, Philip
GUTHRIE, Vivian
GUTMANN, John
GUTMANN, Willi
GUVE, George
GWATHMEY, Edith
GWON, Steven

H

HAACKE, Hans
HAAS, Ernst
HAAS, Richard
HACKMAN, Vida
HADZI, Dimitri
HAESSLE, Jean-Marie
HAFIF, Marcia
HAGIN, Nancy
HAGIWARA, Brian
HAGIWARA, Hideo
HAHN, Batty
HAINES, E. S. M.
HAJICEK, James
HALAHMY, Oded
HALBERSTADT, Ernst
HALE, Robert B.
HALL, Douglas Kent
HALL, Susan
HALLMAN, Gray
HALVORSEN, Francine
HAMAGUCHI, Yozo
HAMBLETON, Richard
HAMBLETT, Theora
HAMBOURG, Serge
HAMILTON, Richard
HAMMERBECK, Wanda
HAN, H. N.
HANSELL, Freya
HANSEN, Gaylen
HARA, Takeshi
HARDING, Goodwin
HARE, David
HARE, Jacki
HARIKAE, Shoji
HARING, Keith
HARKINS, George
HARNETT, William M.
HARRIOT, A. M.
HART, Gordon
HARTLEY, Marsden
HARTMAN, Sheigla
HARTUNG, Hans
HASHEY, Jan
HASIOR, Joanna
HASKE, Joseph

HASSAN, Mansoora
HATCH, Tom
HATCHER, Brower
HATKE, Walter
HAUB, Christian
HAUBENSAK, Pierre
HAUER, Erwin
HAUPTMAN, Susan
HAVAS
HAXTON, David
HAY, Alex
HAYAKAWA, Shigeaki
HAYDEN, Henri
HAYES, Charles
HAYES, David
HAYNES, Nancy
HAYTER, S. W.
HAYWARD, Bill
HAYWARD, George
HAZLITT, Don
HEAD, Michael
HEDGE, Gene
HEIDEKEN, Karl
HEIFERMAN, Marvin
HEILIGER, Linda
HEILMANN, Mary
HEJDUK, John
HELD, Al
HELION, Jean
HELLER, Dorothy
HENDON, Cham
HENLE, Fritz
HENLE, Jan
HENNEMAN, Jeroen
HENNINGSEN, Chuck
HENNESSY, Richard
HENRIQUES, Cletus
HENRY, Edward Lamson
HERBERT, James
HERBIN, Auguste
HERMAN, Alan
HERON, Patrick
HEWITT, Charles
HIGA, Yoshiharu
HIGGINS, Edward
HIGGINS, Wilfred
HIGHSTEIN, Jene
HILL, Charles Christopher
HILL, Clinton
HILL, John
HILLARD, John
HILL-MONTGOMERY, Candace
HILTON, Ralph
HINES, Felrath
HINMAN, Charles
HINZ, Randal
HITCH, Stewart
HITCHENS, Ivon
HITCHENS, John
HLITO, Alfredo
HOAGLAND, W.
HOCHHAUSEN, S. H.
HOCHHAUSEN, William W.
HOCKNEY, David
HODGKIN, Howard
HOFMANN, Richard
HOFMEISTER, Johannes
HOHLWEIN, Ludwig
HOKANSON, Hans
HOLDEN, Norman
HOLLAND, Tom
HOLLINGSWORTH, Al
HOLLWEG, Alexander
HOLMES, J. B.

HOLMES, Reg
HOLSTE, Tom
HOLSTEIN, Pieter
HOLT, Nancy
HOLZER, Jenny
HOMER, Winslow
HOMMA, Kazufumi
HOMPSON, Davi Det
HONEGGER, Gottfried
HORIE, Ryoichi
HORIUCHI, Paul
HORVAT, Joze-Jaki
HORVATH, Frank Charles
HORWITT, Will
HOSHI, Joichi
HOUGHTON, Barbara
HOUSE, Gordon
HOVEYDA, Fereydoun
HOWARD, Michael
HOWE, Nelson
HOYLAND, John
HSI, Chen Wen
HSIAO, Ren-Jen
HUBBARD, Eleanor
HUDDLESTON, John
HUGHES, Manuel
HUGHES, Patrick
HUJAR, Peter
HULL, Richard
HULTBERG, John
HUMBOLT
HUMPHREY, Ralph
HUNDERTWASSER
HUNT, Bryan
HUNT, Richard
HUNTER, Clementine
HUNTINGTON, Jim
HURSON, Michael
HURST, Ray
HUSHLAK, Gerlad
HUTCHINSON, Peter
HUXLEY, Paul
HWANG, Kyu-Baik

I

IANELLI, Arcangelo
IBRAHIM, Saadiya
IDA, Shoichi
IMMENDORF, Jorg
IHARA, Michio
INCANDELA, Gerald
INCONIGLIAS, Vincent
INDIANA, Robert
INOKUMA, Guen
INSLEY, Will
INUKAI, Naohiko
IPPOLITO, Angelo
IRELAND, Patrick
IRIZARRY, Carlos
IRWIN, Albert
ISAACS, Ron
ISOBE, Yukihisa
ISRAEL, Robert
ITO, Miyoko
ITZKOWITZ, Lynn
IVES, Norman
IWASA, Toshio

J

JACKSON, Herb
JACKSON, William H.

JACOBI, Rizzi and Peter
JACOBS, Jim
JACOBSEN, Antonio
JACOBSEN, Kreg
JACOBSHAGEN, Keith
JACQUES, Eddy
JACQUET, Alain
JACQUETTE, Yvonne
JAEGER
JAMES, Christopher
JAMESON, Susan
JAMIESON, Philip
JANNETTI, Tony
JANOWICH, Ron
JANSEN, Angela
JANSONS, Andrew
JASEK-FLANCZEWSKA, Jrma
JAUDON, Valerie
JEFFERS, Wendy
JENKINS, Paul
JENNIS, Stevan
JENSEN, Alfred
JENSEN, Bill
JENSHEL, Len
JIMENEZ, Edith
JINN, Shiy Oe
JOELSON, Suzanna
JOHN, Isabel
JOHNS, Jasper
JOHNSON, Cletus
JOHNSON, Daniel
JOHNSON, Floyd
JOHNSON, Lester
JOHNSTON, Medford
JONAS, Joan
JONES, Allen
JONES, Pamela
JOO, Seah Kim
JORDAN, Rachel
JUDD, Donald
JUSZCZYK, James

K

KAHN, Louis
KAHN, Scott
KAHN, Wolf
KALINOWSKI, H. E.
KAMIYA, Shin
KANEKO, Jun
KAPLAN, Leo
KAPLAN, Peter
KAPLOWITZ, Jane
KAPP, David
KARDON, Dennis
KARSH, Yousuf
KARWOSKI, Richard
KASSEL, Barbara
KASTEN, Barbara
KATZ, Alex
KAUFMAN, Jane
KAUFMAN, Ronnie
KAUPELIS, Robert
KAWABATA, Minoru
KAWASHIMA, Takeshi
KAZLOV, Brian
KEE, Chueng
KEERY, Francene
KEISTER, Steve
KELLERS, Michael
KELLNER, Lucia
KELLOGG, D. W.

KELLY, Ellsworth
KELLY, James
KELLY, Leon
KELSEY, Steve
KEMBLE, Kenneth
KEMPSTER, William
KENDRICK, Mel
KENNEDY, Ailsa
KENNEDY, Clarence
KENNY, Charles
KENSETT, John Frederick
KEPES, Gyorgy
KEPETS, Hugh
KERNS, Ed
KERWIN, Claire
KERTÉSZ, André
KESSLER, Alan
KHAL, Helen
KHALIFE, Jean
KHEEL, Constance
KIEFER, Anselm
KIM, Bong Tae
KIM, Ki Sung
KIM, Tchah-Sup
KIMBEI, Kusakabe
KIMURA, Reiji
KIMURA, Takao
KING, E. Kevin
KING, Moses
KING, Ron
KINNE, Carol
KINOSHITA, Shin
KINOSHITA, Tomio
KIPP, Lyman
KIRCHBERGER, Gunther C.
KITCHEN, Robert
KLEIN, Gloria
KLEINHAMMES
KLENK, William
KLIPPER, Stuart
KNATHS, Karl
KNERR, Theodore
KNORR, Karen
KNIPSCHILD, Robert
KOBERLING, Bernd
KODAKA, Hiroyuki
KOEGEL, John
KOENECKE, Hans Werner
KOESTER, Ralph
KOHLHOFER, Christof
KOHLMEYER, Ida
KOHN, William
KOKINES, George
KOKOSCHKA, Oskar
KOK-SIONG, Lo
KOLAR, Jiri
KOMOSKI, Bill
KOMURO, Itaru
KOO, Chun-Kuang
KOOLHAUS, Rem
KOON, Yeo-Hoe
KORAB, Balthazar
KOREN, Schlomo
KORMAN, Harriet
KOSAKA, Ryoji
KOSCIANSKI, Leonard
KOSUTH, Joseph
KO-UDOMVIT, Thayorn
KOZLOFF, Joyce
KRAJNC, Toni
KRAMER, Harry
KRAMER, L.
KRAMER, Margia
KRANZ, Kurt

KRAUS, G.
KRAUSS, Anthony
KREUTZ, Heinz
KRIESBERG, Irving
KRODY, Barron
KROLL, Boris
KRUGER, Barbara
KRUGER, Louise
KRUSHENICK, Nicholas
KRZYZANOWSKI, Michel Szulc
KUCEROVA, Alena
KUHRMAN, Paul
KUI-TING, Leung
KULICKE, Robert
KUNG, Kan Tei
KUNICHIKA
KUNISADA
KUNIYOSHI
KUNO, Shin
KUNZ, Don
KUROZAKI, Akira
KURT, Kay
KURTZ, Elaine
KUSAKA, Ken Ji
KUSHNER, Robert
KWAN, David Shee
KWAN, Goh Beng
KWANG, Choo Keng
KWANG, Tan Teo
KWILECKI, Paul
KYU, Lee Han

L

LACK, Stephen
LA CROIX, Richard
LADERMAN, Gabriel
LAEMMLE, Cheryl
LAFITTE, Pierre
LAING, Gerald
LAM, Jennett
LAMB, Ernest
LAN, Peter
LANCASTER, Mark
LANDFIELD, Ronnie
LANDSCHUTZ, Peter
LANE, Lois
LANG, Daniel
LANGE, Vidie
LANGENSTEIN, Michael
LANGERMAN, Elaine
LANGLAIS, Bernard
LANGLOIS, Jean-Yves
LANIER, Ruth Asawa
LA NOUE, Terence
LANSKOY, André
LANYON, Ellen
LANYON, Peter
LARSEN, Ed
LARTIGUE, Jacques
LASANSKY, Mauricio
LASSAW, Ibram
LAU, Peter
LAU, Rex
LAUGHLIN, Clarence John
LAURENT, Juan
LAW, Carolyn
LAWLESS, Philip
LAWSON, Thomas
LAZAR, Ruth
LEAVER, Dorian
LE BROCQUY, Louis
LE BRUN, Christopher

LE CORBUSIER
LEDESMA, Velerio
LEE, Bang-Ja
LEE, Henry, Jr.
LEE, Shi-Chi
LEE, Wen-Han
LEECH, John
LEEPER, Doris
LEES, John
LEE-SMITH, Hughie
LEFF, Juliette
LE GAC, John
LÉGER, Fernand
LEIBER, Gerson
LELAND, Whitney
LENK, Kasper-Thomas
LENKOWSKY, Marilyn
LEONE, Mauro
LERAILLE, Eric
LERE, Mark
LESLIE, Seaver
LEUFERT, Gerd
LE VA, Barry
LEVERETT, David
LEVI, Julian
LEVIN, Robert
LEVINE, David
LEVINE, Marilyn
LEVINE, Martin
LEVINE, Sherrie
LEVINE, Tom
LEVINSON, Mon
LEVIS, Cintia
LEVITT, Helen
LEVY, Paul
LEWIS, Edmund Darch
LEWIS, J. Newel
LEWIS, Larry
LEWIS, Susan
LEWITT, Sol
LEYNES, Nestor
LIAO, Shiou-Ping
LIBERMAN, Alexander
LICHTENSTEIN, Roy
LIEBERMAN, Nathaniel
LIEBMANN, Gerhardt
LIEGME, J. F.
LI FA, Shiah
LIFSCHITZ, Daniel
LIGARE, David
LIJN, Liliane
LIM, Kim
LINDNER, Richard
LINDSAY, Steve
LINDZON, Rose
LINFANTE, Paul
LINHARES, Joaquin E.
LINHARES, Judith
LINK, John
LINTZ, Rita
LIPSKI, Donald
LIU, Max C.
LIVINGSTONE, Biganess
LLOYD, Elliott
LLUCH, Erick
LOBE, Robert
LOCKS, Norman
LONDO, I. Nyoman
LONGO, Robert
LOPEZ, Domingo
LOPEZ DEL CAMPO, Rafael
LOPEZ-GARCIA, Antonio
LOPRETE, Hebe
LORBER, Stephen

LORCINI, Gino
LORIETO, Mario
LORING, John
LORING, Josiah
LOUISON, D.
LOVELESS, James
LOWNEY, Bruce
LOZANO, Lee
LOZOWICK, Louis
LUCERO-GIACCARDO, Felice
LUDOLF, Rubem
LUFTSCHEIN, Joseph
LUKIN, Sven
LUN, Liao Yung
LUNA, Antonio Rodriguez
LUND, David
LUSKER, Ron
LU-YUN, Irene Chou
LYON, Danny
LYTLE, Richard

M

MABE, Manabu
MABELE, Clementine
MABERRY, Phillip
MACCIO, Romulo
MACENTYRE, Eduardo
MACHADO, Ivens
MACK, Heinz
MACKRELL, J.
MACLAY, David
MACLEAN, Alex
MACWHIRTER, J.
MADI, Hussein
MAGEE, Brian
MAGLIONE, Milvia
MAIA, Antonio
MAISEL, Joe
MAJORE, Frank
MAJORS, William
MAKI, Haku
MALCHOW, Rick
MALDONADO, Alex
MALLORY, Ronald
MALTZ, Russell
MAMOSIMA, Geargina
MANANSALA, Vincente
MANDIARGUES
MANGOLD, Robert
MANGOLD, Sylvia Plimack
MANSO, Carlos
MANSUR, S.
MANZONI, Piero
MAPPLETHORPE, Robert
MARAZ, Adriana
MARCA-RELLI, Conrad
MARCOTE, José
MARCUS, Marcia
MARCUS, Peter
MARDEN, Brice
MARGO, Boris
MARGOLIES, John
MARGOLIS, Margo
MARI, Enzo
MARINI, Marino
MARISOL
MARMELSTEIN, Michael
MARMOL, Ignacio
MAROTTA, Vincente
MARQUIS, David
MARSH, Reginald
MARTIN, Agnes

MARTIN, Kenneth
MARTIN, Ray
MARTIN, Susan Kraus
MARTIN, Thomas
MARTINS, Aldemir
MARTORELL, Antonio
MARUYAMA, Hiroshi
MASSEY, Jack
MASTERS, Robert
MATHIEU, Georges
MATISSE, Henri
MATLOSA, Majanki
MATSUI, Masaharu
MATSUMOTO, Akira
MATSUTANI, Takesada
MATTA
MATTA-CLARK, Gordon
MAURER, Neil
MAUSS, Peter
MAUVINIÈRE
MAYES, Elaine
MAZZONI, Raul
McAULIFFE, J. J.
McCANN, Thomas
McCARTHY, Justin
McCLANAHAN, Preston
McCLANCY, George
McCLARD, Michael
McCOLLUM, Allan
McCOY, Ann
McCRACKEN, John
McDOWELL, Mark
McELHENNEY, Sidney
McFADDEN, Mark
McINESS, Harvey
McKEEVER, Ian
McKIE, Todd
McNAIR, James
McWILLIAMS, John
MEADMORE, Clement
MECKSEPER
MEDINA, Enriqué
MEEKER, Dean
MEEKS, Leon
MEHRING, Howard
MELCHERT, James
MELHEIRO
MELLEN, Mary
MENDELSOHN, John
MENG, Wendy
MENGOLINI, Aldo
MERENSTEIN, Larry
MERIDA, Carlos
MERINOFF, Dimitry
MERTA, I. Nyoman
MERTZ, Albert
MESCHES, Arnold
MESSAGER, Jean
MESTEROU, Maria
METHAPISIT, Suwan
MEURER, Charles A.
MEYEROWITZ, Joel
MICHAELS, Georgia Blizzard
MICHALS, Duane
MICHEL, Jorge
MICHEL, Karl
MICHELIN III, F.
MICHOD, Susan
MIDDAUGH, David
MIECZKOWSKI, Edwin
MIGNONI, Fernando
MIGNOT, Pierre
MILANI, Richard
MILBOURNE, C.

MILCOVITCH
MILLER, Brenda
MILLER, Earl
MILLER, Mary B.
MILLER, Melissa
MILLER, S. P.
MILLER, Steve
MILLINGTON, Terence
MILLINGTON-DRAKE, Teddy
MILLMAN, Edward
MILLOFF, Mark
MILNE, David
MILOW, Keith
MILTON, Peter
MIMOGLOU, Alex
MIN, Hyoung Ok
MINER, Todd
MINICK, Roger
MINNEKOV, Velichko
MINUJIN, Marta
MIR, Imran
MIRÓ, Joan
MISHAAN, Rodolfo
MISRACH, Richard
MISS, Mary
MITCHELL, Joan
MITCHELL, L. M.
MITCHELL, Paul
MIZUFUNE, Rokushu
MIYASHITA, Tokio
MIZUNO, Mineo
MOCK, Richard
MODEL, Lisette
MOGENSEN, Paul
MOHALYI, Yolanda
MOHASSESS, B.
MOHIDIN, Abdul Latiff
MOHR, Manfred
MOLE & THOMAS
MOLINARI, Guido
MOLINARI-FLORES, Luis
MOLL, John
MOMENT, Barbara
MOMOSE, Hisashi
MONNIER, Jacqueline
MONRO, Nicholas
MONTALBA, Clara
MONTI, John
MOON, Jeremy
MOORE, Claire
MOORE, Henry
MOORE, John
MOORE, Robert
MOORE, Vincent Tulsa
MOORMAN, Charlotte
MOOSMANN, E. Peter
MORALES, Armando
MORALES, Carmengloria
MORALIS, Yannis
MORANDI, Giorgio
MORELLET, François
MORENI, Mattia
MORGAN, Norma
MORGAN, Robert
MORI, Yoshitoshi
MORIMOTO, Hiromitsu
MORIMOTO, Kikuko
MORLEY, Malcolm
MORPER, Daniel
MORRIS, Hilda
MORRIS, Kyle
MORRIS, Robert
MORSCH, Roy
MORSE, Barbara

MORTON, Ree
MOSER, Susanne
MOSER, Wilfried
MOSES, Ed
MOSS, Irene
MOTHERWELL, Robert
MOTI, Kaito
MOULTON, Donn
MOY, Seong
MOYNIHAN, Rodrigo
MR. MENTAL
MUDFORD, Grant
MUELLER, Stephen
MUJUNG, I. Wajan
MULLEN, Philip
MULLER, Gregoire
MULLER, Willi
MULLICAN, Matt
MUMPRECHT
MUNARI, Bruno
MUNCH, Marguerite
MUNK, Loren
MUNROE, Olivia
MURAI, Masanari
MURAKAMI, Akira
MURATA, Hiroshi
MURCH, Walter
MURPHY, Adrian
MURPHY, Catherine
MURRAY, Elizabeth
MURRAY, John
MURRAY, Judith
MURRAY, Robert
MURRILL, Gwynn
MURTIC, Edo
MUSIC, Zoran
MUYBRIDGE, Eadweard
MYERS, Joan
MYERS, Robert

N

NAHLE, Wajih
NAKAMURA, Kenshi
NAKAYAMA, François
NAKAYAMA, Tadashi
NAMUTH, Hans
NARES, James
NARKIEWICZ, Paul
NASON, Robert
NATKIN, Robert
NAUMAN, Bruce
NAVARRO, J. Elizalde
NAYLOR, Geoffrey
NECHVATAL, Joseph
NEEL, Alice
NEILAND, Brendan
NELSON, Barry
NELSON, David
NELSON, Dona
NELSON, Roger Laux
NESBITT, Lowell
NEUHAUS, Max
NEUSTEIN, Joshua
NEVELSON, Louise
NEWMAN, Arnold
NICE, Don
NICKSON, Graham
NICOSIA, Nic
NII, Yuko
NIIZUMA, Minoru
NISHIKI, Minoru
NISHIZAWA, Shizuo

NOE, Luis Felipe
NOEL, Georges
NOGUCHI, Isamu
NOLAN, Sidney
NOLAND, Kenneth
NORIKO
NORRIS, Joe
NOUR, Amir
NOVAK, Barbara
NOVELLI, Gaston
NOVROS, David
NOYES, Sandy
NOZKOWSKI, Thomas
NTIRO, Sam J.

O

OBERING, Mary
OBIN, Jean-Marie
OBREGON, Alejandro
OBUCK, John
OCAMPO, Miguel
O'CONNOR, Charles
O'NEIL, Mary Lovelace
O'SULLIVAN, Timothy
OEHM, Herbert
OELMAN, Michael
OHASHI, Yutaka
OHLSON, Doug
OHNO, Masuho
OHTAKE, Tomie
OISTENEAU, Valery
OKADA, Kenzo
OKULICK, John
OLDENBURG, Claes
OLITSKI, Jules
OLLEVACA, A.
OLLMAN, Arthur
OMLOR, P.
ONOGI, Gaku
ONOSATO, Toshinobu
OPALKA, Roman
OPPENHEIM, Dennis
OPPER, John
ORCEL, M.
ORR, Eric
ORTMAN, George
OSBORNE, B. F.
OSBORNE, Elizabeth
OSINSKI, Christine
OTTANELLI, Vittorio
OTTERNESS, Tom
OUTERBRIDGE, Graeme
OUZOUNOV, Detchko
OVENDEN, Graham
OVERSTREET, Joe
OVIEDO, Ramon
OWEN, Frank

P

PACE, Stephen
PACK, John
PAGLIARI, Ulisse
PAIK, Nam June
PALADINO, Dominico
PALENCIA, Benjamin
PALMORE, Tom
PALMYRA
PAN, Chang
PANE, Gina
PANNETT, Elizabeth

PAOLOZZI, Eduardo
PAPAKONSTANTIS, Yiorgos
PAPASPYROPOULOS, S.
PAPPRILL, Henry
PARK, Neil
PARKER, Ann
PARKER, Jim
PARKER, Joe Pat
PARKER, Olivia
PARKER, Raymond
PARSONS, Betty
PARTHORNRATT, P.
PARTURIER
PASIK, Bettina
PASINSKI, Irene
PASMORE, Victor
PATKIN, Izhar
PAUL, Suzanne
PEARSON, John
PEARSON, Henry
PECK, Augustus
PEDJA, Miloslavjevich
PEI, Lee Quan
PEKARSKY, Mel
PENCK, A. R.
PENESTANAN, Nasib
PENG, Cheng Soo
PENKER, Ferdinand
PENNY, Christopher
PENTEADO, Darcy
PERAZA
PEREZ, Matilde
PERILLI, Achille
PERKELL, Jeff
PERR, Herbert
PERSIO, Luio
PESSIN, Marc
PETERDI, Gabor
PETERSON, Robert
PETERSON, Roland
PETIT, Gaston
PETO, John Frederick
PETTERSON, Cliff
PEVERELLI, Cesare
PEZESHK-NIA
PFAFF, Judy
PFAHL, John
PFEIFFER, Werner
PFOHL, Jerry
PFRIEM, Bernard
PHELAN, Ellen
PHILIPP, Helga
PHILLIPS, Alice
PHILLIPS, David
PHILLIPS, Jay
PHILLIPS, Tom
PIACENZA
PICASSO, Pablo
PIENE, Otto
PIENG, Soo
PIERCE, Elijah
PINARDI, Enrico
PINDELL, Howardena
PINK, Jim
PINO, Felipe Carlos
PINOTTI, Tony
PIPER, John
PIRANESI, Giovanni Battista
PIROZZI, Jorge
PITIGLIANI, Letizia
PITTS, Richard
PLAGENS, Peter
PLAMONDON, Peter
PLOTKIN, Linda

PLOWMAN, Chris
PLUMB, John
PLUNKETT, Ed
PNIEWSKA, Barbara
PO-YONG
POLESELLO, Rogelio
POLIAKOFF, Serge
POLKE, Sigmar
POLLOCK, Jackson
POMODORO, Arnaldo
POMODORO, Gio
POMPA, Gaetano
PONCE DE LEON, Michael
POND, Clayton
PONGDAM, Prayat
POON, Anthony
POORTENAAR, Jan
PORTER, Bruce
PORTER, Eliot
PORTER, Fairfield
PORTER, Katherine
PORTER, Liliana
PORTER, Stephen
POSEN, Steven
POSEY, Ernest
POTENZA, Sally
POULOS, Basillius
POUSETTE-DART, Joanna
POVLICH, Robert
POWERS, Susan
POZZI, Lucio
PREECE, Lawrence
PRESTON, Astrid
PRINCE, Richard
PROVISOR, Janis
PRYOR, Gerald
PSIAKIS, Renée Carrie
PUENTE, Alejandro
PUGUR, I. Wayan
PUOTILA, Ritva
PURCELL, Roy
PURDY, Donald
PURINS, Uldis

Q

QUAK, Insik
QUAYTMAN, Harvey
QUEK, Kian Guan
QUINONES, Lee
QUINTE, Lothar

R

RABKIN, Leo
RAFFAEL, Joseph
RAFOSS, Kaare
RAINEY, Ed
RAINIER, A.
RAJS, Jake
RAMANAUSKAS, Dalia
RAMBERG, Christina
RAMIREZ, Eduardo
RAMIREZ, Martin
RAMOS, Mel
RAND, Archie
RAND, Ellen E.
RAUSCHENBERG, Robert
RAYMOND, David
RAY, Man
RAYO, Omar
REDEKER, Peter

RED FEATHER, Mary
REED, David
REESE, Boyd
REESE, Ron
REGAZZONI, Ricardo
REGINATO, Peter
REICE, Milo
REICH, Murray
REINEKING, James
REINHARDT, Ad
REISCHEK, Jesse
REMINICK, Seymour
RENFROW, Gregg
RENOIR, Auguste
RENZI, Juan Pablo
RENZONI, Louis
RESIKA, Paul
RET, Etienne
RETTICH, Jerome
REYES, Jesus
REYNAL, Jean-Claude
REYNOLDS, F.
REYNOLDS, G. H.
RHEINGOLD, Lois
RHODES, Leah
RICH, Clyde
RICH, Garry
RICH, Linda
RICHARD, Jim
RICHARDS, Bill
RICHARDS, Nancy
RICHTER, Gerhard
RICHTER, Scott
RILEY, Barbra
RILEY, Bridget
RINGGOLD, Faith
RIO BRANCO, Miguel do
RIPLEY, Curtis
RIPPS, Rodney
RIVERO, Antonio
RIVERS, Larry
ROBAUDY, F.
ROBBIN, Tony
ROBERTS, Ines E.
ROBERTSON, Mary Ann
ROBINSON, David
ROBINSON, H. R.
ROBIROSA, Josefina
ROCKBURNE, Dorothea
ROCKWELL, Jarvis
RODAN, Don
RODIN, Auguste
RODIN, Muriel
RODRIGUEZ, Raul
RODRIGUEZ-LARRAIN, Emilio
ROJAS, Carlos
ROJO, Benito
ROJO, Vicente
ROLLER-WILSON, Donald
ROLLINSON, William
ROMANO, Salvatore
ROMERO, Nelson
RONALD, William
ROONEY, John
ROONG
ROOS, Gabriele
ROSEBROOK, Rodney
ROSEN, Jane
ROSENBLATT, Phyllis
ROSENQUIST, James
ROSENTHAL
ROSER, Ce
ROSS, John
ROSS, Johnnie

ROSS, Richard
ROSSI, Aldo
ROSSI, Barbara
ROTH, David
ROTH, Dennis
ROTH, Frank
ROTH, Richard
ROTHENBERG, Susan
ROTTERDAM, Paul
ROUALT, Georges
ROUAN, François
ROWE, Nellie Mae
ROY, John
RUBIN, Mitchel
RUBINSTEIN, Barnet
RUBNITZ, Tom
RUDA, Edwin
RUDQUIST, Jerry
RUHTENBERG, Cornelis
RUMM, Ellen
RUPERT, Randal
RUPP, Christy
RURIKKSON, Bjorn
RUSCHA, Ed
RYMAN, Robert

S

SAARI, Onni
SACK, Stephen
SADAHIDE
SADALI, Ahmas
SAGANIC, Livio
SAGE, Kay
SAIKALI, Nadia
SAINT PHALLE, Nicki de
SAITO, Kikuo
SAITO, Kiyoshi
SAITO, Satoshi
SAITO, Yoshishige
SAKAMOTO, Koichi
SAKR, Mohamed
SALAHI, Ibrahim
SALAUN, A.
SALCHOW, Gordon
SALGANIK, Jassa
SALLE, David
SALTZ, Mark
SAMARAS, Lucas
SAMBO, Kingsley
SAMELSON, Andra
SANCHEZ, Emilio
SANDBACK, Fred
SANDER, Ludwig
SANDERS, Benita
SANDERS, Brad
SANDERSON, Doug
SANDLER, Barbara
SANDLIN, David
SAN MARTIN, M.
SANMONJI, Kazuhiko
SANSOTTA, Anthony
SANTLOFER, Jonathan
SANTOMASO, Giuseppe
SANTORE, Joseph
SANTOS, René
SANZ, Eduardo
SAPTOHOEDOJO
SARET, Alan
SARGENT, John Singer
SARNOFF, Lolo
SARTORIUS, John Nott
SATO, Tadashi
SAVELLI, Angelo

SAVINAR, Tad
SAVITSKY, Jack
SAXON, Charles
SCARPA, Gino
SCHAPIRO, Miriam
SCHARF, William
SCHARLIN, Kerri
SCHECHTER, Robert
SCHEGGI, Paolo
SCHIFF, Leslie
SCHIFFREN, Herbert
SCHIRM, David
SCHLESINGER, Mark
SCHMIDT, Julius
SCHNABEL, Julian
SCHNEEBAUM, Tobias
SCHNELL, John
SCHOLTEN, Maria
SCHOMER, Roslyn
SCHONZEIT, Ben
SCHOOLEY-ROBINS, Kathryn
SCHRAGER, Victor
SCHRANK, Linda
SCHREIBER, Barbara
SCHROECK, R. D.
SCHROTH, Peter
SCHUB, Stephanie
SCHUSELKA, Elfi
SCHUTZ, Anton
SCHVARTZ, Marcia
SCHWALBE, Ole
SCHWARTZ, Barbara
SCHWARTZ, Elliott
SCHWEDLER, William
SCIALOJA, Tito
SCLIAR, Carlos
SCOTT, Carrie Adella
SCOTT, William
SCULLY, Sean
SEARLE, Ronald
SECUNDA, Arthur
SEDGLEY, Peter
SEED, Suzanne
SEKINE, Yoshio
SERRY, John
SEFRAN, Gorazd
SEGAL, George
SEHILI
SEKINE, Yoshio
SELEY, Jason
SELF, Colin
SEMPERE, Eusebio
SENBERGS, Jan
SENG, Ong Kim
SENG, Teo Eng
SEPEHRI, Sohrab
SERPA, Ivan
SERRA, Richard
SERRANO, José Luis
SEVEN SEVEN, Olabisi
SEVEN SEVEN TWINS, Olaniyi
SEVERINI, Gino
SEYMOUR, Samuel
SHAFER, Orie
SHALOM of SAFED
SHANK, Stephen
SHAPIRO, Babe
SHAPIRO, Davis
SHAPIRO, Eva
SHAPIRO, Joel
SHARITS, Paul
SHARON, Russell
SHARP, Vincent
SHARP, William

SHATTER, Susan
SHAW, Charles
SHAW, Don
SHAW, Kendall
SHAW, Susan
SHEA, Judith
SHEDLETSKY, Stuart
SHEEHAN, Richard
SHELTON, Tom
SHEMI
SHERMAN, Cindy
SHIANG, Lu Kuo
SHIBRAIN, Ahmen M.
SHIELDS, Alan
SHIELDS, Jody
SHINEMAN, Larry
SHINODA, Toko
SHORE, Stephen
SHOU-KWAN, Lui
SHOWELL, Kenneth
SHROYER, Michael
SIEGEL, Alan
SIEGEL, Isabelle
SIGLER, Hollis
SIGMUND, Gretchen
SIHVONEN, Oli
SILLS, Thomas
SILVA, Carlos
SILVERMAN, Mel
SILVIA, Nancy
SIMA, Joseph
SIMMONS, Laurie
SIMONDS, Charles
SIMSON, Bevlyn
SINCLAIR
SINGER, Gerard
SINGER, Michael
SINGIER, Gustave
SINTON, Nell
SIQUEIROS, David
SISKIND, Aaron
SKOGLUND, Sandy
SKRICKA, Ernst
SKUNDER, Boghossian
SKYLLAS, Drossos P.
SLAVIN, Arlene
SLAVIN, Neal
SLIVKA, David
SLOAN, Jeanette Pasin
SLOAN, John
SMALLMAN, Roy
SMIECHOWSKA, Kristina
SMITH, Beuford
SMITH, Gary Haven
SMITH, Gordon
SMITH, Harry
SMITH, Moysha
SMITH, Philip
SMITH, Richard
SMITH, Rodney
SMITH, Sheila
SMITH, Shirlann
SMITH, Thomas
SMITH, Vincent
SMITH, William D.
SMITHSON, Robert
SMYTH, Ned
SNELSON, Kenneth
SNIDER, Jenny
SNOW, Michael
SNYDER, Joan
SOBRINO, Francisco
SOFFER, Sasson
SOKOL, Ana

SOKOLOV, Joel
SOLARI, Luis
SOLOMON, Elke
SOLOMON, Jack D.
SOMAINI, Francesco
SONENBERG, J.
SONFIST, Alan
SONNEMAN, Eve
SONNIER, Keith
SONTAG, Bill
SORA, Mitsuaki
SORCE, Anthony
SORMAN, Steven
SOTO, Jesus Raphael
SOUBIE, Roger
SOULAGES, Pierre
SOUZA, Al
SOVIAK, Harry
SOYER, Raphael
SPALATIN, Marco
SPARHAWK-JONES, Elizabeth
SPARLING, Marilyn
SPEED, John
SPENCE, Andrew
SPINELLI, Mary
SPITZ, Barbara
SPITZ, Darcy
SPOHN, Clay
SPOLDI, Aldo
SPOONER, Malcolm
STACKHOUSE, Robert
STAFFORD, Lawrence
STALEY, Earl
STALLER, Jan
STAMM, Ted
STAMOS, Theodoros
STANCZAK, Julian
STAND, Luis
STANKIEWICZ, Richard
STARKWEATHER, Cynthia
STARRETT, Jim
STAYTON, Janet
STEELE, Kim
STEEN, Nancy
STEFANELLI, Joseph
STEFFEK, Norbert
STEICHEN, Edward
STEIN, Carole
STEINBERG, Saul
STEINER, Ralph
STEINHART, Alice
STEIR, Pat
STELLA, Frank
STEPHAN, Gary
STEPHENS, Wayne
STERN, Jewel
STERN, Lionel
STERN, Marina
STERNE, Hedda
STEVENS, May
STEVENS, Norman
STEWART, John
STEWART, Leora
STEZAKER, John
STIKAS, Marianne
STOCK, C. R.
STOCK, Frances B. C.
STOKES, Will
STOLLER, Ezra
STONE, Bernard
STONEMAN, Alyson
STOREY, David
STOUT, Myron
STRADANUS

STRAUSSER, Barbara
STRAUTMANNIS, Edvins
STRELAND, Gun
STROUD, Peter
STUART, Michelle
STUBBING, N. H.
STUEMPFIG, Walter
STURMAN, Sally
SUAREZ, Pablo
SUGAI, Kumi
SUGIMOTO, Hiroshi
SUGIURA, Kohei
SUI-HO, Khoo
SULLIVAN, Bill
SULLIVAN, Billy
SULLY, Alfred
SUMMERS, Carol
SUMSION, Calvin
SUNDHAUSEN, Helmut
SUPANIMIT, Pishnu
SUPPLEE, Sarah
SUSANA, Justo
SUTCLIFFE, Frank Meadow
SUTHERLAND, T.
SUTIL, Francisca
SUTTON, Phillip
SUTTON, Sharon
SUTTON, Steven
SUUK, Byun Kyung
SVENNEVIK, Donna
SWAIN, Robert
SWANN, Susan Dallas
SWAVELY, Jane
SWEET, Paula
SYDNEY, Berenice
SZLEMKO, Suzanne

T

TADASKY
TAFT, Steven
TAGEN, I. Ketut
TAJIMA, Hiroyuki
TAKAHASHI, Rikio
TAMARIZ, Eduardo
TAMAYO, Rufino
TANGER, Susanna
TANIA
TANSEY, Mark
TANZER, Michael
TAPER, Geri
TAPIES, Antoni
TAVARELLI, Andrew
TAVINS, Paula
TAYLOR, Lorna
TECK, Sim Kern
TEICHMAN, Mary
TEMPEST, Victor
TESTA, Clorindo
THANGCHALOK, Ithipol
THANGCHALOK, Lukmi
THAOTHONG, Preecha
THOMAS, Alma
THOMAS, Swenn
THOMPSON, Anthony
THOMPSON, Colin
THORNTON, John
THORNTON, Valerie
THORP, Gregory
THURSTON, Sam
TIEBOUT, C.
TILLYER, William
TILSON, Joe

TIMONEY, Tess
TING, Leung Kee
TINGUELY, Jean
TIPPETT, Bruce
TISA, Ken
TIRTA, Iwan
TIVEY, Hap
TJUNGURRAYI, Y.
TOBEY, Mark
TOBIAS, Richard
TODD, Juanita
TOGASHI, Minoru
TOH, Tay Chee
TOLSON, Edgar
TOMPKINS, Riduan
TON, Tay Chee
TONEYAMA, Kojin
TORGER, Eljay
TORREANO, John
TOUCHET, Leo
TOULOUSE-LAUTREC, Henri de
TOWNSEND, John
TOYOKUNI II
TOYOKUNI III
TRACY, Michael
TRAKAS, George
TREFONIDES, Steven
TROVA, Ernesto
TROY, David
TRUE, David
TSAI, Chien
TSU-CHIUN, Yung
TUAN
TUFINO, Rafael
TULCHENSKY, Harvey
TUM SUDEN, Richard
TUNICK, Susan
TUNNARD, John
TURNBULL, William
TURNER, Alan
TURNER, Bill
TURNER, Charles Taylor
TURNER, Pete
TURRELL, James
TURTURRO, Domenick
TUTTLE, Richard
TWOMBLY, Cy
TWORKOV, Jack
TZE, Wang Shih
TZEN, Thank Seet

U

UCHIMA, Ansei
UECKER, Günther
UEHLLING, J.
UNDERHILL
URIBURU, Nicolas
UTAGAWA, Toshi
UZILEVSKY

V

VACHERON, Edilbert
VALENTIN, Helene
VALERAS, Ofelia
VALLE, Cynda
VAN DALEN, Anton
VAN DER GOTT, Els
VAN DER VEEN, Anton
VAN DE WIELE, Gerald
VAN DYKE, Willard

VAN ELK, Ger
VAN HOESEN, Beth
VAN HOEYDONCK, Paul
VAN HOUTEN, Katrine
VAN KYCK, Harry
VAN PORTENY, R.
VAN VECHTEN, Carl
VAN WINKLE, Margaret
VASARELY, Victor
VASI, Giuseppe
VASS, Gene
VEBER, Michael
VEDOVA, Emilio
VEGEZZI, Ileana
VENNEKAMP, Johannes
VERA, Michael
VERKERK, Emo
VESPIGANA, Renzo
VICENTE, Esteban
VIDAL, Miguel Angel
VIGOUREUX, Gilbert
VILDER, Roger
VILLON, Jacques
VILMOUTH, Jean-Luc
VISHNIAC, Roman
VITAL, Not
VLAMINCK, Maurice
VOISEY, Gordon
VOLZ, Wolfgang
VON DONGEN-VILLON
VON WICHT, John
VOUGA, Michel
VOULKOS, Peter
VOZERAVIC, Lazar
VUILLARD, Édouard

W

WADE, Robert
WAGNER, Merrill
WAH, Wong Chong
WAID, Mary Joan
WAITE, Jonathan
WAKABAYSHI, Kazuo
WAKITA, Aijiro
WALKER, John
WALKER, Joy
WALLDORF, Benno
WALTER, Roy
WALTON, William
WANG, Lan
WANG, Roby
WANG, Sam
WARD, Alex
WARD, Lynd
WARE, Michael R.
WARHOL, Andy
WARNER, Mary
WARREN, Catherine
WATANABE, Sadao
WATKINS, Carleton
WATTS, Todd
WAWZONEK, John
WAY, Jeff
WEBB, Boyd
WEBB, Todd
WEEGE, William
WEEGEE
WEGMAN, William
WEIL, Susan
WEINER, Lawrence
WEISBERG, Ruth
WEISS, Harvey

WELCH, James P.
WELCH, Roger
WELLING, James
WELLIVER, Neil
WELLS, Luis
WELLS, Lynton
WELLSTOOD, W.
WEN, Chi
WENDKOS, Gina
WENSTRUP, Maggie
WENTWORTH, P. M.
WESLEY, John
WESSELMAN, Tom
WEST, Avril
WEST & SON
WESTHEIMER, Bill
WESTON, Cole
WESTON, Edward
WHITE, Jack
WHITE, John
WHITE, Mary
WHITE, Minor
WHITE, Randy Lee
WHITE, Wendel
WHITMEN, Robert
WHITNEY, Stanley K.
WHITTEN, Jack
WIEDERHOLD, German
WILDE, John
WILDER, Joe
WILEY, William T.
WILKE, Ulfert S.
WILKS, Harry
WILLENBECHER, John

WILLIAMS, Danny
WILLIAMS, Grace
WILLIAMS, Mark
WILLIAMS, Ron
WILLIAMS, William
WILLIS, Thornton
WILMARTH, Christopher
WILSON, Bryan
WILSON, Jane
WILSON, May
WILSON, Robert
WILSON, Sibyl
WILSON, Wing
WINCKLER, Jochen
WIND, Gerhard
WINGREN, Dan
WINOGRAND, Garry
WINOKUR, Neil
WINNER, Gerd
WINNETT, Merry Moor
WINSTON-RONIBSIN, S.
WINTER, Ezra
WINTER LUMEN, Martin
WISEMAN, Ann
WITKIN, Issac
WOJCIECHOWSKI, Agatha
WONG, Albert Y.
WONG, Wucius
WOOD, Susan
WOODBURN, Stephen
WOODMAN, Betty
WORTH, Don
WRAY, Dick
WU, Hsueh-Jand

WU, Wang Kung
WUNDERLICH, Paul
WYNNE, Rob

X

XI, Zheng

Y

YAMAGUCHI, Gen
YAMAZAKI, Kazuhide
YAP, Arthur
YAYANAGI, Tsuyoshi
YAZZIE, Minne
YEH, Tsui Pai
YEMISI
YEO, Thomas
YEU, Jat See
YOAKUM, Joseph
YODER, Richard
YOKOI, Teruko
YOKOO, Tadanori
YOSHIDA, Hodaka
YOSHIDA, Masaji
YOSHIHARA, Jiro
YOSHITORA
YOSHITOSHI, Tsukioka
YOUNG, Frank
YOUNG, Peter
YOUNGBLOOD, Daisy
YOUNGERMAN, Jack
YRISSARY, Mario

YRIZARRY, Marcos
YU, Marlene Tseng
YUCIKAS, Robert
YUKI, Rei
YUNKERS, Adja

Z

ZAKANITCH, Robert
ZAPICO, J. Torre
ZAPKUS, Kes
ZARO, Samia
ZEIDMAN, Robert
ZEISLER, Claire
ZELENS, Richard
ZELEYA, Daniel
ZEMER, Yigal
ZENDEROUDI, Hossein
ZEIMANN, Richard Claude
ZETTERSTROM, Tom
ZIMMER, Bernd
ZIMMERMAN, Catherine
ZIMMERMAN, Elyn
ZIMMERMAN, Paul
ZOELLNER, Richard
ZOGHEIB, Khalil
ZONGALE, Larry
ZONNEVELD, Franke
ZORACH, William
ZOX, Larry
ZUCCO, Doug
ZUCKER, Barbara
ZUCKER, Joe
ZWACK, Michael

Bibliography

THE CHASE MANHATTAN BANK ART COLLECTION
(Arranged in chronological order)

"In Architecture . . . ", *Industrial Design,* vol. 4, no. 9, September 1957, pp. 104–105.

Kuh, Katherine. "First Look at the Chase Manhattan Bank Collection", *Art in America,* vol. 48, no. 4, Winter 1960, pp. 69–75.

"Modern Art to Adorn New Chase Manhattan Building", *American Banker,* December 29, 1960, p. 8.

"Wall Street Treasure", *Time,* vol. 77, June 30, 1961, pp. 42–47.

"The Chase: Portrait of a Giant", *Architectural Forum,* July 1961, pp. 69–94.

"One Chase Manhattan Plaza", *Interior Design,* August 1961, pp. 78–87.

"The Chase Manhattan Collects", *Arts,* vol. 35, no. 10, September 1961, p. 59.

"Chase Manhattan's New Home", *Interiors,* vol. 121, no. 2, September 1961, pp. 112–117.

Bennett, Ward. "Gli oggetti d'arte nella Chase Manhattan Bank, New York", *Domus,* January 1962, p. 40.

"A Fine Arts Program for One Chase Manhattan Plaza", *Mondo Bancario* (Rome), vol. 4, no. 5, September–October 1962, pp. 41–48.

"Art in Banking—The Chase Manhattan", *Canadian Banker,* Autumn 1962, pp. 84–89.

Pease, Roland Folsom, Jr. "Chase Manhattan: Giant Bank—An Art Collector", *Art Voices,* vol. 1, no. 1, October 1962, p. 30.

Noguchi, Isamu. "New Stone Gardens", *Art in America,* vol. 52, no. 3, June 1964, pp. 88–89.

Landsdale, Nelson. "The Chase Manhattan Bank: A Patron of Art and Artists", *American Artist,* vol. 29, no. 1, January 1965, pp. 32ff.

Paradis, Andrée. "Chase Manhattan Bank: un écrin monumental pour oeuvres d'art", *Vie des Arts* (Montreal), no. 42, Spring 1966, pp. 44–47.

Giusti, Hedy A. "Arte Moderna in Edifici Pubblici", *D'Ars* (Milan), vol. 8, no. 34, January 10–April 20, 1967, pp. 58–63.

Pluchart, François. "L'Art de la Peinture ennoblit les Bureaux d'Aujourd'hui", *Transmodia* (Paris), October 1967, pp. 38–40.

Polites, Nicholas. "Art Boom in the Corporation", *Office Design,* vol. 7, no. 32, May 1969, pp. 22–24.

Forbes, John B. "Businessmen Turning Toward the Art World", *New York Times,* October 12, 1969.

Molina, Antonio J. "La Colleccion de Arte del Chase Manhattan Bank", *Artes Visuales* (San Juan), vol. 1, no. 6, 1971, pp. 18–21.

Moskowitz, David B. "Business and the Arts Get Together", *America Illustrated* (Washington, D.C.: U.S.I.A.), no. 191, September 1972, pp. 30–33.

Davis, Felice. "Art Collecting and New York's Chase Manhattan Bank", *Connoisseur,* vol. 181, no. 730, December 1972, pp. 265–74.

Dean, Andrea O. "Bunshaft and Noguchi: An Uneasy but Highly Productive Architect-Artist Collaboration", *AIA Journal,* October 1976, pp. 52–55.

Cochrane, Diane. "Looking Back: Three Corporations Evaluate their Art Collections", *Interiors,* vol. 136, November 1976, pp. 114–16.

_____. "Corporate Support of the Visual Arts: Some Innovative Programs", *American Artist,* vol. 42, no. 47, February 1978, pp. 58ff.

Sloane, Leonard. "Collecting at the Chase: Fine Art Stands for Good Business", *Art News,* vol. 78, no. 5, May 1979, pp. 47–51.

Peters, Lisa. "Chase Bank's Taking on a Museum Role", *Artworkers News,* vol. 10, no. 6, February 1981, pp. 1ff.

"Chase Manhattan Bank Builds Solid Collection", *Decor,* vol. 102, no. 5, May 1982, p. 75.

Brooks, Valerie F. "Confessions of the Corporate Art Hunters", *Art News,* Summer 1982, pp. 108–12.

Ambrosini, Silvia de. "Memoria de la Vision", *Arte Informa* (Buenos Aires), vol. 7, nos. 40–41, May–June 1983, pp. 19–28.

EXHIBITION CATALOGUES

Paintings on Loan from the Chase Manhattan Bank Art Collection. Buffalo, N.Y.: Albright Art Gallery, Buffalo Fine Arts Academy, 1960.

Selections from the Chase Manhattan Bank Art Collection. Amherst: University Gallery, University of Massachusetts, 1981. Introduction by Helaine Posner.

Chase Manhattan: The First Ten Years of Collecting, 1959–1969. Atlanta: High Museum of Art, 1982. Interview with Dorothy Miller and essay by Peter Morrin.

SELECTED ADDITIONAL READINGS ON CORPORATE ART COLLECTING
(Much of this material also includes information on the Chase Manhattan Bank.)

Albin, Fran A. "Evolution of a Tradition: Corporate Patronage Comes of Age", *National Sculpture Review,* Winter 1973–74, pp. 7ff.

"Art as Investment: The Profits, The Risks", *U.S. News & World Report,* vol. 68, no. 23, June 8, 1970, pp. 90–92.

Bender, Marilyn. "The Boom in Art for Corporate Use: Specialists in Choosing Works are Multiplying", *New York Times,* January 28, 1973, Section F, p. 3.

Burger, Ruth. "The Corporation as Art Collector", *Across the Board,* The Conference Board, Inc., January 1983, pp. 42–50.

"A Business Education in Corporate Art", *Corporate Design,* vol. 2, no. 5, September–October 1983, pp. 95ff.

Chagy, Gideon, ed. *Business and the Arts 1970.* New York: Paul S. Eriksson, 1970. (See also review by Milton Esterow: "The Businessman as Art Patron", *Art News,* vol. 72, no. 9, November 1973, p. 49.)

_____. *The State of the Arts and Corporate Support.* New York: Paul S. Eriksson, 1971.

_____. *The New Patron of the Arts.* New York: Harry N. Abrams, 1972.

Chesner, Alexandra. "The Corporate Use of Art Collections", *Art & Artists,* May 1983, p. 3.

Cochrane, Diane. "Fine Arts Invade the Corporate City", *Interiors,* vol. 135, no. 4, April 1979, pp. 80–83.

Coffin, Anne. "Corporate Collecting: The State of the Art", *Downtown* (Lower

Manhattan Cultural Council), vol. 5, no. 3, March 1982, pp. 1ff.

Cohen, Edie Lee. "Corporate Art: An Overview on the Subject", *Interior Design,* vol. 60, no. 11, November 1979, pp. 208–13.

"The Corporate Art Collector", *Corporate Design,* May–June 1982, pp. 125ff.

"The Corporate Collector: A Report on Businesses Buying Art", *Art Letter,* vol. 5, no. 10, October 1976, pp. 1ff.

Craft, Mary Anne. "The Corporation as Art Collector", *Business Horizons,* vol. 22, no. 3, June 1979, pp. 20–24.

Eells, Richard. *Corporation Giving in a Free Society.* New York: Harper Bros., 1956.

———. *The Corporation and the Arts.* New York: Macmillan/Arkville Press, 1967.

Feldman, Sidney. "From Art in Banking to Banking in Art", *The Bankers Magazine,* vol. 163, no. 5, September–October 1980, pp. 88–93.

Gent, George. "The Growing Corporate Involvement in the Arts", *Art News,* vol. 72, no. 1, January 1973, pp. 21–25.

Georgi, Charlotte. *The Arts and the World of Business: A Selected Bibliography,* 2nd edition. Metuchen, N.J., & London: Scarecrow Press, 1979.

Gingrich, Arnold. *Business and the Arts: An Answer to Tomorrow.* New York: Paul S. Eriksson, 1969. Foreword by David Rockefeller.

Goodman, Suzanne Koblentz. "Building an Art Collection", in *Partners: A Practical Guide to Corporate Support of the Arts.* New York: Cultural Assistance Center, 1982.

Heller, Pamela Markham. "Buying Art for Banks", *Interiors,* vol. 139, no. 4, November 1979, pp. 14f.

Howarth, Shirley Reiff, ed. *Directory of Corporate Art Collections,* 2nd edition. Tampa, Fla.: International Art Alliance, 1983.

Hunter, Sam. *Art in Business: The Philip Morris Story.* New York: Harry N. Abrams, 1979.

———. "The Corporation and the Visual Arts", *Princeton Alumni Weekly,* February 12, 1979, p. 42.

———. "Corporate Patronage and the Commodities Corporation Art Collection", *National Arts Guide,* vol. 2, no. 6, November–December 1980, pp. 23–27.

Jahns, Tim. "The Corporate Art Market", *State of the Arts,* California Arts Council, no. 30, November 1981, pp. 1f, and no. 31, December 1981, pp. 1f.

Kaiden, Nina, and Bartlett Hayes, eds. *Artist and Advocate: An Essay on Corporate Patronage.* New York: Renaissance Editions, 1967.

Karp, Beverly Montgomery. "Survey Report: Corporate Art", *The Collector Investor,* Summer 1982, pp. 24–27.

LaPage, David. "Art and Business: A San Francisco Show Raises Important Questions about the Corporate Patron", *Contract,* vol. 2, no. 1, November 1961, pp. 36–40.

Marlowe, John. "Explosion in Corporate Patronage of the Arts", *Finance Magazine,* May 1975, pp. 37–39.

Medinger, Beatrix. "The Corporation as Art Patron and Collector", in *Proceedings of the Art Patronage Symposium.* Potsdam, N.Y.: State University College of Arts and Sciences, October 30–November 1, 1980, pp. 66–73.

Metz, Robert. "The Corporation as Art Patron: A Growth Stock", *Art News,* vol. 78, no. 5, May 1979, pp. 40–46.

Miller, Irwin. "A Matter of Life and Death: Why it is in Business's Self-interest to Support the Creative Arts", *Princeton Alumni Weekly,* February 12, 1979, pp. 43–45.

Nydele, Ann. "Art for Investment Only is a Risky Venture", *Facilities Design & Management,* vol. 1, no. 8, October 1982, pp. 72–75.

Raynor, Vivien. "Art and Business II: New Ironies and New Opportunities Develop as the Commercial World Embraces the Artist", *Contract,* January 1962, pp. 28ff.

Rosen, Randy. "Corporate Collecting at a Crossroads", *National Arts Guide,* vol. 2, no. 6, November–December 1980, pp. 16–22.

Rosenbaum, Lee. "Choosing the Chooser: How to Pick an Art Consultant", *Art News,* vol. 78, no. 5, May 1979, pp. 52–58.

Toffler, Alvin. "Culture, Incorporated", from *The Culture Consumers.* New York: St. Martin's Press, 1964.

Wagner, Susan E. *A Guide to Corporate Giving in the Arts.* New York: American Council for the Arts, 1978.

Wolmer, Bruce. "Corporate Collecting *is* Different", *Art News,* vol. 80, no. 5, May 1981, pp. 110–12.

Willard, Charlotte. "The Corporation as Art Collector", *Look,* March 23, 1965, pp. 67–72.

SELECTED EXHIBITION CATALOGUES

Business Buys American Art. Whitney Museum of American Art, Petrocelli Press, New York, 1960. Foreword by David A. Prager.

American Business and the Arts. San Francisco Art Museum, San Francisco, 1961. Introduction by George D. Culler.

Corporations Collect. Institute of Contemporary Art, Boston, 1965. Foreword by Sue M. Thurman.

Six Corporate Collections: Western New York's New Art Patrons. Buffalo State College Alumni Foundation, Inc., New York, 1975. Essay by J. Benjamin Townsend.

Art at Work: Recent Art from Corporate Collections. The Whitney Museum of American Art, Downtown Branch, New York, March 1978.

Art, Inc.: American Paintings from Corporate Collections. Montgomery Museum of Fine Arts, Brandywine Press, Alabama, 1979. Forewords by Winton M. Blount and Henry Flood Robert, Jr., essay by Mitchell Douglas Kahan.

Art From Corporate Collections. Brochure published by Wayne Anderson Associates, Boston, for exhibition held at the Union Carbide Corporation Gallery, New York, 1979. Introduction by Wayne Anderson.

American Watercolors, Prints, and Drawings
January 25–March 1, 1959
Pennsylvania Academy of Fine Arts, Philadelphia,
Pennsylvania
 CHARLES BURCHFIELD
 July Wind Rustling, 1948

Business Buys American Art
March 17–April 24, 1960
Whitney Museum of American Art, New York, New
York
 JAMES BROOKS
 R-1953, 1953
 DIMITRI HADZI
 Scudi II, 1959
 THEODOROS STAMOS
 Red Sea Terrace, 1958

Images at Mid-Century
April 13–June 12, 1960
University of Michigan Museum of Art, Ann Arbor,
Michigan
 JOSEF ALBERS
 Homage to the Square in Late Day, 1959
 JOAN MITCHELL
 Slate, 1959
 JACK YOUNGERMAN
 Black Red, 1959

Paintings on Loan from the Chase Manhattan Bank
September 15–October 16, 1960
Albright Art Gallery, Buffalo Fine Arts Academy, Buffalo,
New York
 AFRO
 Estate in Palude, 1957
 JOSEF ALBERS
 Homage to the Square in Late Day, 1959
 MILTON AVERY
 Conversation, 1956
 ELMER BISCHOFF
 Landscape, 1959
 JAMES BROOKS
 Gananogue, 1960
 CHARLES BURCHFIELD
 July Wind Rustling, 1948
 Pink Locusts and Windy Moon, 1959
 Street Light Shining Through Rain and Fog, 1917
 Sunflowers, 1917
 KENNETH CALLAHAN
 Cascade Mountain Drawing, Series II, 1954
 EDWARD CORBETT
 Mt. Holyoke No. 2, 1960
 LEONARDO CREMONINI
 The Bull Tamers, 1951
 LUIS FEITO
 Sun Spot, 1959
 FRITZ GLARNER
 Relational Painting, Tondo No. 46, 1956–57
 JOSÉ GUERRERO
 Blues Converging, 1960
 Fire and Apparition, 1957
 Black Penetration, 1960
 GENICHIRO INOKUMA
 Kabuki II, 1958
 GYORGY KEPES
 Garden of Light, 1959

 CONRAD MARCA-RELLI
 27 October 1959, 1959
 KYLE MORRIS
 Evening Image, 1958
 WALTER MURCH
 Carburetor, 1957
 SAM J. NTIRO
 Chagga Home, 1958
 KENZO OKADA
 Ise, 1959
 LARRY RIVERS
 Me III, 1959
 KAY SAGE
 Signal to Signal, 1954–55
 CHARLES SHAW
 Road to Tomorrow, 1959
 PIERRE SOULAGES
 23 Mars 1960, 1960
 HEDDA STERNE
 Queens No. 1, 1958
 N. H. STUBBING
 Greek Vigil, 1959
 KUMI SUGAI
 Kiri, 1959
 JEAN TINGUELY
 Stabilisateur Asynchrone, 1959
 ESTEBAN VICENTE
 No. 4—1958, 1958
 JACK YOUNGERMAN
 Black Red, 1959

Rorelse I Konsten (Art in Motion)
March 10–April 15, 1961
Stedelijk Van Abbemuseum, Amsterdam
May 17, 1961–September 3, 1961
Moderna Museet, Stockholm
 HARRY BERTOIA
 Untitled, 1960

David Lund and Richard Stankiewicz
March 17–April 27, 1961
Queens College, Flushing, New York
 DAVID LUND
 The Wall, 1960

Paintings and Drawings by Edward Corbett
April 9–May 7, 1961
Walker Art Center, Minneapolis, Minnesota
 EDWARD CORBETT
 Mt. Holyoke No. 2, 1960

American Business and the Arts
September 14–October 15, 1961
San Francisco Art Museum, San Francisco, California
 CHARLES BURCHFIELD
 Sunflowers, 1917
 IBRAM LASSAW
 North Wind, 1960
 CONRAD MARCA-RELLI
 27 October 1959, 1959
 KYLE MORRIS
 Evening Image, 1958

Joan Mitchell: Paintings
November 1–December 15, 1961
University Galleries, Southern Illinois University,

Carbondale, Illinois
 JOAN MITCHELL
 Slate, 1959

Chryssa
November 14–December 16, 1961
Solomon R. Guggenheim Museum, New York, New
York
 CHRYSSA
 Flight of Birds, 1960

Vanguard American Painting
February 28–March 30, 1962
American Embassy, USIS Gallery, London, and nine
 museums in Austria, Yugoslavia, and West Germany
 JAMES BROOKS
 Loring, 1957
 CONRAD MARCA-RELLI
 Runaway #5, 1959

William Calfee: Sculpture
March 13–April 8, 1962
Corcoran Gallery of Art, Washington, D.C.
 WILLIAM CALFEE
 Owl, 1960

Geometric Abstraction in America
March 20–May 13, 1962
Whitney Museum of American Art, New York, New
York
 FRITZ GLARNER
 Relational Painting, Tondo No. 46, 1956–57

Paintings by Charles Burchfield
May 13–June 10, 1962
Edward A. Root Art Center, Hamilton College, Clinton,
New York
 CHARLES BURCHFIELD
 Pink Locusts and Windy Moon, 1959

Artist's Choice
July 9–August 30, 1962
Birmingham Trust National Bank, Birmingham, Alabama
 JAMES BROOKS
 Loring, 1957

Structured Sculpture
September 9–October 9, 1962
Katonah Gallery, Katonah, New York
 ERWIN HAUER
 Form, 1960

Leonard Baskin
October 12–November 11, 1962
Bowdoin College Museum of Art, Brunswick, Maine
 LEONARD BASKIN
 Owl, 1960

Kenzo Okada
January 7–January 27, 1963
Hayden Gallery, Massachusetts Institute of Technology,
 Cambridge, Massachusetts
 KENZO OKADA
 Ise, 1959

Bernard Pfriem
February 10–March 2, 1963
Cleveland Institute of Art, Cleveland, Ohio
 BERNARD PFRIEM
 La Porte de Mon Jardin est Ouverte, c. 1961
 Autel de Passage, 1959

James Brooks
February 12–March 17, 1963
Whitney Museum of American Art, New York, New
 York
 JAMES BROOKS
 R-1953, 1953

Signs and Symbols, U.S.A.
March 11–April 11, 1963
The Downtown Gallery, New York, New York
 ANON. AMERICAN
 Sea bass trade sign, 19th century

Recent Paintings by Charles Burchfield
April 24–May 19, 1963
Upton Hall Gallery, State University College at Buffalo,
 New York
 CHARLES BURCHFIELD
 Pink Locusts and Windy Moon, 1959

Mondrian, de Stijl, and Their Impact
April 7–May 15, 1964
Marlborough-Gerson Gallery, Inc., New York, New York
 FRITZ GLARNER
 Relational Painting, Tondo No. 46, 1956–57

Beauty and the Beast
May 1–June 7, 1964
Smith College Museum of Art, Northampton,
 Massachusetts
 LEONARD BASKIN
 Owl, 1960

Corporations Collect
January 9–February 21, 1965
Institute of Contemporary Art, Boston, Massachusetts
 LEONARD BASKIN
 Owl, 1960
 DIMITRI HADZI
 Elmo I, 1959
 KENZO OKADA
 Ise, 1959
 NELL SINTON
 Falling Water, 1960
 JACK YOUNGERMAN
 Big Red, 1959

Pop Art and the American Tradition
April 9–May 9, 1965
Milwaukee Art Center, Milwaukee, Wisconsin
 ANON. AMERICAN
 Sea bass trade sign, 19th century

Jason Seley
May 22–June 30, 1965
Andrew Dickson White Museum of Art, Cornell
 University, Ithaca, New York
 JASON SELEY
 Swinging Out, 1960

About New York: Night and Day
October 19–November 14, 1965
Gallery of Modern Art, New York, New York
 HEDDA STERNE
 Queens No. 1, 1958

Charles Burchfield: His Golden Year
November 14, 1965–January 9, 1966
University Art Gallery, State University of Arizona,
 Tucson, Arizona
 CHARLES BURCHFIELD
 Pink Locusts and Windy Moon, 1959

Contemporary European Watercolors
January 9, 1966–May 4, 1967
Sponsored by the Museum of Modern Art, New York,
 and eight other museums in the United States
 ALAN DAVIE
 Flute Player's Idea No. 1, 1964

Vasarely
February 14–March 20, 1966
Hayden Gallery, Massachusetts Institute of Technology,
 Cambridge, Massachusetts

VICTOR VASARELY
 Betelgeuse, 1957

Tapestries and Rugs by Contemporary Painters and
 Sculptors
March 11, 1966–November 27, 1967
The Museum of Modern Art, New York, and fourteen
 other museums in the United States and Canada
 JEAN ARP
 Sailboat in the Forest, 1958

Pierre Soulages Retrospective
April 20–May 22, 1966
Museum of Fine Arts, Houston, Texas
 PIERRE SOULAGES
 23 Mars 1960, 1960

J. Iqbal Geoffrey
September 13–October 16, 1966
Santa Barbara Museum of Art, Santa Barbara, California
 J. IQBAL GEOFFREY
 The Great U.S. Landscape, Phase 2, Aspect 4,
 1965

Walter Murch: A Retrospective Exhibition
November 9, 1966–January 28, 1968
The Rhode Island School of Design, Museum of Art,
 Providence; eight museums in the United States and
 Canada
 WALTER MURCH
 Brooklyn, 1964
 Carburetor, 1957

Annual Exhibition 1966: Sculpture and Prints
December 16, 1966–February 5, 1967
Whitney Museum of American Art, New York, New
 York
 HARRY BERTOIA
 Spring II, 1965

Louise Nevelson Retrospective Exhibition
March 8–April 30, 1967
Whitney Museum of American Art, New York, New
 York
May 22–July 2, 1967
Rose Art Museum, Brandeis University, Waltham,
 Massachusetts
 LOUISE NEVELSON
 Expanding Reflection I, 1966

Conrad Marca-Relli
October 4–November 12, 1967
Whitney Museum of American Art, New York, New
 York
December 3, 1967–January 28, 1968
Rose Art Museum, Brandeis University, Waltham,
 Massachusetts
 CONRAD MARCA-RELLI
 27 October 1959, 1959

Charles Burchfield Paintings on Loan from Two New
 York City Collectors: Theodor Braasch and David
 Rockefeller, including Works from the Chase
 Manhattan Bank Art Collection
October 9, 1967–January 30, 1968
Charles Burchfield Center, State University College at
 Buffalo, New York
 CHARLES BURCHFIELD
 Pink Locusts and Windy Moon, 1959
 July Wind Rustling, 1948
 Street Light Shining through Rain and Fog, 1917
 Sunflowers, 1917

Annual Exhibition 1967: Contemporary American
 Painting
December 13, 1967–February 4, 1968
Whitney Museum of American Art, New York, New
 York
 ILYA BOLOTOWSKY
 Black and Red Diamond, 1967
 JAMES BROOKS
 Erelon, 1967

The Animal Kingdom
February 11–April 28, 1968
University Art Museum, University of New Mexico,
 Albuquerque, New Mexico
 LEONARD BASKIN
 Owl, 1960

Charles Burchfield Memorial Exhibition: Paintings and
 Drawings

March 1–April 21, 1968
American Academy of Arts and Letters, New York, New
 York
 CHARLES BURCHFIELD
 Pink Locusts and Windy Moon, 1959

Marcelo Bonevardi
March 1–March 29, 1968
Arts Club of Chicago, Chicago, Illinois
 MARCELO BONEVARDI
 Astrologer's Wall, 1966

Plus by Minus: Today's Half-Century
March 3–April 14, 1968
Albright-Knox Art Gallery, Buffalo, New York
 FRITZ GLARNER
 Relational Painting, Tondo No. 45, 1955

Venice Biennale 1968
June 22–October 30, 1968
Swiss Pavilion, Venice
 FRITZ GLARNER
 Relational Painting, Tondo No. 46, 1956–57

Oeuvres de Soulages
July 23–September 1, 1968
Musée d'Art Contemporain, Montreal
September 26–October 21, 1968
Musée du Québec, Quebec
 PIERRE SOULAGES
 23 Mars 1960, 1960

São Paulo Biennial
September 20, 1968–April 30, 1969
Argentine Pavilion, São Paulo
 MARCELO BONEVARDI
 Astrologer's Wall, 1966

Signals of the Sixties
October 5–November 10, 1968
Honolulu Academy of Arts, Honolulu, Hawaii
 JAMES BROOKS
 Erelon, 1967

Carroll Cloar: A Selection of His Paintings
October 29–November 17, 1968
Art Gallery, State University of New York at Albany,
 New York
 CARROLL CLOAR
 Corner at Marked Tree, 1960

Contemporary American Painting and Sculpture 1969
March 2–April 6, 1969
Krannert Art Museum, University of Illinois, Champaign,
 Illinois
 STEPHEN GREENE
 Blue Line, 1966

Robert Dash: Paintings
July 26–August 24, 1969
Parrish Art Museum, Southampton, New York
 ROBERT DASH
 Near the Ocean, 1963

William Clutz
October 5–November 14, 1969
Brooklyn College Student Center, City University of
 New York, Brooklyn, New York
 WILLIAM CLUTZ
 Summer, 1960

Contemporary Art of Mexico and Brazil
October 16–October 31, 1969
College Art Gallery, State University College at New
 Paltz, New York
 MARIO CRAVO
 Untitled, n.d.

Paintings by East African Artists
October 27–November 14, 1969
Benefit for Community Trust Fund of Tanzania and the
 Society of East African Artists, New York; held at
 Union Carbide Corporation Gallery, New York, New
 York
 SAM J. NTIRO
 Chagga Home, 1958

Ilya Bolotowsky: Paintings and Columns
January 1–January 11, 1970
University Art Museum, University of New Mexico,
 Albuquerque, New Mexico, and three museums in the
 United States

ILYA BOLOTOWSKY
Rising Tondo I, 1968

Manabu Mabe
January 22–March 29, 1970
Museum of Fine Arts, Houston, Texas
MANABU MABE
Condicao Humana, n.d.

American Artists of the 1960's
February 6–March 14, 1970
School of Fine and Applied Arts Gallery, Boston
 University, Boston, Massachusetts
RICHARD ANUSZKIEWICZ
Sun Garden, 1968

Jim Dine
February 27–April 19, 1970
Whitney Museum of American Art, New York, New
 York
JIM DINE
Double Apple Palette with Gingham, 1965

Afro-American Artists: Boston and New York
May 19–June 23, 1970
Museum of Fine Arts and Museum of the National
 Center for Afro-American Artists, Boston,
 Massachusetts
JACK WHITE
Deodate, 1966

Bridget Riley: Paintings and Drawings, 1951–1971
November 14, 1970–September 5, 1971
The Arts Council of Great Britain, traveling to six
 museums in Europe
BRIDGET RILEY
Deny I, 1966

Josef Albers: Paintings and Graphics, 1917–1970
January 5–January 26, 1971
Princeton University Art Museum, Princeton, New
 Jersey
JOSEF ALBERS
Homage to the Square in Late Day, 1959

Fritz Glarner
January 19–February 28, 1971
Institute of Contemporary Art, University of
 Pennsylvania, Philadelphia, Pennsylvania
FRITZ GLARNER
Relational Painting, Tondo No. 45, 1956

Allan D'Arcangelo: Painting, 1963–1970
March 10–April 16, 1971
Institute of Contemporary Art, University of
 Pennsylvania, Philadelphia, Pennsylvania
May 16–June 27, 1971
Albright-Knox Gallery, Buffalo, New York
July 9–August 27, 1971
Museum of Contemporary Art, Chicago, Illinois
ALLAN D'ARCANGELO
Proposition #5, 1966

Romare Bearden: The Prevalence of Ritual
March 25, 1971–September 30, 1972
The Museum of Modern Art, New York, and six other
 museums in the United States
ROMARE BEARDEN
Blue Interior, Morning, 1968

Jacqueline Gourevitch
October 8–October 24, 1971
Davison Art Center, Wesleyan University, Middletown,
 Connecticut
JACQUELINE GOUREVITCH
Ocean Sky, 1966

Rosc '71: The Poetry of Vision
October 24–December 29, 1971
Royal Dublin Society, Dublin
JIRI KOLAR
Arches, 1967

Albert Bierstadt (1830–1902)
January 27, 1972–January 3, 1973
The Amon Carter Museum of Western Art, Fort Worth,
 Texas, and four other museums in the United States
ALBERT BIERSTADT
Rainbow on Lake Jenny, 19th century

James Brooks
May 10–June 25, 1972

Dallas Museum of Fine Arts, Dallas, Texas
JAMES BROOKS
Erelon, 1967
R-1953, 1953

Looking South: Latin American Art in New York
 Collections
May 16–July 28, 1972
Center for Inter-American Relations, New York, New
 York
RODOLFO ABULARACH
Arcano, 1966
RODOLFO MISHAAN
Alvarado's Ghost, 1967

Fritz Glarner
August 12–September 24, 1972
Kunsthalle Bern, Bern, Switzerland
FRITZ GLARNER
Relational Painting, Tondo No. 46, 1956–57

Sally Hazelet Drummond: A Retrospective, 1958–1972
November 3–December 3, 1972
Corcoran Gallery of Art, Washington, D.C.
SALLY HAZELET DRUMMOND
Turner #16, 1969

Robyn Denny
March 6–April 23, 1973
Tate Gallery, London
ROBYN DENNY
By Day #4, 1967

The Emerging Real
April 7–November 3, 1973
Storm King Art Center, Mountainville, New York
CATHERINE MURPHY
View from the Garden, 1972

Ibram Lassaw: Sculpture
June 9–July 22, 1973
Heckscher Museum, Huntington, New York
IBRAM LASSAW
North Wind, 1960

Art du 20e. Siècle: Collections Genevoises
June 28–September 23, 1973
Musée d'Art et d'Histoire, Geneva
FRITZ GLARNER
Relational Painting: Tondo No. 46, 1956–57

Joseph Raffael: Water Paintings
July 18–September 16, 1973
University Art Museum, Berkeley, California
October 13–November 7, 1973
Nancy Hoffman Gallery, New York, New York
March 9–April 28, 1974
Museum of Contemporary Art, Chicago, Illinois
JOSEPH RAFFAEL
Watercolor I, 1973

Bellas Artes
September 7–October 7, 1973
Queens County Art and Cultural Center, Flushing, New
 York
RODOLFO ABULARACH
Arcano, 1966
MANABU MABE
Washington, 1965

Wallpapers by Charles Burchfield
September 20–October 21, 1973
Charles Burchfield Center, State University College at
 Buffalo, New York
CHARLES BURCHFIELD
Sunflowers, 1917

A Sense of Place: The Artist and the American Land
September 23, 1973–June 30, 1974
Sponsored by the Mid-America Arts Alliance; shown at
 seven museums in the United States
GABRIEL LADERMAN
View of Brooklyn #1, n.d.

Harvey Quaytman: Recent Paintings
October 24–December 7, 1973
Contemporary Arts Museum, Houston, Texas
HARVEY QUAYTMAN
Jaboticaba Orange Lima, 1973

Twice as Natural: 19th Century American Genre
 Painting

December 11, 1973–January 20, 1974
Finch College Museum of Art, New York, New York
EDWARD L. HENRY
Station on the Morris and Essex Railroad, c. 1864

Drawings by Alain Gavin
March 14–April 18, 1974
Long Island University, Brooklyn Center, Brooklyn, New
 York
ALAIN GAVIN
Untitled, 1973

Mildred Burrage: Paintings on Mica
May 28–September 30, 1974
Caspary Hall, Rockefeller University, New York, New
 York
MILDRED BURRAGE
Untitled, 1972

The Painter's America: Rural and Urban Life, 1810–
 1910
September 18–November 10, 1974
Whitney Museum of American Art, New York, New
 York
December 2, 1974–January 19, 1975
Houston Museum of Fine Arts, Houston, Texas
February 10–March 30, 1975
Oakland Museum, Oakland, California
EDWARD L. HENRY
Station on the Morris and Essex Railroad, c. 1864

Ilya Bolotowsky Retrospective
September 20–November 10, 1974
Solomon R. Guggenheim Museum, New York, New
 York
December 20, 1974–February 17, 1975
National Collection of Fine Arts, Washington, D.C.
ILYA BOLOTOWSKY
Horizontal and Vertical, 1960–64
Black and Red Diamond, 1967

Six Corporate Collectors: Western New York's New Art
 Patrons
February 1–March 30, 1975
Charles Burchfield Center, State University of New York
 at Buffalo, New York
ILYA BOLOTOWSKY
Horizontal and Vertical, 1960–64
CHARLES BURCHFIELD
Pink Locusts and Windy Moon, 1959
JOHN CLEM CLARKE
Abstract #38, 1972
ALLAN D'ARCANGELO
Proposition #5, 1966
PETER DECHAR
Pears 73–5, 1973
HELEN FRANKENTHALER
Yellow Vapor, 1965
JOHN MOORE
Still Life with Glass of Tea, 1974
JACK TWORKOV
P. 73 #11, 1973
NEIL WELLIVER
Grier's Bog, 1972

Angelo Ippolito Retrospective
February 16–March 16, 1975
University Art Gallery, State University of New York at
 Binghamton, New York
ANGELO IPPOLITO
Table with Flowers, 1974
Red Arrow, 1969

The Language of Color (El Lenguaje del Color)
February 24–November 23, 1975
The Museum of Modern Art, New York, New York, and
 five museums in South America
BRIDGET RILEY
Deny I, 1966

John Willenbecher
March 7–May 4, 1975
Everson Museum of Art, Syracuse, New York
JOHN WILLENBECHER
Cenotaph (1), 1974
Labyrinth 11.IV.72, 1972

The British Are Coming: Contemporary British Art
April 12–June 8, 1975
DeCordova Museum, Lincoln, Massachusetts

ROBYN DENNY
By Day #4, 1967

James Brooks: Paintings, 1952–1972; Works on Paper, 1950–1975
April 30–June 8, 1975
Finch College Museum of Art and Martha Jackson
 Gallery, New York, and six other museums in the
 United States
 JAMES BROOKS
 Embo, 1960
 R-1953, 1953

The Condition of Sculpture
May 29–July 12, 1975
Hayward Gallery, London
 PETER REGINATO
 Mix and Mingle, 1973

The Art of Brazil
June 15–September 14, 1975
Tennessee Fine Arts Center at Cheekwood, Nashville,
 Tennessee
 DANILO DI PRETE
 Untitled, 1964
 IVAN SERPA
 Serie Amazonica, No. 15, 1968
 KAZUO WAKABAYSHI
 Untitled, 1965

Jiri Kolar Retrospective
September 11–November 16, 1975
Solomon R. Guggenheim Museum, New York, New
 York
 JIRI KOLAR
 Arches, 1967

*Weathervanes, Carvings and Quilts from the Chase
 Manhattan Bank Art Collection*
September 14, 1975–April 3, 1977
The Whitney Museum of American Art, Downtown
 Branch, New York, New York, and eleven other
 museums in the United States
 10 weathervanes
 8 carvings
 14 quilts

Theaters by Cletus Johnson
September 23–December 7, 1975
Neuberger Museum, State University College at
 Purchase, New York
 CLETUS JOHNSON
 Oasis, 1974

Paintings by Catherine Murphy
February 14–March 28, 1976
The Phillips Collection, Washington, D.C.
April 20–May 25, 1976
Institute of Contemporary Art, Boston, Massachusetts
 CATHERINE MURPHY
 Lexington Backyard, 1970
 View from the Garden, 1972

Five Contemporary Greek-American Artists
March 19–April 25, 1976
Birmingham Museum of Art, Birmingham, Alabama
 THEODOROS STAMOS
 Red Sea Terrace, 1958

A Child's Comfort: Baby Dolls and Quilts
October 5, 1976–January 23, 1977
Museum of American Folk Art, New York, New York
 ANON. AMERICAN
 Diamond in the Square pattern crib quilt, c. 1880
 ANON. AMERICAN
 Lady of the Lake pattern crib quilt, c. 1895

Seven Decades at the Colony
October 24–October 29, 1976
Benefit for the MacDowell Colony, James Yu Gallery,
 New York, New York
 SUSAN CRILE
 Indian Summer, 1972
 JOHN WESLEY
 *An Atlantic Storm Sea Six Hours from the Tagus
 Estuary and the City of Lisbon*, 1974

Tenth Street Days: The Co-ops of the Fifties
December 20, 1976–January 7, 1977
Amos Eno Gallery, 14 Sculptors Gallery, Noho Gallery,
 Pleiades Gallery, and Ward-Nasse Gallery, New York,
 New York

JOE FIORE
Medomak II, 1959

The Material Dominant
January 29–March 27, 1977
Museum of Art, Pennsylvania State University,
 University Park, Pennsylvania
 JOHN OKULICK
 Ghost Dance, 1975

Carolyn Brady
February 22–March 12, 1977
Main Gallery, Fine Arts Center, University of Rhode
 Island, Kingston, Rhode Island
 CAROLYN BRADY
 Williamsii, 1976

Giorgio Cavallon: Paintings, 1937–1977
May 3–September 4, 1977
Neuberger Museum, State University of New York at
 Purchase, New York
 GIORGIO CAVALLON
 12.1.1965, 1965

Sculpture and Paintings by Alexander Liberman
May 18–August 29, 1977
Storm King Art Center, Mountainville, New York
 ALEXANDER LIBERMAN
 BA #31, 1969
 Collage #5, 1962
 Untitled, n.d.

J. & J. Bard: Picture Painters
June 5–September 11, 1977
Hudson River Museum, Yonkers, New York
 J. BARD
 New York Hudson River Line Sidewheeler, 1888

Michael Singer
June 30–September 11, 1977
Art Museum of South Texas, Corpus Christi, Texas
 MICHAEL SINGER
 Ritual Series, 1975

20th Century American Art from Friends' Collections
July 27–September 27, 1977
Whitney Museum of American Art, New York, New
 York
 ILYA BOLOTOWSKY
 Horizontal and Vertical, 1960–64

Carolyn Brady: Watercolors
October 2–October 27, 1977
University of Missouri, St. Louis, Missouri
November 20–December 15, 1977
University of Missouri, Kansas City, Missouri
 CAROLYN BRADY
 Williamsii, 1976

New York: The State of Art
October 8, 1977–January 15, 1978
New York State Museum, Albany, New York
 ELIZABETH MOSEMAN
 Star of Bethlehem pattern quilt, c. 1849

Contemporary Tableaux/Constructions, 1974–1977
November 9–December 11, 1977
Art Museum, University of California, Santa Barbara,
 California
 CLETUS JOHNSON
 Oasis, 1974

Howard Mehring: A Retrospective Exhibition
December 10, 1977–January 22, 1978
Corcoran Gallery of Art, Washington, D.C.
 HOWARD MEHRING
 Two on Four, 1965

Joseph Raffael: The California Years, 1969–1978
January 20–March 5, 1978
San Francisco Museum of Modern Art, San Francisco,
 California, and four other museums in the United
 States
 JOSEPH RAFFAEL
 Two Goldfish, 1977

*Funf Pionere der konkreten Kunst in der Schweiz [Five
 Swiss Pioneers in Concrete Art]: Bill, Glarner, Graeser,
 Loewensberg, Lohse*
February 12–March 12, 1978
Bundner Kunstmuseum, Chur, Switzerland
 FRITZ GLARNER

Relational Painting, Tondo No. 46, 1956–57

Seven Artists: Contemporary Drawing
February 28–April 30, 1978
Cleveland Museum of Art, Cleveland, Ohio
 SUSAN ROTHENBERG
 Untitled, 1976
 JEANETTE PASIN SLOAN
 Still Life, 1977

Three Realists
March 5–March 26, 1978
Canton Art Institute, Canton, Ohio, and four other
 museums in the United States
 PAMELA BERKELEY
 Still Life (Fishbowl), 1976

Art at Work: Recent Art from Corporate Collections
March 9–April 11, 1978
The Whitney Museum of American Art, Downtown
 Branch, New York, New York
 CHRISTO
 Package/Handtruck Project, 1973
 CLETUS JOHNSON
 Oasis, 1974
 HUGH KEPETS
 Fifth Avenue, 1977
 JOSEPH RAFFAEL
 One Bird, 1977

Rackstraw Downes: Paintings and Drawings
March 20–April 5, 1978
Swain School of Design, New Bedford, Massachusetts
 RACKSTRAW DOWNES
 Oxen and Draft Horses, 1974

George Cohen Retrospective
April 20–September 25, 1978
Smith College Museum of Art, Northhampton,
 Massachusetts
 GEORGE COHEN
 Double Red, c. 1965
 Emblem Grey, c. 1965

Gyorgy Kepes: The MIT Years, 1945–1977
April 28–June 9, 1978
Hayden Gallery, Massachusetts Institute of Technology,
 Cambridge, Massachusetts
 GYORGY KEPES
 Garden of Light, 1959

Masters of Watercolor in 20th Century American Art
July 23–September 10, 1978
Katonah Gallery, Katonah, New York
 CHARLES BURCHFIELD
 Pink Locusts and Windy Moon, 1959
 Sunflowers, 1917

Two Photorealists
August 1–August 31, 1978
San Jose Museum of Art, San Jose, California
 CAROLYN BRADY
 Williamsii, 1976

Bridget Riley: Works 1959–1978
September 1, 1978–June 28, 1980
Sponsored by The British Council, London; seven
 museums in Australia, Japan, Scotland, and the United
 States
 BRIDGET RILEY
 Deny I, 1966

François Rouan: Paintings and Drawings, 1972–1976
November 13–December 30, 1978
Arts Club of Chicago, Chicago, Illinois
 FRANÇOIS ROUAN
 Casilina, Porta Maggiore, 1973

Point
November 20–December 15, 1978
Philadelphia College of Art, Philadelphia, Pennsylvania
 SALLY HAZELET DRUMMOND
 Turner #16, 1969

John Willenbecher
January 14–February 25, 1979
Allentown Art Museum, Allentown, Pennsylvania
May 27–September 10, 1979
Neuberger Museum, State University of New York at
 Purchase, New York
 JOHN WILLENBECHER
 Cenotaph (1), 1974

Narrative Imagery
February 6–March 3, 1979
ARC Gallery, Chicago, Illinois
 ALAIN GAVIN
 Untitled, 1973

Art in Boxes
February 27–April 1, 1979
Philadelphia Art Alliance, Philadelphia, Pennsylvania
 JOHN OKULICK
 Ghost Dance, 1975

Art Inc.: American Paintings from Corporate Collections
March 7–May 6, 1979
Montgomery Museum of Fine Arts, Montgomery,
 Alabama, and three other museums in the United
 States
 ROMARE BEARDEN
 Blue Interior, Morning, 1968
 CHARLES BURCHFIELD
 Pink Locusts and Windy Moon, 1959
 HELEN FRANKENTHALER
 Yellow Vapor, 1965

*The Illusory Essence of Fabric: Watercolors, Oils and
 Drawings by Alain Gavin*
March 18–April 15, 1979
Park Forest Art Center, Park Forest, Illinois
 ALAIN GAVIN
 Untitled, 1973

*Okada, Shinoda and Tsutaka: Three Pioneers of Abstract
 Painting in 20th Century Japan*
April 14–May 26, 1979
The Phillips Collection, Washington, D.C., and four
 other museums in the United States
 TOKO SHINODA
 Kiri Tsubo, 1964
 Unseen Forms, 1964

Another Generation
April 15–June 24, 1979
Studio Museum in Harlem, New York, New York
 WILLIAM MAJORS
 Untitled, 1969
 JACK WHITTEN
 Alpha Group #3, 1975

Art From Corporate Collections
May 9–May 30, 1979
Sponsored by AT&T and held at the Union Carbide
 Corporation Gallery, New York, New York
 RAFAEL FERRER
 Celebes, 1974
 CATHERINE MURPHY
 Lexington Backyard, 1970
 SUSAN ROTHENBERG
 Untitled, 1976
 ARLENE SLAVIN
 Yellow Flying Geese, 1978

The Inspirational Century: The Black Artist in America
February 3–March 31, 1980
The Bruce Museum, Greenwich, Connecticut
 FELRATH HINES
 Landscape, 1969
 ALMA THOMAS
 Untitled, 1960
 Untitled, 1960

L'Amérique aux Indépendants
March 13–April 13, 1980
Sponsored by the Société des Artistes Indépendants,
 Paris, at the Grand Palais, Paris
 JEREMY GILBERT-ROLFE
 Grey Genevieve, 1979

Helen Frankenthaler Prints: 1961–1979
April 11–May 11, 1980
Sterling and Francine Clark Art Institute, Williamstown,
 Massachusetts, and six other museums in the United
 States
 HELEN FRANKENTHALER
 Brown Moons, 1961
 Spoleto Festival Poster, 1972

*Between Inventory and Memory: The Architecture of
 Aldo Rossi*
May 24–June 22, 1980
Hayden Gallery, Massachusetts Institute of Technology,
 Cambridge, Massachusetts

 ALDO ROSSI
 Model for the Modena Cemetery, 1976

Religious Art: Contemporary Directions
May 31–June 29, 1980
Thorpe Intermedia Gallery, Sparkill, New York
 JOHN OKULICK
 Four Corners, 1977

Plane Truths: American Trompe l'Oeil Painting
June 7–July 20, 1980
Katonah Gallery, Katonah, New York
 WILLIAM M. HARNETT
 Paint Tube and Grapes, 1874

The 11th International Sculpture Conference Exhibition
Summer 1980
Sponsored by International Sculpture Center,
 Washington, D.C.
 ISAAC WITKIN
 Papageno, 1973

*Master Weavers: Tapestry from the Dovecot Studios,
 1912–1980*
August 15, 1980–January 21, 1981
Sponsored by the Scottish Arts Council, Edinburgh; four
 museums in Scotland
 IVON HITCHENS
 (Director of weaving: Archie Brennan)
 Untitled, 1973

Roger Welch: Subconscious Sculpture, 1970–1980
October–November 1980
Museo de Arte Moderno, Institute Nacional de Bellas
 Artes, Mexico City, Mexico
 ROGER WELCH
 Proposed Film for the Roger Woodward–Niagara
 Falls Project, 1974

Don Gummer: Sculpture
November 8, 1980–January 4, 1981
Akron Art Museum, Akron, Ohio
 DON GUMMER
 Ionic Loggia, 1978

Nell Sinton: A Thirty-Year Retrospective
January 27–March 8, 1981
Mills College Art Gallery, Oakland, California
 NELL SINTON
 Falling Water, 1960

*Machineworks: Vito Acconci—Alice Aycock—Dennis
 Oppenheim*
March 12–April 19, 1981
Institute of Contemporary Art, University of
 Pennsylvania, Philadelphia, Pennsylvania
 ALICE AYCOCK
 Drawing for the Machine that Makes the World,
 1979

The Americans: The Landscape
April 4–May 31, 1981
Contemporary Arts Museum, Houston, Texas
 CATHERINE MURPHY
 Lexington Backyard, 1970

Five American Masters of Watercolor
May 5–July 12, 1981
Terra Museum of American Art, Evanston, Illinois
 CHARLES BURCHFIELD
 Pink Locusts and Windy Moon, 1959

Kes Zapkus: Drawing into Painting
June 27–September 6, 1981
Museum of Art, Carnegie Institute, Pittsburgh,
 Pennsylvania
 KES ZAPKUS
 Fictional Targets (Dresden Series), September
 1980
 Shattered Calm (Dresden Series), August 1980

*Drawing Distinctions: American Drawings of the
 Seventies*
August 15–September 20, 1981
Louisiana Museum of Modern Art, Humlebaek,
 Denmark, and three museums in Switzerland and
 West Germany
 ROBERT GROSVENOR
 Untitled, 1975

*Selections from the Chase Manhattan Bank Art
 Collection*
September 19–December 20, 1981
University Gallery, University of Massachusetts at
 Amherst, and four other museums in the United States
 VITO ACCONCI
 Ladder Drawing, 1979
 SIAH ARMAJANI
 Model for a House #3, 1971
 ALICE AYCOCK
 Drawing for the Machine that Makes the World,
 1979
 ROBERT BARRY
 Untitled, 1980
 JENNIFER BARTLETT
 Graceland Mansions, 1979
 BERND & HILDA BECHER
 Watertowers, New York, 1978
 JOSEPH BEUYS
 American Hare Sugar, 1974
 MEL BOCHNER
 Rules of Inference, 1974
 JONATHAN BOROFSKY
 Me (I Dreamed the Letters ME were Written on
 my Forehead), 1975
 JOHN CAGE
 49 Waltzes for 5 Boroughs, 1977
 CHRISTO
 The Mastaba of Abu Dhabi, 1980
 JAN DIBBETS
 Land, 1972
 Sea, 1972
 VERNON FISHER
 Monahan's Sandhills, 1976
 CHARLES GAINES
 Geometric Landscape II, Palm Trees, Set I, Black
 Numbers, 1981
 GERALD INCANDELA
 Oatfield and Morning Glory, 1979
 BARRY LE VA
 Installation Study #1, 1980
 ROBERT MANGOLD
 Three aquatints, 1979
 ROBERT MAPPLETHORPE
 Lily NYC, 1977
 Gordon MATTA-CLARK
 Circus, The Caribbean Orange, No. 203, 1977
 MARY MISS
 Study for Veiled Landscape, 1979
 ROBERT MORRIS
 Untitled, 1976
 ELIZABETH MURRAY
 Call, 1979
 ROBERT MURRAY
 Spinnaker, 1979
 CLAES OLDENBURG
 Screwarch Bridge, 1980
 Soft Screw, 1975
 DOMINICO PALADINO
 Viaggiatori della Notte, 1980
 ALDO ROSSI
 Model for the Modena Cemetery, 1976
 RICHARD SERRA
 Vertical, 1979
 SANDY SKOGLUND
 Radioactive Cats, 1980
 ROBERT SMITHSON
 Tailings Terrace Project, 1972
 EVE SONNEMAN
 Two Trees, 1978
 JAMES TURRELL
 Roden Crater Project, 1979
 RICHART TUTTLE
 Print, 1976
 CY TWOMBLY
 Trees—Castanea Sativa, 1976
 GER VAN ELK
 Tarn Waters, 1978
 WILLIAM WEGMAN
 Elks Club, 1980
 LAWRENCE WEINER
 Hung About . . . , 1979
 WILLIAM WILEY
 O.T.P.A.G., 1978
 ROBERT ZAKANITCH
 Shadrack, 1981

Animals in American Art, 1880's–1980's
October 4, 1981–January 17, 1982
Nassau County Museum of Fine Art, Roslyn, New York
 RACKSTRAW DOWNES
 Oxen and Draft Horses, 1974

Neil Welliver: Paintings, 1966–1980
November 11, 1981–January 9, 1983
Sponsored by the Currier Gallery of Art, Manchester,
 New Hampshire, and five other museums in the
 United States
 NEIL WELLIVER
 Grier's Bog, 1970

*Chuck Forsman: Meditations on Realist
Form and Content*
December 5, 1981–January 17, 1982
Wichita Art Museum, Wichita, Kansas
 CHUCK FORSMAN
 Nebraska School, 1972

Boyd Webb Photographs
January 12–February 28, 1982
Badischer Kunstverein, Karlsruhe, West Germany, and
 four museums in The Netherlands, France,
 Switzerland, and West Germany
 BOYD WEBB
 Laurentian, 1981

*Realism and Realities: The Other Side of American
Painting, 1940–1960*
January 17–March 28, 1982
Rutgers University Art Gallery, New Brunswick, New
 Jersey, and three museums in the United States
 WALTER MURCH
 Carburetor, 1957

Constructed Paintings
February 2–March 14, 1982
Institute of Contemporary Art of the Virginia Museum,
 Richmond, Virginia
 MARILYN LENKOWSKY
 Untitled, 1974

Lower Manhattan from Street to Sky
February 23, 1982–April 30, 1982
Whitney Museum of American Art, Downtown Branch,
 New York, New York
 RICHARD ESTES
 Chase Manhattan Plaza, 1981 (from "Urban
 Landscapes III")

Tim Duch
March 5–March 27, 1982
Hallwalls Gallery, Buffalo, New York
 TIMOTHY DUCH
 Grandma Was Having a Ball, 1980
 She Dreamt Often of Courageous Acts, 1980

The Midwest Artists Series
March 7, 1982–March 28, 1982
Artlink, Fort Wayne, Indiana
 RICHARD GEORGE
 A Painted Ship on a Painted Ocean, 1978

William Fares: Detwiller Visiting Artist
April 19–May 14, 1982
Van Winckle Gallery, Lafayette College, Easton,
 Pennsylvania
 WILLIAM FARES
 Coal Train, 1981
 Metropolis, 1981

Frames of Reference
May 6–June 11, 1982
Whitney Museum of American Art, Downtown Branch,
 New York, New York
 THOMAS LAWSON
 Battered Body in Freezer, 1981

Rutgers Master of Fine Arts 20th Anniversary Exhibition
May 8–June 20, 1982
New Jersey State Museum, Trenton, New Jersey
 JOAN SNYDER
 Symphony V, 1981–82

Lucio Pozzi
May 9–June 27, 1982
Kunsthalle Bielefeld, Bielefeld, West Germany
 LUCIO POZZI
 Fall Cut, 1979

Mythe, Drame, Tragédie
Summer 1982
Musée d'Art et d'Industrie, Saint-Etienne, France
 CHRISTOPHER LE BRUN
 Mars in the Air, 1981

Concentrations VI: Al Souza
June 6–July 18, 1982
Dallas Museum of Fine Arts, Dallas, Texas
 AL SOUZA
 The Painting, 1979

Summer Studio Atelier '82
June 9–July 16, 1982
Washington Square East Galleries, New York University,
 New York, New York
 MEL KENDRICK
 Black and White (The Lock), 1981

The Americans: The Collage
July 11–October 3, 1982
Contemporary Arts Museum, Houston, Texas
 CHARLES CLOUGH
 Nasion VII, 1981

Incidents and Events
July 28–October 28, 1982
Fourth Floor Gallery, Joseph E. Seagram & Sons, Inc.,
 New York, New York
 MILO REICE
 Androcles and the Lion, 1982

*Chase Manhattan: The First Ten Years of Collecting,
1959–1969*
October 5–October 31, 1982
The High Museum of Art, Atlanta, Georgia
 JOSEF ALBERS
 Homage to the Square in Late Day, 1959
 MILTON AVERY
 Sandbar, 1959
 LEONARD BASKIN
 Owl, 1960
 ROMARE BEARDEN
 Blue Interior, Morning, 1968
 JAMES BROOKS
 R-1953, 1953
 CHARLES BURCHFIELD
 Pink Locusts and Windy Moon, 1959
 ALEXANDER CALDER
 Untitled, 1959
 GENE DAVIS
 Red Jumper, 1967
 JEAN DUBUFFET
 Demeure IV (à l'Escalier d'Entrée), 1966
 FRIEDEL DZUBAS
 Hex, 1966
 SAM FRANCIS
 Untitled, 1959
 ADOLPH GOTTLIEB
 Turbulence, 1964
 ROBERT INDIANA
 The Marine Works, 1960–62
 ALFRED JENSEN
 Color Wheel, 1959
 Even Number Magic, 1960
 CONRAD MARCA-RELLI
 Runaway #5, 1959
 MARINO MARINI
 The Juggler, 1951
 WALTER MURCH
 Brooklyn, 1964
 LOUISE NEVELSON
 Expanding Reflection, 1966
 KENZO OKADA
 Ise, 1959
 FAIRFIELD PORTER
 Sycamore in September, 1961
 BRIDGET RILEY
 Deny I, 1966
 LARRY RIVERS
 Me III, 1959
 JASON SELEY
 Triptych, 1964
 PIERRE SOULAGES
 23 Mars 1960, 1960
 SAUL STEINBERG
 Grand Ratification, 1966
 JACK YOUNGERMAN
 Black Red, 1959

*Recent Acquisitions from the Chase Manhattan
Collection*
October 5–October 31, 1982
The High Museum of Art, Atlanta, Georgia
 JOHN ALBERS
 Untitled, 1981
 GARY BOWER
 The Charlotte, 1977

 TOM BUTTER
 L/F, 1982
 TONY CRAGG
 Palette, 1981–82
 TIMOTHY DUCH
 She Dreamt Often of Courageous Acts, 1981
 NANCY HAYNES
 Untitled, 1980
 Untitled, 1980
 Untitled, 1980
 THOMAS LAWSON
 Battered Body in Freezer, 1981
 DAVID REED
 123-2, 1977
 RODNEY RIPPS
 Untitled, 1976
 JANE ROSEN
 Silver Man (For Martin), 1982
 JEFF WAY
 Chief with Cherries Shaman, 1974
 Copper Mask, 1979
 Elvis Study, 1980
 Fred and Son Study, 1978
 Moth Mask, 1979
 New Mexico Rock Painting for Viola Heller, 1980
 New York Head X, 1978
 Snake Mask, 1976
 Two Horn Mask, 1979

Zeitgeist
October 15–December 19, 1982
Martin-Gropius-Bau, Berlin, West Germany
 CHRISTOPHER LE BRUN
 Mars in the Air, 1981

Beast: Animal Imagery in Recent Painting
October 17–December 12, 1982
Institute for Art and Urban Resources, Project Studios
 One, Long Island City, New York
 EARL STALEY
 The Story of Acteon II, 1977
 BERND ZIMMER
 Kuhe in der Abendsonne, 1980

New Figuration in America
December 3, 1982–January 23, 1983
Milwaukee Art Museum, Milwaukee, Wisconsin
 MICHAEL GLIER
 Crying Man, 1981
 EARL STALEY
 The Story of Acteon I, 1977

Fairfield Porter: Realist Painter in an Age of Abstraction
January 5, 1983–March 13, 1983
Museum of Fine Arts, Boston, and four other museums in
 the United States
 FAIRFIELD PORTER
 The Harbor through the Trees, 1954
 Main Street, n.d.

The Re-Gentrified Jungle
January 8–February 12, 1983
Fred L. Emerson Gallery, Hamilton College, Clinton,
 New York
 CLEMENTINE HUNTER
 Baptismal Scene, c. 1975
 Cotton Picking with Geese, 1977
 ELIJAH PIERCE
 When Joe Became Champ, 1971
 NELLIE MAE ROWE
 The Red Bird, 1980

Abstract Painting, 1960–1969
January 16–March 13, 1983
Institute for Art and Urban Resources, Project Studios
 One, Long Island City, New York
 SALLY HAZELET DRUMMOND
 Turner #16, 1969

Concepts in Construction: 1910–1980
February 12, 1983–March 31, 1985
Sponsored by Independent Curators, Incorporated, New
 York; to nine museums in Canada and the United
 States
 MEL KENDRICK
 Black and White (The Lock), 1981

Rudy Fernandez: Secular Santos
March 20–April 17, 1983
University of Arizona Museum of Art, Tucson, Arizona
 RUDY FERNANDEZ
 Rituals and Rites of Passage #2, 1981

Charles Clough: Recent Work
April 8–May 8, 1983
Albright-Knox Art Gallery, Buffalo, New York
 CHARLES CLOUGH
 Nasion VII, 1981

Back to the U.S.A.
May 1983–June 1984
Sponsored by the Rheinisches Landesmuseum, Bonn,
 West Germany, and two other museums in
 Switzerland and West Germany
 MICHAEL GLIER
 Crying Man, 1981
 GORDON MATTA-CLARK
 Circus, The Caribbean Orange, 1977–78

James Brooks: Paintings and Works on Paper, 1946–
 1982
May 14–September 4, 1983
Portland Museum of Art, Portland, Maine
 JAMES BROOKS
 Erelon, 1967
 R-1953, 1953

Homage to Simón Bolívar (1783–1830)
May 24–June 26, 1983
Center for Inter-American Relations, New York, New
 York
 ANON. PERUVIAN
 Textile (Simón Bolívar), c. 1940

Arbitrary Order: Paintings by Pat Steir
May 27–July 17, 1983
Contemporary Arts Museum, Houston, Texas
 PAT STEIR
 Lima Being (Being/Been), 1980

Expressions: New Art From Germany
June 24–August 21, 1983
St. Louis Art Museum, St. Louis, Missouri, and six other
 museums in the United States
 ANSELM KIEFER
 Der Kyffhausser, 1981

Alice Aycock: Projects and Ideas, 1972–1983
August 3–September 18, 1983
Wurttembergischer Kunstverein, Stuttgart, West
 Germany, and four other museums, in West Germany,
 Switzerland, and The Netherlands
 ALICE AYCOCK
 The Disintegration of Micro-Electronic
 Memories, The Storyboard, 1980
 Drawing for the Machine that Makes the World,
 1979

The World of Quilts
September 8–September 25, 1983
Meadow Brook Hall, Oakland University, Rochester,
 Michigan
 ANON. AMERICAN
 Alphabet pattern quilt, c. 1915

Language, Drama, Source & Vision
September 24–November 9, 1983
New Museum of Contemporary Art, New York, New
 York
 BRICE MARDEN
 From Bob's House #1, 1970

Jack Whitten: Paintings, 1970–1980
October 1, 1983–April 13, 1984
Studio Museum in Harlem, New York, New York
 JACK WHITTEN
 Alpha Group III, 1975

Bill Richards
October 18–November 18, 1983
Allen R. Hite Art Institute, University of Louisville,
 Belknap Branch, Louisville, Kentucky
 BILL RICHARDS
 Fernswamp with Hanging Branch, 1975

Earl Staley
December 3, 1983–February 5, 1984
Contemporary Arts Museum, Houston, Texas
March 24–May 16, 1984
The New Museum of Contemporary Art, New York,
 New York
 EARL STALEY
 The Story of Acteon I, 1977
 The Story of Acteon II, 1977

Korean Folk Art: Paintings of the Yi Dynasty and Related
 Objects
December 8, 1983–January 22, 1984
Asia House, New York, and five museums in the United
 States
 ANON. KOREAN
 Temple funeral sculpture of four dragons,
 nineteenth century

Charles Burchfield
January 30–November 11, 1984

Metropolitan Museum of Art, New York, New York
 CHARLES BURCHFIELD
 Pink Locusts and Windy Moon, 1959
 Sunflowers, 1917

Radical Painting
March 4–April 22, 1984
Williams College Museum of Art, Williamstown,
 Massachusetts
 CARMENGLORIA MORALES
 Dittico N.Y. 82-3-1, 1982–83
 Dittico N.Y. 83-9-2, 1983

Humanism: An Undercurrent
March 26–May 4, 1984
University of South Florida, Tampa, Florida
 MICHAEL GLIER
 Ulli Calling, 1983

Robert Indiana (Sculpture)
April 1984–June 1984
National Museum of American Art, Washington, D.C.
 ROBERT INDIANA
 The Marine Works, 1962

Adja Yunkers: A Retrospective
April 22–June 17, 1984
Fine Arts Museum of Long Island, Hempstead, New York
 ADJA YUNKERS
 Untitled, 1960
 Variation on Composition XI, 1972

Victor Burgin
May 15, 1984–July 15, 1984
Yale Center for British Art, Yale University, New Haven,
 Connecticut
 VICTOR BURGIN
 Gradiva, 1982

Paradise Lost/Paradise Regained: American Visions of
 the New Decade
June 1984
Venice Biennale
 JUDITH LINHARES
 Broken Tree, 1982

10th Anniversary Exhibition
October 3, 1984–January 6, 1985
Hirshhorn Museum, Washington, D.C.
 EARL STALEY
 The Story of Acteon I, 1977

Index
Works illustrated

The page numbers to the left of the artists' names refer to illustrations; the page numbers following the names refer to the text.

PHOTO CREDITS

A large percentage of the photographs of works of art were taken by D. James Dee, New York, and another large number were taken by Chase Manhattan staff photographers, including: Lee Boltin, Christopher Gerould, Jan Jachniewicz, Elwood Johns, Raymond Juschkus, Arthur Lavine, and Grant Taylor. Other photographs were supplied by: Archival Color, Inc., John Dominus, Courtney Frisse, Masaru Miyazaki, John Rose Associates, George Routhier, Daniel Kramer, and Ron Vickers. The Chase Manhattan Corporation Archives provided the black-and-white documentary photographs. The photographs in the montages on pages 1–3 were taken by D. James Dee.